RAPHAEL
The Pursuit of Perfection

Raphael

THE PURSUIT OF PERFECTION

National Galleries
of Scotland

1994

Published by the Trustees
of the National Galleries of Scotland
for the exhibition *Raphael: The Pursuit of Perfection*
held at the National Gallery of Scotland,
Edinburgh, 5 May – 10 July 1994.
© Trustees of the National Galleries of Scotland
ISBN 0 903598 40 X

Designed and typeset in Trinité by Dalrymple
Printed and bound by BAS Printers Ltd

Front cover:
Detail from the *Holy Family with a Palm Tree*
Raphael (cat. no. 5)

Contents

Lenders

Her Majesty The Queen

His Grace the Duke of Sutherland

His Grace the Duke of Northumberland

His Grace the Duke of Devonshire
and the Trustees of the Chatsworth Settlement

Florence, Galleria degli Uffizi

Glasgow University, Hunterian Art Gallery

Haarlem, Teylers Museum

Lille, Musée des Beaux-Arts

London, The British Museum

London, The Courtauld Institute

London, The Victoria and Albert Museum

London, Michael Simpson Ltd

Oxford, The Ashmolean Museum

Paris, Musée du Louvre

Rome, Istituto Nazionale per la Grafica

Vatican, Biblioteca Apostolica Vaticana

Vienna, Graphische Sammlung Albertina

Preface

This exhibition is something of a curiosity in that most institutions that boasted major holdings of the work of Raphael exhibited them in the great celebrations in 1983 of the quincentenary of his birth. The National Gallery of Scotland then had on loan three great Raphael Madonnas from the Duke of Sutherland's collection, and indeed these pictures have been most generously lent to us since 1945. However, in 1983 none of them had been restored, but now they have all been subjected to conservation and so it is a fitting opportunity to re-assess them. We were also fortunate enough to buy a major *Madonna* by Raphael's favourite pupil, Giulio Romano, and more recently two wonderful drawings by Raphael himself. The Gallery also possesses a small group of drawings by Raphael's pupils, collaborators, and contemporaries. The purpose of this small exhibition is to unite these objects as a group, to borrow associated material, and show them all as Scotland's homage to the great master. It does not pretend to be comprehensive, but it does attempt to explore, discuss and put into context the works in our charge. For reasons of space and cost, our investigation of the influence of these Raphael images on future artists is necessarily restricted to a few examples. We have, however, provided a substantial number of reproductive prints after the works, which not only demonstrate their importance to contemporaries, but were also the way by which the images became assimilated by later artists and craftsmen, and became familiar to a wide audience. Raphael's art was well known in Scotland, and his style and imagery became a major influence on generations of Scottish painters.

Raphael was, of course, not just one of the greatest Renaissance painters, but became an authority on antique sculpture and antiquities, designed tapestries, metalwork and sculpture, and was greatly influential as an architect. Unfortunately, none of these aspects of his activity falls within the scope of this exhibition. It is, however, the most exhaustive and detailed discussion of one small aspect of Raphael's endeavours that is likely to happen for very many years, and should solve some problems and pose others. Above all, it is an opportunity for us in Scotland to understand a little better works by one of the greatest of artistic geniuses.

The two splendid drawings by Raphael, which have been bought by the National Gallery of Scotland in the last decade, are central to the exhibition. To this nucleus are added a few drawings in the collection by Raphael's pupils, followers, contemporaries, and imitators, but above all the focus of the exercise is to explore in depth the five principal works. We are fortunate in being able to include the Duke of Northumberland's *Madonna of the Pinks*, cleverly rediscovered by Nicholas Penny, our colleague at the National Gallery, London. It offers a fascinating contrast to the *Holy Family with a Palm Tree* and the *Bridgewater Madonna*, all three painted within the space of two or three years. The picture usually hangs at Alnwick, the Duke's great mediaeval castle built as a bulwark in the Borders against the Scots.

The visitor may be perplexed by the chronological development of Raphael as argued by this exhibition. There is nothing here of Raphael's first or Umbrian manner, and the emphasis is on the three Madonnas that were created during Raphael's Florentine period, 1504-8. It must be remembered that during these four years even though the artist was domiciled in Florence he travelled around quite freely, certainly visiting his home town, Urbino, and his old haunts in Umbria, notably Perugia. My colleague Aidan Weston-Lewis and I, using the same evidence, sometimes interpret the material a little differently. We do not differ on grounds of attribution, but on areas of interpretation and chronology. This friendly divergence of views is perfectly healthy, and reflects in microcosm within this Gallery the multitude of equally valid opinions held by other scholars on these works.

I should especially like to take this opportunity to register the Gallery's appreciation for the help of the following in the preparation of the catalogue and the organisation of loans: Veronika Birke, Padre Leonard Boyle, Barbara Brejon, Michael Bury, Mungo Campbell, Hugo Chapman, Marco Chiarini, Nicola Christie, Michele Cordaro, Peter Day, Gabriele Finaldi, Donald Forbes, Catherine Goguel, Antony Griffiths, Dennis Harrington, Martin Hopkinson, Paul Joannides, Morag Kinnison, Edward Lewine, Sheila McIntyre, Manuela Mena, Annamaria Petrioli Tofani, Myril Pouncey, Janice Reading, Jane Roberts, Erich Schleier, Sheila Scott, Janet Skidmore, Helen Smailes, Dorothy Stuart, Julien Stock, Carel van Tuyll, Françoise Viatte, Jonathan Voak, Diane Watters and Catherine Whistler.

Special thanks are due to Lady Victoria Cuthbert and Nicholas Penny for co-ordinating the loan of the Alnwick Raphael; to Arabella Cifani and Franco Monetti for so generously sharing their archival discoveries about the collector, Genevosio; to Sarah Davidson, who wrote the entries for the two Perino del Vaga drawings; and to Antonia Reeve for her careful photography.

The considerable expense of mounting the exhibition has been partially offset by the generous support of Dundas & Wilson CS.

I am most grateful to my colleague, Aidan Weston-Lewis, who compiled the catalogue entries; to Janis Adams, who has co-ordinated the production of the catalogue with customary efficiency; and to the Keeper of the National Gallery, Michael Clarke, for his support and general assistance. Margaret Mackay has skilfully organised all practical aspects of the loans.

Technical and scientific information, which we increasingly depend upon, has been provided by John Dick, the Keeper of Conservation, in an illuminating introductory essay. The interpretation of the paintings provided in the catalogue also relies heavily on evidence furnished by this technical examination. When the three Sutherland paintings were being conserved, members of the curatorial and conservation staff discussed their progress, an opportunity which provided for us all a very special privilege. To witness familiar images distressed and darkened, like crumpled tobacco leaves, transformed into something brilliant and effulgent, resembling the state in which they left the master's studio nearly 500 years ago, was an exciting and memorable experience.

Above all, the Gallery is greatly indebted to His Grace The Duke of Sutherland for the continuing loan of such great paintings, and for his support and encouragement of the cleaning and restoration programme.

TIMOTHY CLIFFORD
Director, National Galleries of Scotland

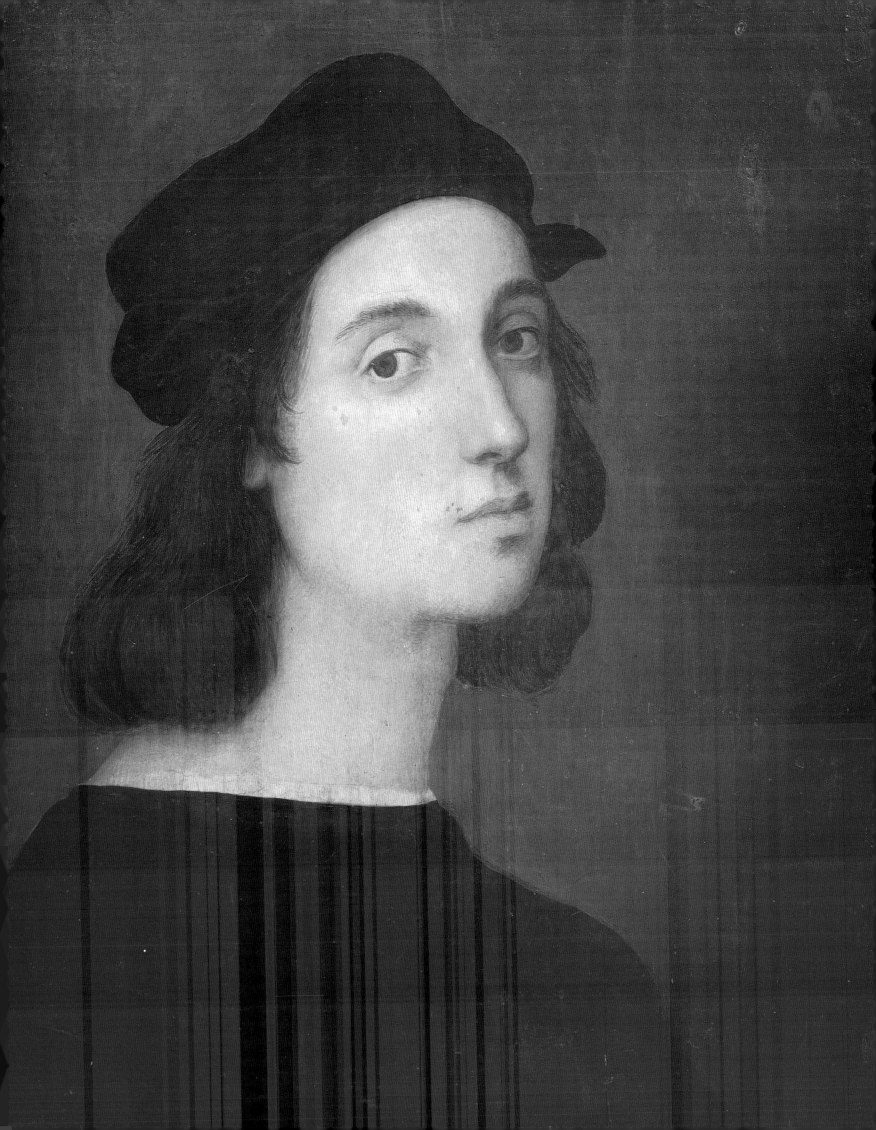

Raphael: The Pursuit of Perfection

TIMOTHY CLIFFORD

Having confessed and shown penitence, he finished the course of his life on the day of his birth, Good Friday, aged thirty-seven. We may believe that his soul adorns heaven as his talent has embellished the earth.[1]

So Giorgio Vasari, author of the *Vite*, wrote in 1568, forty-eight years afterwards, about Raffaello Sanzio da Urbino, known familiarly as 'Raphael'. Unlike Mozart and Watteau who both died tragically young from consumption, a disease which acted as a catalyst on their productive genius, he died in very different circumstances:

Raphael continued his secret pleasures beyond all measure. After an unusually wild debauch he returned home with a severe fever, and the doctors believed him to have caught a chill. As he did not confess the cause of his disorder, the doctors imprudently let blood, thus enfeebling him when he needed restoratives. Accordingly, he made his will, first sending his mistress out of the house, like a Christian, leaving her the means to live honestly.[2]

We can be sure that Vasari was well informed about the particulars. He was, after all, only a generation younger than the great painter, and was intimately acquainted with many of Raphael's friends, patrons, and pupils. There is a curious contradiction between the grace, purity and piety of Raphael's images of the Madonna and his racy private life but this enigma we find again in Mozart who composed sounds as pure and ethereal as any ever written while the composer led a grimy existence, writing letters peppered with scatology.

Vasari further embellished the encomium about our painter:

In Raphael ... the rarest gifts were combined with such grace, diligence, beauty, modesty and good character that they would have sufficed to cover the ugliest vice and the worst blemishes. We may indeed say that those who possess such gifts as Raphael are not mere men, but rather mortal gods ...[3]

Rome at the time of Raphael was fuelled by morally contradictory posturing by Renaissance humanists. For example, Giulio Romano, Raphael's favourite pupil, made designs for a series of highly erotic prints - I Modi (the Positions) - which were to be engraved by Marcantonio Raimondi (Raphael's engraver) with lascivious texts supplied in 1523 by Pietro Aretino (1492-1557), the satirist. But it was the same Aretino who objected so vocally to the nakedness of Michelangelo's figures in the Sistine Chapel.[4]

Raphael was seen by many, particularly the Victorians, as not just the painter of grace but of purity, and this rather cloying angelic image we can now see to have been far from the truth.[5]

This exhibition has been mounted to concentrate principally on three Raphael paintings in the collection of the Duke of Sutherland that have been on loan to the National Gallery of Scotland since 1945 and two drawings by Raphael recently bought by the Galleries. The three Sutherland pictures, the *Bridgewater Madonna*, the *Holy Family with a Palm Tree*, and the *Madonna del Passeggio*, have shared the same provenance since the 1720s and, since 1797, have been in Britain on virtually continuous public view, allowing for a break during the last war (fig. 2). These three pictures from the great collection of the Ducs d'Orléans, largely formed in the early years of the 18th century by the Régent Philippe, Duc d'Orléans, used to hang in the Palais Royal close to the Louvre. Philippe Égalité, of infamous memory, sold all his Italian and French pictures to a Belgian banker, Walchiers, who in turn sold them, at considerable profit, to M. Laborde de Méréville.[6] M. Labord, at the outset of the Revolution, fled to London with his collection but then, as it turned out rather ill-advisedly, returned only to be guillotined. His pictures were obtained by Michael Bryan, a well-known picture dealer, known nowadays for his *Dictionary of Painters and Engravers*, who sold them to

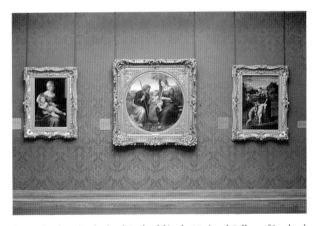

fig. 2 The three 'Sutherland Raphaels' in the National Gallery of Scotland

fig. 1 Raphael, detail from *Self-Portrait* (Florence, Uffizi)

a consortium consisting of the Duke of Bridgewater, the Earl Gower (his nephew), and the Earl of Carlisle for £43,000. When the Duke died in 1803, he left his portion of the Orléans collection to his nephew George Granville Leveson-Gower, 2nd Marquis of Stafford, later Duke of Sutherland. For these pictures the Marquis rebuilt his house, Cleveland House, overlooking Cleveland Square in St. James's. From 1806 he opened the collection on Wednesday afternoons for three months in the summer. John Britton in *The Catalogue Raisonné ... of the Gallery of Cleveland House* noted that entry was only by ticket issued on personal recommendation. He expressed the view that:

> ... in England, where ignorance, vulgarity, or something worse, are the characteristics of the lower orders, and where frivolity, affectation, and insolence, are the leading traits in a class of lounging persons, who haunt most public places, it would be excess of folly for gentlemen who possess valuable museums, to give unlimited admission to the public.[7]

This was eighteen years before the National Gallery in London was founded.

We know how the Raphaels looked in 1818. They hung in the New Gallery, a room 40 feet by 25 feet, between the Drawing Room and the Ante Room of the Old Gallery (fig. 3). The so-called 'old' gallery was built for the Duke of Bridgewater by John Lewis

in 1795-7, the 'new' or Second Gallery was added by his heir to the designs of Charles Heathcote Tatham, c.1804-5. The *Holy Family with a Palm Tree* was on the south wall, flanked by the other two Raphael *Madonnas*. Above them was Annibale Carracci's *Danaë*, and on the opposite wall was Guercino's *David and Abigail* (both destroyed during the Second World War). Standing before the Raphaels was one of a pair of grand marble-topped tables designed by Tatham carved with addorsed gilded dolphins (now both in the collection of the Duke of Sutherland at Mertoun, St. Boswells) and by 1818 standing above them were large campana-shaped vases, one of which partly blotted out the lower section of the *Holy Family with a Palm Tree*.

These pictures, first at Cleveland House and then next door at Bridgewater House, were justly famous and were visited frequently by amateurs and cognoscenti. Dr. G. F. Waagen, sometime Director of the Royal Gallery at Berlin, visited old Bridgewater House, and in his *Works of Art and Artists in England* (1838) wrote:

*After repeated visits, I am now able to give you some account of the cele-
brated Bridgewater Gallery. It has this name from its founder, the Duke of
Bridgewater, who left it to his brother, the Marquis of Stafford, on condition
that it should go to his second son, Lord Francis Egerton, its present owner.
During the time that it was in the possession of the Marquis of Stafford, it
was called the Stafford Gallery, and was described by that name by Mr. W.
Young Ottley, in a work in four volumes, with engravings. By the variety of
its contents, it holds the first rank among all the collections of paintings in
England, for it has masterpieces of the Italian, Dutch, and French schools,
and the Flemish, Spanish, and English are not neglected. Of the rooms in
Bridgewater House which contain it, two are lighted by lanterns above.*[8]

The great picture gallery at Bridgewater House on Cleveland Row
was clearly a rival to the neighbouring picture gallery at Bucking-
ham Palace, built by Nash in 1825. Sir Charles Barry's Bridgewater
House Gallery was designed *c*.1841, but not opened to the public
for another decade.[9]

As the pictures' very handsome rococo, or more accurately
Régence, revival frames, do not appear in the 1808-18 engravings
of the pictures at Stafford House, they probably date from be-
tween 1833 when Lord Francis Leveson Gower, later 1st Earl of
Ellesmere, inherited the collection, and 1851 when the richly
refurbished Barry interior opened to the public. As part of the
honourable history of the paintings, the present Duke of Suther-
land has been advised by the National Gallery of Scotland to
retain these frames and not have reproductions made in the
Cinquecento taste.

This essay is intended to explain briefly something of the life
of Raphael and to provide an intelligible linking narrative to the
works of art in the exhibition. Around these pictures and draw-
ings has been grouped related material, cartoons, drawings,
prints, medals, and maiolica that illuminates these precious
images.

In Italian Renaissance terms Raphael was something of a
provincial, born the son of a relatively undistinguished artist in
the Marche – a mountainous zone in the north east of Italy with a
long Adriatic coastline, Tuscany to the north west, and Umbria to
the south west. The capital city of the Marche was Urbino and the
Dukes of Urbino were 'condottieri', or mercenary soldiers, who
were much employed by Venice. During Raphael's lifetime the
Dukedom passed from the Montefeltro to the Della Rovere fami-
lies. Both, on a small scale, supported sophisticated humanist
courts and the Dukes, like mediaeval monarchs, moved around
their territory, spending much of their time at Urbino but also at
Pesaro, Loreto, and Gubbio. Urbino, then as now a delightful city,
was in terms of wealth, population and power, hardly another
Florence or Milan. One should use 'provincial' guardedly because
the Marchigian court had employed the great architects Alberti
and Francesco di Giorgio, the medallist Pisanello, painters like

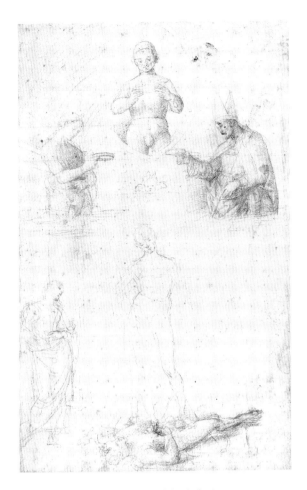

fig. 4 Raphael *The Coronation of St. Nicholas of Tolentino*
(Lille, Musée des Beaux-Arts)

Hugo van der Goes, Justus van Ghent, Piero della Francesca
and Melozzo da Forlì; it boasted the great statesman
Baldassare Castiglione, author of *Il Cortegiano* (*The Courtier*) and
long-term resident in the city and the architect of St. Peter's,
Donato Bramante.[10] The place of one's birth was crucial for a
Renaissance man of ambition.

Raphael was born the only son of Giovanni Santi and
Magia di Nicola Ciarla on 6 April 1483. Vasari makes a special
point of telling us that not only was it a good augury that the
child was named after the archangel Raphael but that he had
his 'mother's milk and not that of a nurse ... so that the child
might see the ways of his equals in tender years rather than
the rough manners of clowns and people of low condition'.[11]
When Raphael was aged eleven his father died. His earliest
years are obscure but we know that his father was a painter,
poet, merchant, money changer and intellectual. He wrote an
epic on the life of Duke Federigo da Montefeltro, but was also
a competent painter reflecting the style of other greater art-
ists that worked in the Marche. In all probability he taught
his son the rudiments of painting.

According to Vasari, Raphael in his early years worked in the shop of Pietro Perugino in Perugia, the capital of Umbria. Perugino's style is typified by his gentle sentimental figures with drooping postures, tilted heads and oval faces which, although elegantly painted, tend to a routine repetitiveness. The earliest works of Raphael already show him competing with his master, if master he was. It is likely that Raphael by this stage was a privileged trainee. On December 10, 1500, together with another artist, he began to paint the *Coronation of St. Nicholas of Tolentino* for the Baronci Chapel of the Church of Sant'Agostino in Città di Castello in Umbria and by 13 September 1501 we know this altarpiece was completed. The picture is now dismembered but from the surviving fragments and a fine compositional drawing at Lille we can understand what a remarkable picture it was, showing an intelligent use of drapery, elegant mastery of forms and already a mature knowledge of geometry (fig. 4).

By 1502-3 Raphael appears to have been preparing designs for the Piccolomini Library frescoes in the Duomo, Siena, which were executed by that decorative Umbrian painter, Bernardino Pinturicchio (*c.*1454-1513), who was some thirty years his senior.

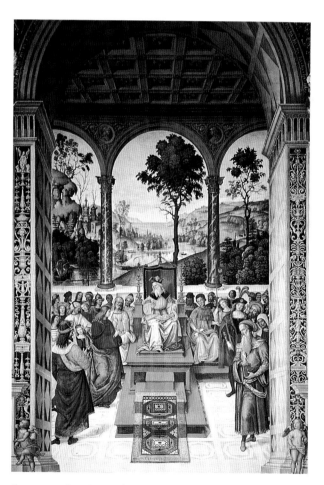

fig. 5 Bernardino Pinturicchio *Enea Silvio Piccolomini before James I of Scotland,* fresco (Siena, Duomo, Piccolomini Library)

These frescoes, completed by 1508, are doubly interesting to a Scottish audience as one of them shows Enea Silvio Piccolomini delivering an oration to King James I of Scotland, where he had been sent as ambassador by the Council of Basle (fig. 5), while another early drawing of the Piccolomini library type in an American private collection (fig. 53) shows a kneeling figure in a pose that Raphael was to repeat, many years later, in that of Tobias in the *Madonna of the Fish* (cat. nos. 29-31). It is evident that Raphael followed the usual practice and retained his old drawings as a bank of images, to be re-cycled again later.

Not only did Raphael re-use his old ideas but often borrowed from other masters, and assimilated such borrowings so skilfully that they became transformed entirely into his own inventions.

Raphael was the youngest and most eclectic of the three great artists that created the Italian High Renaissance. It was probably in late 1504, just after completing his *Marriage of the Virgin* ('Sposalizio') for the Albizzini Chapel in the Church of S. Francesco, Città di Castello (now Brera, Milan) that he moved to Florence where he saw the cartoons of the *Battles of Anghiari* and *Cascina* by, respectively, Leonardo and Michelangelo destined to be executed in fresco for the Council Hall in the Palazzo Vecchio.

These two massive images showing consummately grouped fighting cavalry in the one by Leonardo and vigorous male nude figures preparing for battle in the other by Michelangelo, provided the greatest academy for young aspiring artists in Italy. Raphael came armed with a letter of introduction from Giovanna Feltria Della Rovere, mother of the next Duke of Urbino, to Piero Soderini, the chief magistrate (*gonfaloniere*) of the Florentine Republic. The letter stated the artist's intention to spend some time in the city to learn ('*per imparare*').[12] And learn he did, speedily transforming his Umbrian manner growing out of Perugino into something of an entirely different order of magnitude.

Exposure to masterpieces by Leonardo and Michelangelo certainly excited him to experiment and excel; he learned compositional devices and Leonardo's methods to express form and draperies, colour and sentiment, while at the same time he marvelled at the grandeur and muscular energy of Michelangelo's imagery. On to the stock of these two supreme artists he grafted his own blend of grace and piety. Above all he added an innate sense of naturalness, decorum and a bell-like clarity of palette akin, in musical terms, to perfect pitch.

He did not abandon his patrons in Umbria and completed in 1505 the *Holy Trinity* in S. Severo for the Camaldolite Order at Perugia and the sophisticated *Ansidei Madonna*, now in the National Gallery, London, for the Servites in the same city. At first in Florence with few commissions to hand, he drew indefatigably from Donatello, Masaccio, Leonardo and Michelangelo and, following his father's practice, painted portraits and that great staple, Madonnas. During his Florentine period that lasted from 1504 to

1508 he seems to have painted about fifteen and it is above all for these devotional images that he is still world famous. They were purchased, if not commissioned, by such prominent Florentine families as the Canigiani, Nasi, Taddei, and Niccolini.

Other great artists excelled in the production of Madonnas, especially Donatello, Luca della Robbia, and Giovanni Bellini. The challenge was at once compositional and psychological. The infinite possibilities of portraying an ideal, unblemished woman embracing with pride and humility an ideal, innocent child, when both the participants and the spectator are well aware of the ultimate and inevitable passion, death and resurrection of the Child, became for many artists obsessive.

An artist who should not be ignored as a formative influence on the young, but immensely precocious Raphael, was Baccio della Porta called 'Fra Bartolommeo'. According to Vasari the older Fra Bartolommeo learnt the principles of perspective from Raphael but Raphael learnt from him 'his management and blending of colours'. He admired his ingenuity of composition and learnt from him the 'sfumato' technique of producing vaporous shadow that Fra Bartolommeo himself had adopted and perfected from Leonardo.

We are most fortunate to include in this exhibition the Duke of Northumberland's *Madonna of the Pinks* (dei garofani) (cat. no. 16) which is on a very small, exquisite scale – a scale which Raphael often used for such polished cabinet pieces. This Madonna is one of the most Leonardesque of Raphael's works and indeed largely depends on that master's *Benois Madonna* at St. Petersburg. Raphael would have come into contact with Leonardo soon after he arrived in Florence in 1504 and would have been directly acquainted with several of his paintings and many of his drawings. This access to Leonardo's genius remained with Raphael until the older artist's departure from Florence for Milan in 1506 called there by Charles d'Amboise, Maréchal de Chaumont and Lieutenant of the French King in Lombardy.

In the *Madonna of the Pinks* the composition may be Leonardo's but the physiognomy is entirely Raphael's and the picture's close stylistic connection with the *Holy Family with the Lamb* dated 1507 at Madrid and the *Canigiani Madonna* at Munich would endorse that date. It is therefore probably the earliest of the Raphael Madonnas in this exhibition to be painted. It was possibly being worked upon in the studio at the same time as both the *Holy Family with a Palm Tree* (cat. no. 5) and the *Bridgewater Madonna* (cat. no. 18) now to be discussed, but was completed earlier.

I believe that the second of the Raphael paintings in this exhibition to be finished was the *Holy Family with a Palm Tree* (cat no 5). It was the subject of a lecture that I gave for the National Art Collections Fund at the Royal Geographical Society in London in 1991 and my ideas have been little modified since then.[13]

The *Madonna of the Palm Tree* is circular, repeating the format of his much earlier *Terranuova Madonna* (Berlin) and the *Connestabile Madonna* (St. Petersburg). Raphael, using the circular format, was following what began as an essentially Florentine concept in painting, a shape not appearing much before the mid-15th century. One of the earliest painted examples must be the *Adoration of the Magi* in the National Gallery of Art, Washington, which is a collaborative effort between Fra Angelico and Filippo Lippi painted, probably for the Medici, c.1445-7. There were circular precedents in sculpture, but sculpture in the Renaissance is commonly more innovative.

The circle was the symbol of God's perfection and was also a natural form. Leon Battista Alberti in *De re aedificatoria*, libri x, 1458, observed:

> Some temples are round, some square, and others, lastly, have many sides. It is manifest that Nature delights principally in round figures, since we find most things which are generated, made or directed by Nature, are round. Why need I instance in the Stars, Trees, Animals, the Nests of Birds, or the like parts of the creation, which she has chosen to make generally round?[14]

Thus the circular form, the centrally planned churches, the *tondi* of Raphael, were simultaneously the spiritual, aesthetic, and architectonic ideal of the Renaissance.

Raphael's composition consists of a seated figure of the Virgin to the right, holding the Christ Child in her arms centre, who is venerated by the kneeling figure of Joseph left. The Virgin is dressed canonically correctly with a red tunic, blue mantle, and her head veiled. Joseph wears a white linen shirt with long pointed collar, indigo jerkin, and a sunflower yellow cloak. The colours of Joseph's clothing appear to follow no prescribed ecclesiastical formula. The composition depends on a very delicately balanced linkage of opposing or confronted forms in terms of colour, mass, void and contour. The figures are pushed close up against the picture plane, filling the surface like a relief. The figure group is placed across the circle like a frieze and, in this final form, is little tailored to fit the form. The composition is, however, closely but invisibly knit together like a spider's web by eye contacts. The Virgin monumental, enthroned on her sarcophagus, with a detached expression, is sensible of the fate of her Son, while looking towards Joseph. He in turn, with a face of almost indescribable sweetness, venerates the Christ Child and offers Him a handful of wild flowers. Christ Himself gazes back, again foreseeing His tragic end. A pastoral Madonna, she is portrayed as the 'Alma Mater Redemptoris', clasping the Christ Child in swaddling bands attached by a loop from off her right shoulder, a clear reference to the shroud in which He is let down from the Cross and with which He is generally associated in pictures of the *Deposition* and *Lamentation*. Such grave linen is much in evidence in the *Borghese Entombment* to which reference will be made later.

The Virgin is seated in a meadow richly enamelled with wild flowers, a reference to the Canticles (II, 1, 2): 'I am the rose of

Sharon and the lily of the valleys.' She is also seated beside the palings of a fence, a clear reference to the 'hortus clausus' or 'conclusus' that appears in the *Song of Solomon* (Cant. IV.12) and is symbolic of the pure virginal status of Mary despite the birth of our Saviour.

Raphael at this time was increasingly enamoured of the Antique. Loosely, in the *Holy Family with a Palm Tree* he may have been recalling classical gems like the celebrated Medicean *Poseidon and Athena* or *Aesculapius and Hygeia* (fig. 16) now in Naples, which was copied in the workshop of Donatello for a roundel in the courtyard of the Medici Riccardi Palace.[15] Here we have confronted antique figures of a man and woman in strict profile, separated by a tall tree and inscribed in a circle. Or he may have remembered a classical gem of the infancy of Dionysus formerly in Lorenzo il Magnifico's collection, where a seated profile figure of a maenad appears with the youthful Dionysus riding on the back of a panther.[16] The handling of the drapery around the maenad's legs is especially similar. Finally, he would have known the colossal porphyry seated figure then believed to be *Roma* or *Vesta* (now restored as *Apollo*, Naples Museum) which was in the courtyard of Palazzo Sassi on the present Via del Governo Vecchio in Parione, Rome.[17] Whether Raphael had these antiques specifically in mind or not, the *Madonna of the Palm Tree* is certainly the most classical of all his Florentine Madonna series.

Aidan Weston-Lewis discusses in detail the existing studies for this picture. One, a very slight study in chalk for the draperies around the Virgin's knees in the Lugt Collection, Paris (fig. 41), is on the back of a pen *Study for a figure of Mary Magdalen* (fig. 9) which was used for his *Borghese Entombment* (Rome, Villa Borghese). This picture was painted in 1507 for Atalanta Baglione's chapel in

S. Francesco, Perugia. An excellent copy in oil of it, of full size, has been lent from the Hunterian Collection, University of Glasgow (cat. no. 67). It was Sir John Pope-Hennessy who pointed out that, the central panel of an altarpiece, it betrayed not only the influence of Michelangelo's *Cascina Cartoon* but also showed that 'Raphael turned to a new source of inspiration, a classical sarcophagus with the death of Meleager.'[18] Evidence of especial study of the Antique can also be found in the predella of the *Borghese Entombment* (fig. 7) where a putto is quoted by Raphael from the 'amoretti' or 'erotes' carrying attributes on the so-called 'Throne of Neptune'.

These reliefs, that were at S. Vitale, Ravenna, in the Middle Ages before reappearing in Venice in the 16th century, were believed in the Renaissance to be works by one of the great Greek sculptors, Praxitiles or Polyclitus.[19] The dolphin frieze was adapted and re-used by Laurana in the library portal of the Palazzo Ducale, Urbino, and was engraved by Marcantonio (fig. 8), which confirms that the complete relief would have been familiar to Raphael. The artist conceived the predella as a series of stone sculptures set in niches for which sculpted sources seem most appropriate. *The Charity* also has a sculpted source in Michelangelo's *Tondo Pitti*.

The composition of the *Holy Family with a Palm Tree*, with its strict use of profiles and its borrowings from Antique sculpture, in many ways prefigures the first ideas of the master for the *Parnassus* in the Stanza della Segnatura of about 1508. The earlier scheme has come down to us in the form of an engraving by Marcantonio Raimondi, but the Parnassus fresco, as executed, was softened, with the figures and heads given much greater naturalism.

We still have to establish for whom the picture was painted.

 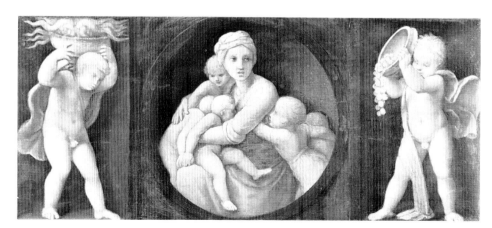

left
fig. 6 *Athena and Poseidon Disputing for Attica*, Hellenistic cameo (Naples, Museo Nazionale Archeologico)

above
fig. 7 Raphael *Charity Flanked by Two Putti* (Vatican, Pinacoteca Vaticana)

There are good reasons to dismiss the idea, first suggested by Passavant[20] that it was painted for Taddeo Taddei in Florence. Another suggestion, first made by Crowe and Cavalcasselle in 1882 and repeated recently by Dussler, that it might be identified with a painting by Raphael appearing in the Duke of Urbino inventory commands greater credence.[21] The manuscript *Inventario di Guardarobba*, in the Oliveriana of Pesaro, 1623, lists:

> *Quadro uno di mano di Raffaelle con un Cristo, Madonna, S. Gioseffe, et ornamento a foggia di specchio*
>
> i.e. One painting by the hand of Raphael with Christ, the Madonna and St. Joseph [in a frame] ornamented in the shape of a looking glass.[22]

If we accept that most Renaissance looking-glasses were circular (e.g. the Parmigianino self-portrait looking into a mirror at Vienna), and that there are no other known paintings by Raphael extant with unrecorded provenances to fit this description, there is good reason to believe it was commissioned by one of the Dukes of Urbino.

Earlier I avoided discussing the prominent palm tree. Palms normally appear in pictures to denote either the *Flight into Egypt* or the *Rest on the Flight into Egypt* where Jesus, according to the Golden Legend, commands the date palm to bow down its branches to shade His mother. But this picture is not a *Rest on the Flight* for Joseph carries no belongings in a sack; he has no water bottle; there is no pack saddle; no sign of the ass, and indeed no sign of the usual attendant guardian angels to minister to the needs of the Holy Family. That is why the Edinburgh picture is always called, and correctly, the *Holy Family with a Palm Tree*. The Palm Tree is otherwise a symbol of Victory.

If we look at G. F. Hill's celebrated *Corpus of Italian Medals of the Renaissance before Cellini* (London, 1930) of the 1,330 medals listed only five on the reverses bear a single date palm as a device.[23] Hill no 320 shows on the reverse a palm tree with one branch depressed by a stone, with a scroll around the trunk inscribed INCLINA RESVRGO. The reverse bears a profile portrait of Francesco Maria della Rovere (1490–1538), 4th Duke of Urbino. He succeeded Guidobaldo and became Duke in 1508. His supposed portrait by Raphael is in the Uffizi.

Much later, in 1536, Titian painted a superb *Portrait of Duke Francesco Maria della Rovere in Armour*, which is now in the Uffizi, a picture that came to Florence in 1631 with the della Rovere inheritance. The pendant, also in the Uffizi and painted perhaps a year later, shows his Duchess, Eleonora Gonzaga in a black and gold dress (figs. 10 & 11). The Duchess wrote on 9 January 1539 to the Ducal Ambassador in Venice, Leonardi, asking him to send her shoulder cover ('spalere') of *yellow* satin and *black* velvet.[24] Black and gold (i.e., Sable and Or) were the colour and metal of the della Rovere arms, a black eagle displaying on a gold field. Significantly, these are also the colours worn by St. Joseph. Also, if we examine the top of the sarcophagus on which the Blessed Virgin sits, we find the two leaves closest to her are *oak leaves*. 'Rovere' is the Italian for oak (Quercus sessiflora). Oak leaves were the device of the della Rovere, much used by Francesco Maria's uncle Pope Julius II della Rovere.

We know that Raphael visited Urbino in October 1507 to settle his affairs concerning his purchase of a house from the heirs of Serafino Cervasi of Monte Falcone.[25] He returned to Florence and shortly afterwards (on 21 April 1508) wrote to his uncle Simon Ciarla at Urbino, commiserating about the recent death of Duke Guidobaldo; he casually referred to a 'Madonna' which had been delivered to Giovanna della Rovere, and alluded to her patronage

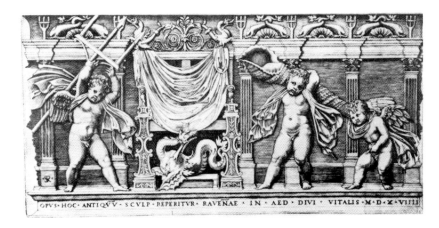

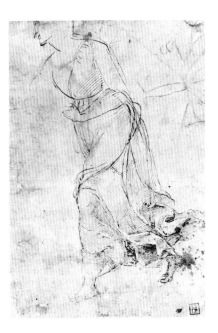

above
fig. 8 Marcantonio Raimondi, *Bas-Relief with Three Putti*, engraving (London, British Museum)

right
fig. 9 Raphael *Study for a figure of Mary Magdalen*
(Paris, Institut Néerlandais, Frits Lugt Collection)

15

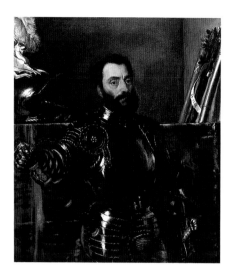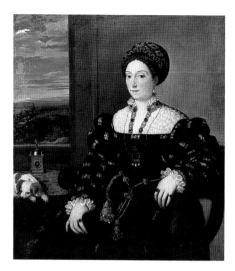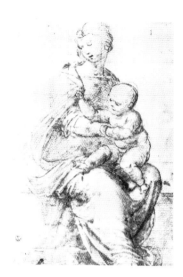

and that of her family as both important and desirable to him.[26]

To sum up, we know from examining the preparatory drawings that the picture was painted *c.*1507. It shows the Virgin Mary, after whom Francesco Maria was christened, sitting beside oak leaves, which were the device of Francesco Maria's mother, with Joseph kneeling before the Virgin wearing black and gold, Francesco Maria's heraldic colouring, and between them a palm tree, Francesco Maria's device.

Raphael returned to Urbino in October 1507 and by 21 April 1508 was back in Florence. He had recently supplied the Prefectess Giovanna with a *Madonna*. In 1623 amongst the pictures in the Ducal Collection was a picture answering the description of the *Holy Family with a Palm Tree*. The evidence suggests that it may well have been painted for Giovanna as a gift to her son at the moment of his accession to the Dukedom of Urbino.

As studies possibly for the *Holy Family with a Palm Tree* appear on the same sheet as studies for the so-called *Bridgewater Madonna* (cat. no. 21), it seems likely that both pictures were in gestation at the same time. Which one preceded the other is a matter of conjecture. In the catalogue it is argued that the *Bridgewater Madonna* in both design and execution dates from Raphael's Florentine period, but the solution appears to me not to be quite so straightforward.

Firstly, we know nothing of its provenance until it appears in France in the collection of Jean-Baptiste Colbert, Marquis de Seignelay (1651-90) but the existence of a number of 16th-century French paintings deriving closely from this composition would suggest that this picture, or an old copy, found its way to France very early on.[27] There is no evidence to show that it belonged to François I but it might well have come to France through someone like Cardinal Giulio de'Medici, Bishop of Narbonne, or one of the French cardinals familiar with the Papal court.

The idea is very Leonardesque, but the type of head, body, lighting and 'contrapposto' is only realised later in Leonardo's lost painting of *Leda* painted for Cardinal Giulio de'Medici, 1512-15, but in gestation through drawings from 1507-8.[28] The posture again reminds us of the National Gallery's *St. Catherine of Alexandria*, the model apparently being the same sitter, and also usually dated *c.*1507-8. It ultimately seems to develop from Leonardo's *Madonna of the Yarnwinder* in the Buccleuch collection where, in reverse, the Christ Child, a large figure wriggling in His Mother's lap, creates a broad diagonal. In this little picture Christ turns His back on the Virgin to gaze at the cross formed by the yarnwinder.[29]

The pose of the Christ Child is really most peculiar, elegant in its mannered and complex convolutions but unconvincing, almost awkward, in the way that the Child is supported on the Virgin's knees while 'strap hanging' to her veil by His right hand. Raphael quotes the pose in a drawing at Chatsworth (cat. no. 2 verso) derived from Michelangelo's marble relief of the *Taddei Tondo* now at the Royal Academy, London. Both this Michelangelo relief and the *Pitti Tondo* relief date from *c.*1503-4 and show, not only a common dependence on Leonardo, but also a profound knowledge of classical sculpture. The *Bridgewater Madonna*, an image of sublime beauty, is nevertheless a slightly uncomfortable work, for the physical relationship between Virgin and Child is not entirely convincing and we are left believing that the Blessed Virgin Mary gingerly supports on her lap a porcelain doll - or a finely fashioned tinted antique sculpture of a putto - rather than a flesh and blood child. Raphael later uses a very similarly posed putto in the foreground of his *Galatea* fresco in the Villa Farnesina,

who there looks rather more happily positioned gambolling with nereids and dolphins.

A bold black chalk drawing showing a remarkably similarly posed Virgin to the *Bridgewater Madonna* by Fra Bartolommeo is in the Uffizi, Florence (fig. 12). This demonstrates that others in Raphael's immediate circle were also interested in this composition, while the Friar's friend, Mariotto Albertinelli, used it in a painting of the Holy Family dated 1509 (location unknown).[30]

The recent technical examination and cleaning, if taken in conjunction with a careful reading of the rich group of drawings associated with this work, are indications of its date. The first loose sketches scattered across the sheet are not only compositionally like Leonardo but are idiosyncratically reminiscent of Leonardo's own technique. Raphael works on the idea *c.*1506-8 and probably starts on the panel at this time. The x-rays indicate that he began with a landscape background like the *Small Cowper Madonna* in Washington and those more ambitious compositions the *Madonna of the Meadow* (Vienna)and the *Madonna del Cardellino* (Uffizi) and in about 1506. He then left the picture incomplete; experimented later by painting most of the background out, but leaving just a window onto the landscape, like Leonardo's *Madonna with a vase of flowers* at the Alte Pinakothek, Munich or the Leonardo workshop *Madonna Litta* at the Hermitage. Finally, in a bold step, he painted out the whole of the landscape, thus transforming the image from something decoratively rustic into an object of real monumentality. At the same time, he enriched the *chiaroscuro* and provided for the drapery over the Virgin's knees something much heavier and more plastic. Studies, probably for the *Bridgewater Madonna*, appear on a sheet in the Uffizi for the *Stanza delle Segnatura* in the Vatican, Raphael's first major work in Rome. The head of the Virgin reappears very similarly in several heads in the background of the Muses on *Parnassus*. The whole picture has taken on an heroic quality only intelligible from Raphael's response to the stimulus of Rome, his renewed excitement in Antique sculpture, and a competitive awareness of his rival Michelangelo. A careful examination of this picture alongside the *Holy Family with a Palm Tree* leaves me in little doubt that in the form that it is in now, the *Bridgewater Madonna* dates from Raphael's early Roman period, probably 1508-9.

We have little evidence to show exactly when Raphael moved from Florence to Rome but it seems to have been the early summer of 1508. He is first documented as there by 13 January 1509. Vasari tells us he responded to the call of his fellow countryman and friend, Donato Bramante, the architect in charge of St. Peter's, and there seems no reason to doubt him. Why he came was clearly in the hope of being commissioned to decorate a room in the Vatican for the Pope, Julius II della Rovere (1443 – Pope 1503-13). Julius II was the warrior pontiff who crushed Cesare Borgia, humiliated Venice and, through the Holy League (uniting with Spain and Henry VIII of England), drove France out of Italy. It was Julius who commissioned Bramante as his chief architect and it was Julius who presented to James IV of Scotland in 1507 the great Sword of State made by Domenico da Sutri, the scabbard worked with the della Rovere oak tree and acorns. To this day it forms part of the Honours of Scotland displayed at Edinburgh Castle.

Rome was at this time a city consisting of clusters of mediaeval fortified buildings scattered amongst a plethora of ancient churches and antique Roman ruins amongst which goats and cattle browsed. Apart from the omnipresent and very grand memorials of the great classical past, the city had yet to be laid out in the way we know it today with handsome straight roads, fine vistas, obelisks, *piazze* and fountains.

In 1506, Pope Julius had already started to transform the city; the old Romanesque basilica of St. Peter's had been torn down and was to be replaced by a great new classical domed structure, and the Vatican Palace was being extended and decorated, as the greatest of Renaissance palaces. As classical sculptures, inscriptions and gems were excavated when foundations were being dug, so they were collected for the Pope.

Before Raphael arrived in Rome, he had had little experience of planning or indeed painting in fresco other than his designs for Pinturicchio's Piccolomini Library, Siena and the *Trinity and Saints* at San Severo, Perugia. In Rome, he started working with other artists to decorate a suite of rooms, beginning with the *Stanza della Segnatura*, which it seems functioned as the Pope's Library. The programme, according to Vasari, was devised by Julius II and each of the four walls was devoted to one of the four faculties – Theology, Philosophy, Poetry and Jurisprudence.

The remarkable perspectival arrangement of the *Stanza della Segnatura* frescoes, especially the *School of Athens*, has been attributed to Bramante himself. Even though this may not be quite the case, as Raphael excelled in geometry, it is likely that Raphael would have discussed the project with his compatriot Bramante and have received welcome advice. This room with its four great lunette shaped walls and the four rectangular frescoes on the vault executed later, *c.*1510, epitomises the purity, balance and majesty of the Italian High Renaissance.

Raphael, and his studio, continued in Rome to decorate the Vatican Palace with the suite of these *stanze*, namely *Segnatura* (1509-10), *d'Eliodoro* (1511-14), *dell'Incendio* (1514-17), the *Cardinal Bibbiena Bathroom* (1516), the *Logge* (1517-19), the *Loggetta* (1519), and finally the *Sala di Costantino* (1517-24) – which was completed by his studio after his death. These decorations were one of Raphael's staples during the Roman period and required increasingly the major participation of his most talented group of studio assistants: Giulio Romano, Perino del Vaga, Giovanni Francesco Penni, and Giovanni da Udine. The master himself continued to be most actively employed outside the Vatican.

Fortunately, the National Galleries of Scotland managed to buy last year a fine highly wrought drawing in black chalk, with brush and brown (bistre) wash heightened with white, for the so-called *Madonna of the Fish*, probably painted in 1513.

Vasari wrote:

At the same time Raphael did a panel for Naples which was placed in S. Domenico in the chapel containing the crucifix which spoke to St. Thomas Aquinas. It represents the Virgin, St. Jerome dressed as a Cardinal, and the Angel Raphael accompanying Tobias.[31]

This altarpiece is now in Madrid at the Prado, but we have, as a substitute, an excellent full size copy (cat. no. 29) by Ferréol Bonnemaison made for the 1st Duke of Wellington in 1818 and lent to us by the Victoria and Albert Museum (Apsley House). We can follow the evolution of Raphael's picture from the very unusual first compositional study in red chalk at the Uffizi, Florence (cat. no. 30) with the participants posed as studio assistants ('garzoni'), the Virgin Mary, a boy assistant seated on a Savonarola type wooden chair, a sack in his arms, and Jerome to the right beardless and the angel Raphael wingless and even Tobias, fishless. This was worked up in the more polished sheet in the National Galleries of Scotland (cat. no. 31) that belonged to Sir Thomas Lawrence and later to the King of Holland. Above all it was made to establish the *chiaroscuro* of the altarpiece in its setting. He also carefully worked up the pose of the Christ Child, while the position of St. Jerome has evidence of alterations (*pentimenti*) and has been pushed further forward to the left, closer to the Virgin and Child.

Having been used in the preparation of the painting, the Edinburgh sheet was then faithfully reproduced in a print from Marcantonio Raimondi's workshop (cat. no. 32). Vasari believed it to have been by Marcantonio himself but recent scholars have argued that it is too coarse and more probably by his pupil Marco Dente da Ravenna. It was this print that was copied by maiolica painters within a few years of its publication (cat. no. 34), and also in a gilt bronze plaquette in the Walters Art Gallery, Baltimore (fig. 13).[32]

Raphael's images and ideas, through the agency of the excellent prints by Marcantonio and his school, were becoming very widely distributed. Sometimes indeed Raphael seems to have made drawings solely for such reproductions, like his celebrated *Massacre of the Innocents* of c.1510-11. This complex composition of male and female nudes in motion, a very Tuscan work, has its antecedents in Pollaiuolo and Michelangelo.

Almost as celebrated as the frescoes in the *stanze*, which have a decorum and majesty suitable for papal apartments, were the frescoes painted for the Roman suburban villa (now Farnesina) on the banks of the Tiber. They were commissioned by the wealthy Sienese banker, Agostino Chigi.

They were devised for a large room with an open loggia looking out over a formal garden, and consisted of a series of lunettes and an almost flat ceiling vault decorated with frescoes of the *Story of Cupid and Psyche*, taken largely from Apuleius' *Golden Ass*, something from Ovid, and other incidents probably supplied from the invention of contemporary classicists in Chigi's immediate circle. The invention was Raphael's but the execution from c.1517-18 seems to have been left largely to studio assistants, Giulio Romano and Giovanni Francesco Penni, while the festoons of flowers and foliage interspersed with animals and birds were the work of Giovanni da Udine.

Seven years ago, when the Duke of Devonshire dispersed a second group of drawings from Chatsworth the National Galleries of Scotland were given the opportunity to buy, using the beneficial terms of a private treaty sale, a magnificent red chalk study of a *Kneeling Nude Woman* (cat. no. 47). This has been confirmed to be a study for an attendant of Psyche for a lunette in the Villa Farnesina designed by Raphael but never executed. The composition, the *Toilet of Psyche* is known to us from another preparatory sheet for a figure of a nude *Woman holding a mirror* in the Louvre (cat. no. 48), an engraving after the composition by Giulio Bonasone (cat. no. 50), and a drawing by Alberto Alberti (cat. no. 49), in the Istituto Nazionale per la Grafica, Rome. A few of the twenty odd surviving drawings for the *Cupid and Psyche* cycle are by the master but many more are by assistants. The Chatsworth sheet is generally regarded to be a masterpiece from Raphael himself and betrays none of the idiosyncracies of his pupils.

There must have been a great demand for easel pictures from Raphael's own hand, but not time enough for him to execute them all. Unlike Michelangelo, he ran a highly efficient workshop and all of his students were taught both to draw and paint in a manner almost indistinguishable from his own. The *Madonna del Passeggio* (cat. no. 37), one of the three Sutherland Raphaels, is a case in point. The picture is in excellent condition and, unlike its two companions was never transferred from panel to canvas. It has a very distinguished provenance – in the collection of Cardinal Pietro Aldobrandini by 1603, then given by Olimpia Aldobrandini to Cardinal Ludovico Ludovisi, then possibly King Philip IV of Spain, certainly Queen Christina of Sweden and thence through a further chain of Roman princes to Philippe Duc d'Orléans, Régent of France.

Such a magnificent provenance does not make the picture autograph and it is agreed by most scholars to be a superb example of the work of Raphael's closest follower Giovanni Francesco Penni called 'il Fattore' (c.1496-1528). The landscape is certainly not Raphael's; the underdrawing to the figures is most uncharacteristic and indeed the morphology of the figures, particularly the Christ Child and St. John, is difficult to parallel in any of Raphael's autograph works. It is nonetheless an object of special beauty and such a work would not be imbued by such quality were it not for its pro-

pinquity to Raphael himself. The Madonna was almost certainly painted within Raphael's lifetime and payments were presumably made to Raphael himself. Penni is the most shadowy, elusive figure within the Raphael shop. There is still considerable dispute concerning the late Raphael drawings as to which are by Penni and which by Raphael, a problem which may never be resolved.

A case in point is the fine pen study, recently bought by the National Galleries of Scotland, for the oil of *St. John the Baptist in the Wilderness* (Uffizi, Florence). It is very close to a class of drawings often called Raphael, similar for example to the drawing at Windsor for the marble figure of *Jonah* (fig. 66), for the Chigi Chapel in Sta. Maria del Popolo.

The National Gallery of Scotland's so-called *Novar Madonna*, or *Holy Family with the Infant St. John* (cat. no. 54), was re-discovered by Hugh Brigstocke when on the Gallery staff in 1972 and identified by him as a characteristic example of Giulio Romano's work of the early 1520s and, in 1980, bought by the Gallery. The composition depends closely on the *Madonna of the Rose* in the Prado, by some still given to the late Raphael. With its richly rusticated gateway

behind, I suspect it was painted just a little before Giulio left Rome for Mantua *c.*1523-4.[33]

Fittingly, the show culminates in a faithful full-size copy of Raphael's *Transfiguration* (1516-20) now in the Vatican Gallery. The copy was painted in Rome in the 1820s by Grigor Urquhart of Inverness and recommended as a purchase by the Scottish painters David Wilkie and Andrew Wilson in 1827 to the Royal Institution, Edinburgh, the National Galleries' *fons et origo*. Wilkie and Wilson took 'the liberty to observe that such a copy of the *Transfiguration*, in directing the taste of the student and the public to the high class of art to which this masterpiece of Raphael's belongs, would if consistent with the means of the Institution, be in every respect an important acquisition'.

This is the first opportunity that the public have had to view Urquhart's copy for very many years. It has been specially relined, cleaned and framed for the occasion. The original numbers amongst Raphael's most sublime works and it was this picture that was displayed at the head of Raphael's body as it lay in state in his studio in April 1520.

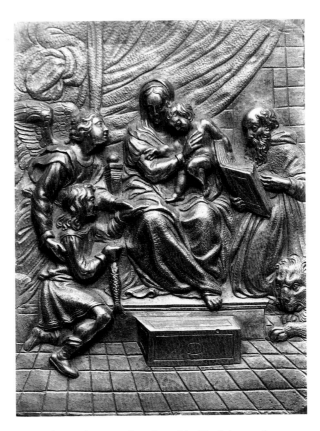

fig. 13 Italian, 16th century *The Madonna of the Fish*, gilt bronze plaquette (Baltimore, Walters Art Gallery)

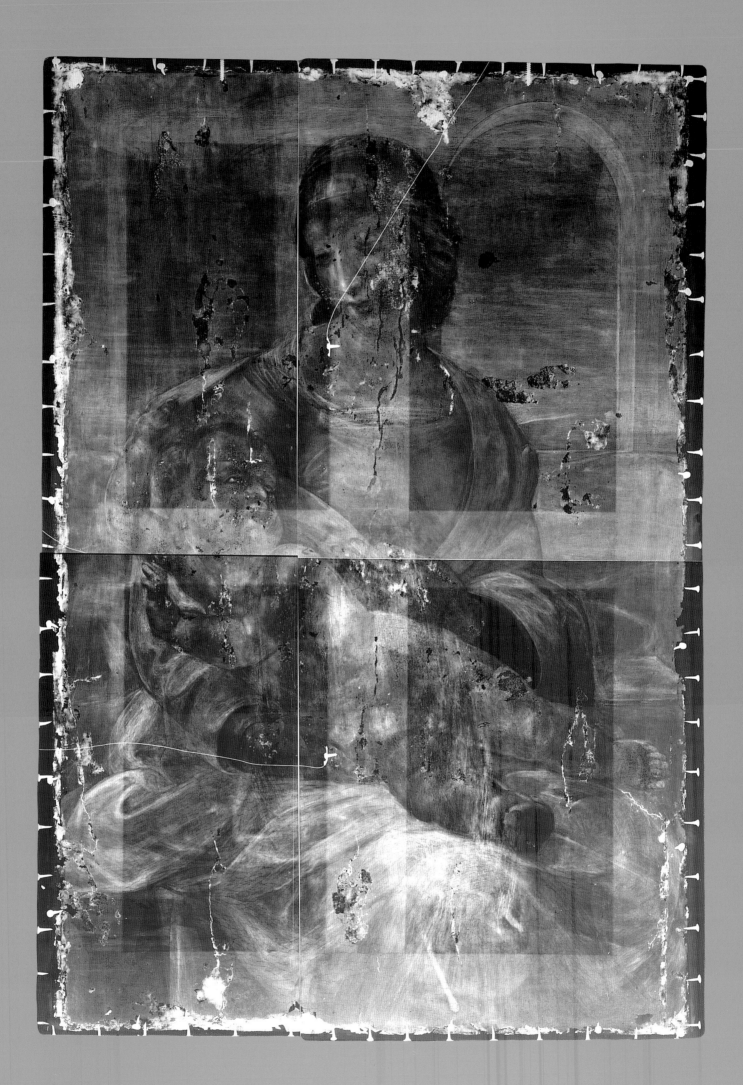

The Cleaning of the Sutherland Raphaels

JOHN DICK

The cleaning, over the last few years, of the paintings by Raphael on loan from the Duke of Sutherland to the National Gallery of Scotland has permitted a more accurate assessment to be made of their condition and status. As part of the cleaning project, use was made of the established investigative tools; examination under ultra violet light (UV) and by infra-red vidicon (IRV reflectography) as well as by x-radiography and paint sample cross-sections.[1] These not only give information, useful to the restorer, of the structural condition of the works, but also afford the bonus of valuable art historical information, particularly the under-drawings made visible by IRV.

It is assumed that all three works are painted using an oil binder although no analytical examination has been carried out to confirm this. By the time these works were painted, the gradual transition from tempera, which uses an egg binder, to the more expressive potential of the oil medium was almost complete. Already in the *Mond Crucifixion* in the National Gallery, London, datable to 1503, oil has been identified as the medium.[2] Significantly Perugino, Raphael's master, was a pivotal figure in this crucial transition as was Leonardo da Vinci who was also to be a powerful influence on him.

In the earlier of these works, the *Holy Family with a Palm Tree*, it is possible to see the remaining influence of tempera with its emphasis on restrained handling and the painting closely following a carefully planned design. However, the fluency of the oil medium is already present, particularly in the treatment of costumes. The technique is largely carried on in the *Bridgewater Madonna* but minor adjustments in outlines are increasingly to be found. Also the Madonna's mantle is much thicker than the rest of the painting. The x-radiograph shows that this is due, in part, to the rearrangement and repainting of the folds of the drapery (fig. 14) but is also a reflection of the amount of medium required by the pigment to make paint. A similar thick blue layer in the Madonna's mantle which shows the same cracking is found in the *Small Cowper Madonna* in the National Gallery of Art, Washington.[3] The ease in making fairly rapid and substantial alterations in composition was one of the advantages offered by the oil medium over tempera

but the prominent cracking present in this passage is an indication of the problems associated with the oil medium if it is exploited too far. This development in technical handling is an important factor in determining the dating of Raphael's work which increasingly exploits the inherent ability of oil paint to create a variety of textures and effects.

All three works were painted on wood, the usual support for Italian paintings up to the middle of the 16th century when the use of canvas as a support became predominant. The most common timber used was poplar and the panels were made by specialist craftsmen. The wood was generally of a thickness (2-3 cm) which would tend to resist the effects of changes in environment and could survive well if conditions allowed. However, such supports were at the mercy of extreme environmental conditions and also from attack by insects.[4]

It has always been known that both the *Holy Family with a Palm Tree* and the *Bridgewater Madonna* were transferred from their original wood supports to canvas in Paris in the 18th century while they were in the Orléans collection. One of the great exponents of this procedure was the French restorer Hacquin who treated many major paintings. While Hacquin was acclaimed for what was widely regarded as a technical *tour de force* there were, at the same time, signs of disquiet and evidence of failure of the treatment. There is documentary evidence of a Raphael from the Orléans collection being treated but as there were several Raphaels in that collection it is not possible to say that it was either of the transferred Sutherland paintings.[5] William Buchanan, the Scottish dealer and collector wrote approvingly of the technique, mainly because of the technical information thus disclosed, quoting extensively from Hacquin's records and listing an impressive number of masterpieces treated.[6]

It is worth considering what actually took place during the transfer of a painting from panel to canvas. It can be deduced from the x-radiographs that the condition of the painting would have been in a precarious condition. The available evidence indicates a degraded support due to splitting and insect damage and poor adhesion of the paint/priming layers to the support. This usually

fig. 14 The *Bridgewater Madonna*: x-radiograph mosaic

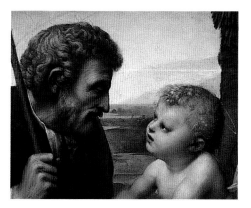

far left
fig. 15 The *Holy Family with a Palm Tree*: detail of x-radiograph

left
fig. 16 The *Holy Family with a Palm Tree*: detail of same area as fig. 15

resulted in significant loss of paint. To begin with the painting was faced with paper or fine gauze both to protect the surface and to offer support through what was an extremely hazardous procedure. The wooden support was then cut away from the reverse until the ground layer was reached. It was then that the ground itself might be removed to the point, as described by Buchanan, where the painter's original drawing became visible on the priming layer. If this was also removed it may explain how the underdrawing, normally found during examination with IRV, may be only partially retrieved. In some cases, such as the *St. Cecilia* in the Pinacoteca in Bologna, a new ground of white lead was applied. [7] This has the effect of rendering the painting opaque to x-rays. (This procedure was not carried out on either of the Sutherland paintings as successful x-radiographs have been made of both.) Further confirmation of this came from scanning electron microscope examination of a paint cross-section from the *Bridgewater Madonna* where the fragment of ground present was identified as gypsum;[8] calcium sulphate which mixed with size to form *gesso* was the most commonly used ground in Italy in contrast to the practice in Northern Europe where the usual ground was chalk (calcium carbonate). At this point in the procedure the security of the paint layer is dependant upon the effectiveness of the temporarily applied facing. A fine fabric was then attached to the reverse with a mixture of glue and paste, and this was followed by a further, heavier fabric, usually linen, to give additional support. The adhesion was effected by the use of hot irons acting on the moist adhesive which may explain some of the problems visible today.

Unfortunately these fabrics often transmitted a weave pattern to the paint surface and actually did not provide sufficient support for the paint layer. Most transferred paintings show a disturbingly deformed surface. Perhaps most regrettably the typical variety in the thickness of the different passages of paint and therefore a liveliness of surface in a painting on wood, is usually completely and irrecoverably lost. A comparison of the transferred works with the *Madonna del Passeggio* or the *Novar Madonna* by Giulio

Romano, still on their original wood supports, shows the extent of this loss.

The first painting to be cleaned was the *tondo*; the *Holy Family with a Palm Tree* because its apparent good condition was severely obscured by a deeply discoloured and crystallised varnish. In addition the structure of the work was severely deformed due to the lack of support from the old lining and because of this an extensive cracking in the paint layer was showing signs of movement and a consequent risk of paint loss.

The x-radiograph reveals the location of the joins in the former wood panel and evidence of considerable paint loss particularly along the central join which passes down through the Child's body. A disturbing random network of cracking also showed prominently because of the white lead filling which had been used (figs. 15 & 16) and was also visible on the surface because of the discoloration of the retouching. The only significant change in composition is the relatively minor one of the altered line of the horizon in the centre background now visible to the naked eye. Also shown is the comparative thinness in the painting of the flesh which appears dark in the x-radiograph because of the lack of white lead in the flesh paint. This demonstrates that the luminosity of the flesh is dependant upon the reflectance of the white ground shining through the thin paint. This is a feature of the pre-Roman paintings by Raphael and has been noted on several occasions.[9]

Examination by IRV revealed little evidence of underdrawing. This may be, in part, due to disturbance of the priming layer during the transfer but there are indications which suggest the painted composition follows the initial design very closely making it difficult to distinguish the drawn line. This slight appearance of underdrawing is also found in the *Alba Madonna* in the National Gallery of Art, Washington – another transferred painting.[10]

After removal of the discoloured varnish and retouching the condition of the painting was found to be less satisfactory than expected. This was mainly because when the fillings were removed from the wrinkled paint surface, which was probably caused by

contraction of the layer during transfer, it was discovered that they had been concealing original paint and it was decided to leave the wrinkling unfilled. There is also a disturbing weave pattern which is transmitted from the support canvas (fig. 17). However, the gains are considerable, particularly in the revelation of the vibrancy of the remarkably well preserved pigments and in the aerial perspective of the distant landscape (fig. 18). More surprising, in view of the damage inflicted on the paint, is the still delicately modulated modelling to be seen in the heads of the Madonna and Joseph and in the figure of Christ.

The palette is restricted to a combination of intense primary colours; the organic red glaze of the Madonna's dress, the remarkably powerful ultramarine of her robe and the strong, rich yellow of Joseph's robe, complemented by the deep purple (a mixture of an organic red pigment and azurite) of his tunic and the notably well preserved green glaze in the lining of the Madonna's robe. A result of previous cleaning is the damaged gilded lines of the haloes and the decoration on the Virgin's dress.

In contrast with the *Holy Family with a Palm Tree* the surface condition of the *Bridgewater Madonna* had always been disturbing because of the very obvious disfiguring losses which were accentuated by clumsy and severely discoloured restoration. In addition the painting was obscured by a heavy, discoloured and blanched varnish. Fortunately, due to a combination of a thicker paint layer and perhaps a less extreme transfer, the paint surface had suffered less in that no canvas texture imprinting had taken place.

The x-radiograph (fig. 14) shows that the vertical losses followed the grain of the former deteriorated wood support but fortunately skirted the finely preserved features and profile of the Virgin (fig. 19). Further damage had occurred in areas of paint which apparently had not been sufficiently supported during the transfer process and had been fragmented. These areas too had avoided any sensitive part of the work and on the whole, though the damages were severe they were also quite localised. The remainder of the surface is in surprisingly fine condition.

The radiograph also revealed that the construction lines of the architectural background, including the niche, had been fully and carefully incised with a stylus – the 'geometric scaffolding' which Penny noted Raphael was to use from his earliest altarpiece onwards. There is clear indication that the niche had been a window looking on to a landscape. This was later painted out presumably by Raphael himself although there is no certain evidence to support this other than the directness of handling and the subtlety of the representation of the fall of light over the forms of the architecture. The rather discordant brown shape at upper right only seems to make tonal sense if read as a shutter catching light from the previously existing window. There is a parallel here with the *Madonna del Granduca* in the Pitti Palace in Florence which also had a window framing a landscape which was then painted out. This was

fig. 17 The *Holy Family with a Palm Tree*: detail of Madonna's head after removal of repaint and varnish and before retouching

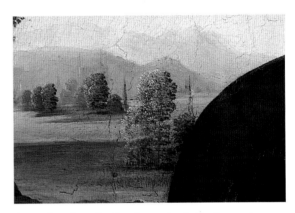

fig. 18 The *Holy Family with a Palm Tree*: detail of landscape after cleaning and removal of filling

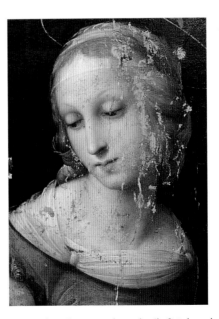

fig. 19 The *Bridgewater Madonna*: detail of Madonna's head after removal of repaint and varnish and before retouching

thought formerly to be a later alteration by another hand but subsequent examination suggests that it was made by Raphael. The supporting evidence for this includes convincing original details such as the curls of the Child's hair encroaching on to the overpainted area.[11]

A further revelation of the x-radiograph is the major alteration in the folds of the Madonna's mantle. Originally the mantle enfolded her body with the Child seen against it. Indications of the blue mantle appear in small abraded areas by the side of Christ's face and a thick underlying edge of this paint shows on the Madonna's breast. The folds around her lower body were also considerably simplified. The flesh painting in this work appears dark in the radiograph like that in the *Holy Family with a Palm Tree*.

IRV examination in this case was more rewarding revealing numerous instances of a fairly vigorous, intermittent underdrawing, probably in chalk, which diverge from the painted composition. These show most clearly in the ear of the Child and also in the foreshortened foot (figs. 20 & 21). This intermittent appearance of the underdrawing may be the result of the relatively poor penetration of our IRV equipment which also lacks the facility of computer cleaning of the image used by among others, the National Gallery, London. This has produced the remarkable reflectogram of the *Madonna dei Garofani* which shows Raphael freely creating the composition on the support (fig. 23).[12] These very fully worked out underdrawings seem to be associated with small-scale paintings.[13]

Cleaning has revealed a fairly subdued colour range with the dark purplish blue (once again a mixture of an organic red pigment and azurite) of the curtains, which had previously only been suggested by engravings, set against the dark brown of the architecture. The blue of the Virgin's mantle is built up with a thin layer of ultramarine over azurite (fig. 24), a combination which Raphael used on numerous occasions.[14] Another well preserved detail is the

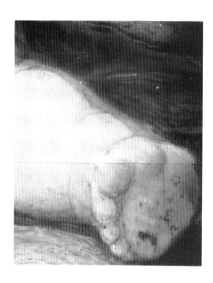

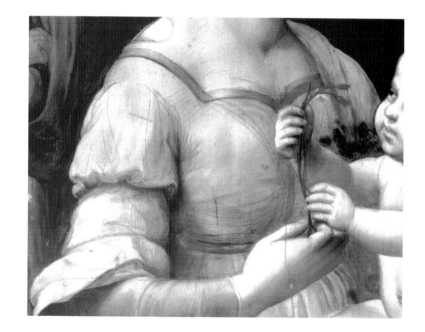

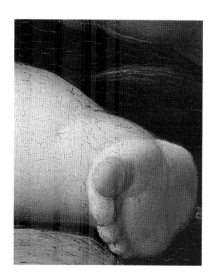

left
fig. 20 The *Bridgewater Madonna*: infra-red reflectogram showing the Child's ear

far left
figs. 21 & 22 The *Bridgewater Madonna*: detail of infra-red reflectogram showing the Child's foreshortened leg and detail of the same area of the painting

above
fig. 23 Raphael *Madonna of the Pinks* (cat. no. 16): detail of infra-red reflectogram.

fig. 24 The *Bridgewater Madonna*: paint cross-section of the blue of the Madonna's mantle showing the thin layer of ultramarine over a layer of azurite. Ground layer missing.

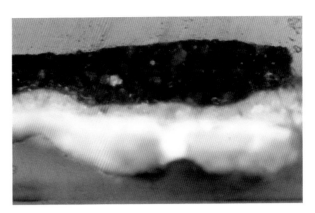

fig. 25 The *Bridgewater Madonna*: paint cross-section from lower left edge showing a thin green layer under the dark blue of the curtain.

fig. 26 The *Bridgewater Madonna*: paint cross-section from lower left edge showing a thin blue/green layer under the dark blue of the curtain

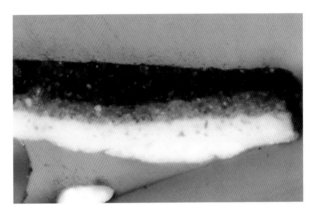

fig. 27 The *Bridgewater Madonna*: paint cross-section from left of Madonna's head showing a thin pale blue layer under possibly the brown of the architecture under the dark blue of the curtain

fig. 28 The *Bridgewater Madonna*: paint cross-section showing a thin green layer under the brown of the architecture.

fig. 33 The *Madonna del Passeggio*: paint cross-section showing pink layer under blue of sky and over a grey ground

crisp painting, probably in lead-tin yellow, of the Child's curls.

A small fragment, the only remaining part of the original edge of the painting, is preserved at upper left. This hints at a blue green underpaint which suggests that the figure group might originally have been set out of doors like the *Belle Jardinière* in Paris and the *Canigiani Madonna* in Munich. Since the scattered

damages provided convenient sites for sampling the paint to make cross-sections, a series of samples were taken at intervals from the background around the figures and in the brown shape at upper right. All of these show a green to green/blue underlayer which strengthens the possibility of an outdoor setting (figs. 25, 26, 27 & 28).

fig. 29 The *Madonna del Passeggio*: detail of infra-red reflectogram showing alteration in landscape

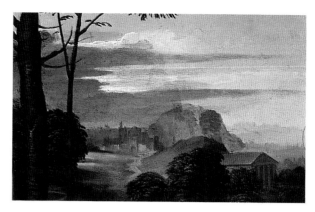

fig. 30 The *Madonna del Passeggio*: detail of same area as fig. 17

As part of the conservation treatment of the *Holy Family with a Palm Tree* and the *Bridgewater Madonna* they were mounted on composite panels not only to provide necessary support but also in an attempt to recreate the feeling of solidity of the former supports. Retouching of the losses was carried out in a variety of styles to accord with the surrounding paint and ranges from a fine stippling in the *Bridgewater Madonna*'s head to the striated technique (so-called *trattegio* method) used to fill out the unequal edges of the *Holy Family with a Palm Tree*, all of which should be visible on close inspection.

The *Madonna del Passeggio* is the only one of the Sutherland paintings which has not been subjected to transfer and is still on its original wood support. It therefore provides valuable evidence of the appearance and construction of a painting from this period, particularly as it is in such good condition. The panel is 2.5 cm thick and is constructed of two vertical planks. The join has opened along a good part of its length and was recently re-glued and cramped. While being treated it was seen that fabric was embedded in the *gesso* ground layer. It is not clear whether it covers the whole surface or is confined to reinforcing the join as was noted by von Sonnenberg on the *Canigiani Madonna* in Munich.[15] This is intended to prevent the joins appearing on the surface but the insertion of cross members in the reverse of the panel has caused the join to give way. A significant alteration in the composition appears in the landscape at top left and shows now because of the increasing transparency, with age, of the overlying paint (figs. 29 & 30).

As well as the alteration mentioned above, the x-radiograph, in contrast with the other paintings discussed, shows the flesh solidly painted using modulations in the quantity of white lead for the modelling rather than depending on the reflectance of the white ground (fig. 31). This is normally seen as supporting evidence for a relatively late date for paintings by Raphael.

The reflectogram shows a careful, tentative underdrawing

fig. 31 The *Madonna del Passeggio*: detail of x-radiograph

fig. 32 The *Madonna del Passeggio*: detail mosaic of infra-red reflectogram

with much finer lines than those in the *Bridgewater Madonna* possibly indicating the use of a metalpoint. The close hatching appears to indicate areas to be in shadow rather than describing form. Further detail is also revealed of the alteration in the landscape.

Because of the good condition of the work it was not possible to take many paint samples for cross-sections. However, a sample taken from the line of the crack in the sky shows a pink underlayer over probably a grey ground (fig. 33). A similarly coloured layer structure also appears in the *St. Cecilia* in Bologna[16] and in the *Holy Family of Francis* I in the Louvre.[17]

The Giulio Romano *Holy Family with St. John* was cleaned shortly before its acquisition by the Gallery and nothing is recorded of its previous condition. It is still on its original wood support and its condition is approaching that which might once have justified transfer – the joins have sprung and have been clumsily repaired with wood screws and there is extensive insect damage. There is severe cleavage and flaking of the paint layer notably at the bottom left.

There is an interesting evolutionary quality about the composition with additions apparently made at a later date. These can be recognised by a fine, distinctive cracking and by not being convincingly integrated with the earlier layer. These passages include the rusticated columns, the figures of Joseph and the ass, the Virgin's veil and the Baptist's foot at the bottom left. They have all suffered from abrasion and are apparently vulnerable to cleaning solvents to judge by the way the paint has broken up. There is a distinctive porcelain-like cracking pattern in the flesh paint of the Virgin's head which might indicate a certain amount of difficulty or indecision during painting and the x-radiograph shows a high percentage of white lead in the modelling.

The remarkable colour range includes the brilliant blue robe, which appears to be a mixture of azurite and white, over a crimson underlayer. A similar colour combination appears in the *Holy Family of Francis* I in the Louvre.[18] This contrasts with a well preserved copper green resinate glaze which also displays its own localised cracking type. The x-radiograph shows a notable alteration of the line of the Virgin's head which appears to have been carried out by smearing the paint with the finger (fig. 34).

The infra-red reflectogram made very recently shows an extensive and bold underdrawing probably in chalk, much of which does not relate to the visible composition (fig. 35). This must await a closer examination which will be published more fully at a later date.

fig. 35 Giulio Romano *Novar Madonna*: detail of infra-red reflectogram

fig. 34 Giulio Romano *Novar Madonna*: detail of x-radiograph

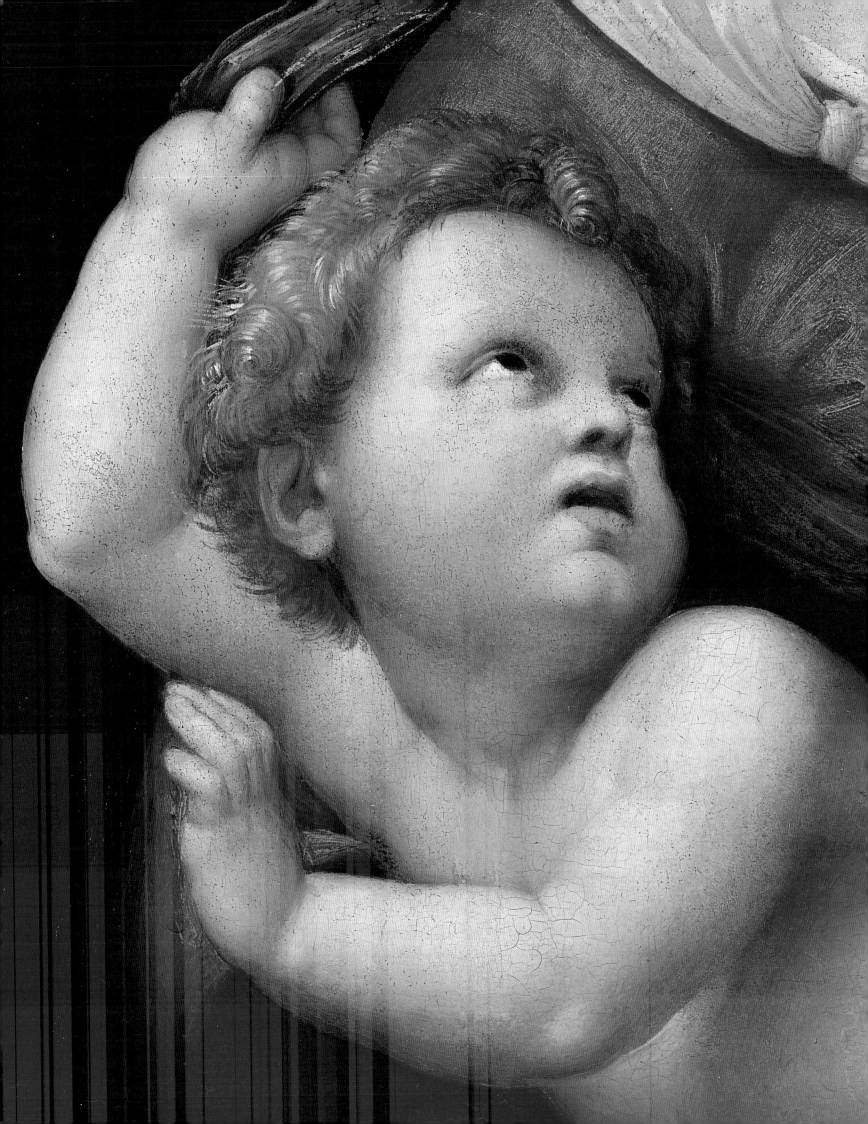

Catalogue

AIDAN WESTON-LEWIS

In given dimensions, height precedes width.

In the provenance section, the abbreviation L. refers to Frits Lugt's *Les Marques de Collections* (see Bibliography).

The footnotes indicated in the catalogue entries are printed together on pages 139-43.

The entries for catalogue numbers 64 and 65 were written by Sarah Davidson [S.D.].

For the sake of brevity, references in the notes to works by Raphael have been restricted wherever possible to the standard publications, both in English, by Dussler (for the paintings and frescoes) and Joannides (for the drawings).

References to Brigstocke's catalogue of *Italian and Spanish Paintings in the National Gallery of Scotland* are to the second, revised edition of 1993, which supersedes the first edition of 1978.

1 *Studies of the Virgin and Child with the Infant St. John the Baptist [recto and verso]*

Pen and ink over stylus underdrawing; the paper folded in half and repaired in
places along the fold; 24.6 × 36.3 cm.
PROVENANCE: Albert von Sachsen-Teschen.
REFERENCES: Passavant, 1860, II, p.435, no.189; Crowe and Cavalcaselle, 1882-85, I,
pp.262-63; Fischel, 1922, III, nos.116-17; Vienna, 1983, pp.23-26, nos. 2-3;
Joannides, 1983, p.54 and no.110; Knab, Mitsch, Oberhuber and Ferino Pagden,
1983, nos.119 and 122; Ames-Lewis, 1986, pp.60-63; Birke and Kertész, 1992, p.119,
no.207.

Vienna, Graphische Sammlung Albertina (Inv. no. 207)

Both sides of this sheet, together with the following two draw-
ings, are connected with Raphael's *Madonna of the Meadow* (*Madonna
im Grünen*) in the Kunsthistorisches Museum in Vienna (fig. 36).[1]
The painting is dated among the gold letters of the neckline of the
Virgin's dress, although in such a way that it can be read as either
1505 or 1506. On the basis of information furnished by the late
17th century artists' biographer Filippo Baldinucci, the picture
can be securely identified as one of the two described by Vasari[2] as
having been painted by Raphael for his friend Taddeo Taddei, a
wealthy Florentine merchant and patron of artists.[3]

Raphael three times during his Florentine years tackled the
theme of the full-length Virgin and Child with the Young St. John
in a landscape. The composition of the *Madonna of the Meadow* was
developed more or less in tandem with that of the *Madonna del
Cardellino* (*Madonna of the Goldfinch*) in the Uffizi (see cat. no. 4), while
the *Belle Jardinière* in the Louvre, the third version of this subject,
was painted a year or two later.[4] In all three, Raphael experi-
mented with a fairly tightly controlled, triangular arrangement of
the figure group. All contain allusions to the Passion of Christ.[5]
And all reflect in varying degrees and in different ways Raphael's
response to the recent works of Michelangelo and Leonardo da
Vinci. They were presumably intended for private devotional
purposes, the arched top of the *Belle Jardinière* suggesting a specific
destination such as the altar of a family chapel within a palace.

The evolution of the *Madonna of the Meadow* as it can be traced in
the preparatory drawings has been discussed in detail elsewhere.[6]
The central motif, which Raphael hit upon early and around
which the composition grew, was that of a standing Christ Child
framed and supported by his mother's outstretched hands (it may
have been borrowed from Leonardo). All the sketches on both
sides of the present sheet include this feature (with the exception
of one on the verso which is apparently not related to the Vienna
picture), and most also include the fully extended right leg of the
Virgin which so insistently contributes to the compositional
triangle. Having established a focus, Raphael's task was to create
an attractive and meaningful rapport between the two children, a
problem he investigated here with a fertility of invention not
previously seen in his work. Ideas are jotted down in rapid
succession across the page, and seemingly every permutation tried

out, with Christ kneeling in one sketch, looking back over his
shoulder or out at the viewer in another, and the Baptist unde-
cided as to whether to tug his forelock or cross his arms in
deference. The *pentimenti* (visible alterations) around the legs of the
infants in some of the sketches indicate that Raphael wanted at
least one of them to be walking forward in greeting (as is appro-
priate to their legendary encounter). It is no surprise that this role
was in due course assigned to Christ, since it helps to explain the
Virgin's supportive gesture. In two of the sketches on the verso,
the Baptist's long cane cross is made the compositional and
emotional focus, as it is in the final painting. It hardly features,
however, in the sketch at the centre of the recto which otherwise
comes closest to the chosen solution.

Raphael's creative procedure as illustrated in this drawing
conforms to the method advocated by the mid-16th century
Venetian writer Lodovico Dolce: *When a painter is sketching down the
first ideas for a subject that his imagination throws up, he shouldn't be content
with one solution only but should try out many, tackling both the whole
composition and its individual parts, and then choose the most successful one.
This was how Raphael himself used to work, who was so inventive that he always
produced four or six different ideas for a composition, each of them beautiful and
successful.*[7] Raphael's sheets of studies drawn a year or so later
exhibit an even greater wealth of ideas and brio of handling (cat.
nos. 20-21).

fig. 36 Raphael
Madonna of the Meadow
(Vienna, Kunsthistorisches
Museum)

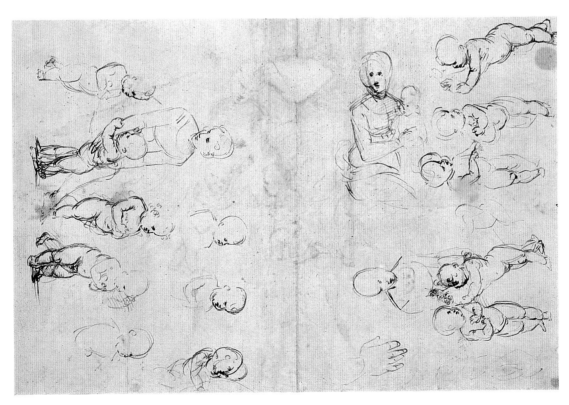

2 *Studies of the Virgin and Child and the Infant John the Baptist* [recto]
An Adaptation of the Virgin and Child from Michelangelo's 'Taddei Tondo' [verso]

Pen and brown ink over stylus underdrawing; 25.2 × 19.4 cm.
PROVENANCE: Sir Peter Lely (L.2092); William, 2nd Duke of Devonshire (L.718)
REFERENCES: Passavant, 1860, II, p.515, no.564; Crowe and Cavalcaselle, 1882-85, I,
p.263; Fischel, 1922, III, no.117; Washington, 1969, p.31, no.57; London, 1983, p.73,
no. 54; Joannides, 1983, no.111; Knab, Mitsch, Oberhuber and Ferino Pagden, 1983,
no.118; Ames-Lewis, 1986, pp.60-63.

Chatsworth, The Duke of Devonshire and the Trustees of
the Chatsworth Settlement (Inv.no.723)

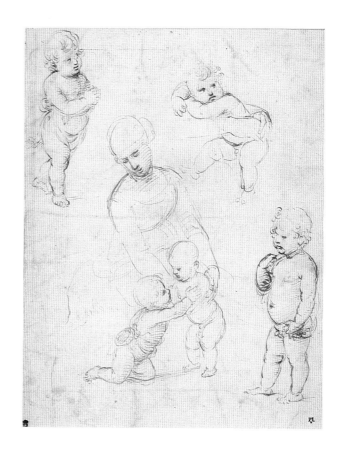

The principal study on this sheet, and those of the standing
infants, are certainly related to Raphael's *Madonna of the Meadow* (fig.
36) and explore similar ideas to those considered on both sides of
the sheet from Vienna (see previous entry). The upright postures
of the boys in the top left and bottom right corners of this sheet
have more in common with those on the verso of the Vienna
drawing than with its more fluent recto. The central sketch of the
latter is also closer in some respects to the painting than is the
main sketch here. Two details in the Chatsworth drawing which
were not used for the Vienna picture but which do appear in the
Madonna del Cardellino (fig. 37) are the dish attached to the Baptist's
hip (a motif borrowed from the *Taddei Tondo*, fig. 45) and the
gesture of Christ at lower right by which he loosely grips a veil
wound round his waist, a connection which underscores the close
links between the two paintings.

The moving sketch of a child embraced by his mother at the
top right of this sheet is an arrangement which has its closest
parallels in the famous *Madonna della Seggiola* (*Madonna of the Chair*) in
the Palazzo Pitti, Florence, painted nearly a decade later.[1] A faint
echo, in reverse, can be detected earlier in the *Holy Family with the
Beardless St. Joseph* in the Hermitage, St. Petersburg.[2]

For a discussion of the drawing on the verso see cat. no. 19. It is
perhaps no coincidence that these two drawings appear on the
either side of the same sheet, since one is a study for a picture
painted for Taddeo Taddei and the other a copy of a work in his
collection.

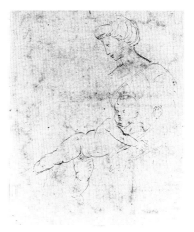

verso

3 The Virgin and Child with the Infant St. John

Brush and brown wash heightened with touches of white (oxidised) over traces of underdrawing in metalpoint, the contours indented and the sheet lightly squared in metalpoint; the subsidiary sketch in red chalk; 21.9 × 18 cm.
PROVENANCE: Viti-Antaldi (L.2246); Samuel Woodburn; Thomas Dimsdale; Sir Thomas Lawrence (L.2445); Samuel Woodburn.
REFERENCES: Crowe and Cavalcaselle, 1882-85, I, pp.263-64; Fischel, 1922, III, no.118; Parker, 1956, p.266-67, no.518; Pope-Hennessy, 1970, pp.193-95; London, 1983, p.73, no.55; Joannides,1983, p.66 and no.112; Knab, Mitsch, Oberhuber and Ferino Pagden, 1983, no. 123; New York, 1987, p.56, no.7.

Oxford, Ashmolean Museum (P II 518)

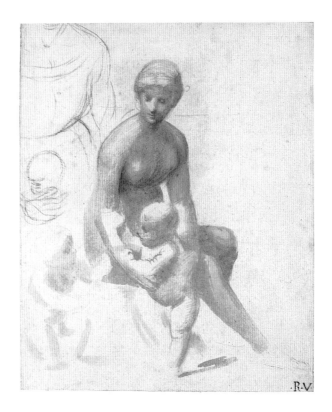

From the point of view of both technique and type, this drawing is unusual for Raphael at this point in his development, so much so that several 19th-century scholars rejected its attribution to him.[1] It is evidently the earliest surviving drawing by him drawn very delicately with the tip of the brush using brown wash. The spared paper is activated to represent the highlights, which are strengthened in a few places with touches of lead white (which has blackened with time). The study is not concerned with compositional problems, which, to judge from the sureness of the metalpoint underdrawing, must already have been fully resolved. The outlines of this drawing may even have been transferred directly using indentation from another, now lost, study.

Raphael's main interest here was to establish the fall of light and shade in the *Madonna of the Meadow* composition (fig. 36), a concern especially evident in the ghostly figure of the Baptist. His pose, which the artist had explored so thoroughly on earlier sheets (cat. nos. 2-4), is in the end borrowed from Leonardo's *Virgin of the Rocks* (versions in the Louvre and the National Gallery, London). As in other, later drawings of this type (see cat. no. 31), the washes have faded somewhat and the tonal contrasts moderated. Details are all but eliminated, and the torsos and limbs have a geometric, tubular appearance. The Virgin Mary is rendered *as if in a close-fitting garment*,[2] rather than naked, although there are slight metalpoint indications of the form the drapery was to take around her legs. The study demonstrates that beneath the ample folds of the Virgin's mantle in the Vienna painting, her body is naturally and convincingly articulated.

The red chalk used for the subsidiary sketch here was also a rarity in Raphael's work at this time, although it was the medium of the latest and most elaborate of the studies for the *Madonna of the Meadow*, now in the Metropolitan Museum of Art in New York.[3] Although the sketch here appears to belong to a slightly earlier phase of the preparatory process than the wash drawing, it is in fact later and shows Raphael still questioning the solution he had arrived at. As if to demonstrate his technical versatility, one further drawing for this painting not so far mentioned, a detailed study for the head of Christ in Hamburg, is in silverpoint.[4]

4 The Virgin and Child with the Infant St. John

Pen and brown ink over metalpoint, the original sheet very irregular and made up at upper left and and at the right side; 22.9 × 16.3 cm.
PROVENANCE: Viti-Antaldi (L.2246); Samuel Woodburn; Thomas Dimsdale; Sir Thomas Lawrence (L.2445); Samuel Woodburn.
REFERENCES: Passavant, 1860, II, p.501, no.485; Crowe and Cavalcaselle, 1882-85, I, p.262; Parker, 1956, II, p.266, no.517; Pope-Hennessy, 1970, pp.194-95; London, 1983, p.75, no.57; Joannides, 1983, no.116; Knab, Mitsch, Oberhuber and Ferino Pagden, 1983, nos.148 and 152.

Oxford, Ashmolean Museum (P II 517)

This lively drawing is a preparatory study for one of Raphael's best-known pictures, the Madonna del Cardellino (Madonna of the Goldfinch) in the Uffizi in Florence (fig. 37).[1] According to Vasari, who in this instance gives quite a detailed description, the picture was painted for Lorenzo Nasi, with whom Raphael had a 'great friendship', and he associated the commission with Nasi's wedding.[2] Recent archival discoveries have established that this took place in 1505 or early 1506, and it has been argued that the painting must have been completed by then.[3] However, if anything Vasari's wording implies that the picture was painted after rather than before the happy occasion. Nasi was linked by his sister's marriage to the Taddei (see cat. no. 1) and by his own to the Canigiani (see cat. no. 66), which illustrates well the close ties that existed between Raphael's main patrons in Florence, many of whom he appears also to have known socially. Raphael may have been introduced to this circle of patrons by his former master Pietro Perugino, who some fifteen years previously had supplied an altarpiece for the Nasi family chapel in what is now the church of Santa Maria Maddalena dei Pazzi in Florence, and one of whose works is also mentioned by Vasari in the Taddei collection.[4] The Madonna del Cardellino was smashed into numerous pieces during a landslide in 1547 which destroyed the Nasi palace, but the fragments of the panel were salvaged and put back together again, although it remains very severely damaged and heavily restored.

In this drawing we can witness Raphael thinking simultaneously about the fall of the drapery and the coherence of the underlying body structure. The group of the Virgin holding up a book for Christ to read was drawn first, and forms a unified, triangular composition in its own right.[5] St. John was added in a position which contributes to the pre-established pattern, his face overlapping the Virgin's elbow. While visually pleasing, this arrangement had obvious drawbacks in terms of content, for the Baptist is isolated from the main action. The decision in the painting to have St. John present a goldfinch to Christ resolved this problem, and he is further integrated by the placement of the Virgin's hand on his back, which gently coaxes him forward. It is reasonable to infer from the introduction of the goldfinch, whose red markings were believed to have their origins in drops of Christ's blood, that the passage in the book they are reading in the preparatory drawing also referred to Christ's Passion. The idea for Christ's pose, leaning back between his mother's knees and looking along the line of his outstretched arm, appears in a slightly earlier sketch for the same painting, also at Oxford.[6] Both infants in the drawing are indebted to Michelangelo, the Baptist to his Taddei Tondo (fig. 45) and Christ, notably in his hairstyle, to the Bruges Madonna, completed in 1506.[7] The distinctive detail of Christ resting his foot on his mother's is retained in the painting. St. John's shallow dish is similar to the one he uses to scoop up water in many depictions of the Baptism of Christ.

There are some architectural sketches on the back of the sheet which can be seen in strong light through the backing sheet, including a plan for a small church or chapel.[8]

4 verso

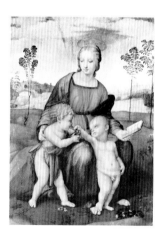

fig. 37 Raphael
Madonna of the Goldfinch
(Florence, Uffizi)

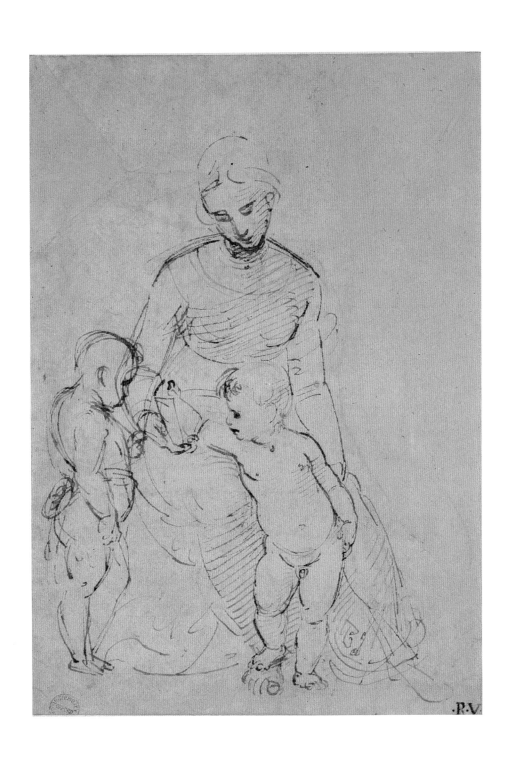

35

5 The 'Holy Family with a Palm Tree'

Oil on canvas, transferred from panel; circular, 101.5 cm diameter.
PROVENANCE: Henri Hurault, Comte de Cheverny; Anne Hurault de Cheverny, Marquise d'Aumont; sold by her c.1648 to the Abbé de La Noue; President Antoine Tambonneau; Monsieur de Vannolles; sold by him to the Régent, Philippe Duc d'Orléans by 1723; by descent to Louis Philippe Joseph, Duc d'Orléans (Philippe Égalité); sold by him in 1791 to Viscount Walchiers, Brussels; François de Laborde de Méréville; sale: Bryan's Gallery, London, 1798 (lot 113), reserved for the 3rd Duke of Bridgewater; thence by descent.
REFERENCES: Félibien, 1725, I, p.339; Crozat, 1729, I, p.11; Passavant, 1860, II, pp.38-39; Gruyer, 1869, III, pp.259-72; Crowe and Cavalcaselle, 1882-85, I, pp.285-88; Dussler, 1971, p.23; Pope-Hennessy, 1970, p.195; Oberhuber, 1982, pp.44, 49; Rome, 1992, p.87; Cordellier and Py, 1992, p.56.

Edinburgh, National Gallery of Scotland
(Duke of Sutherland loan, 1945)

Compared to many of Raphael's Madonnas, the *Holy Family with a Palm Tree* has not been accorded the attention it deserves in the recent literature on the artist. This neglect can in part be explained by the picture's imperfect state of preservation. The paint layer was transferred from its original panel support onto canvas at some point between 1786 and 1808, probably when it was still in the Orléans collection. This process caused the canvas weave to be imprinted on some areas of the surface and provoked a subsequent shrinkage and wrinkling of the paint layer (see the introductory essay by John Dick). Its recent restoration, however, has done a great deal to improve the appearance of the picture, particularly with regard to its luminosity and strength of colouring.

The patron and early history of the *Holy Family with a Palm Tree* are unknown, although several theories have been advanced. It is, however, unanimously recognised as an autograph work by Raphael dating from what is generally designated his Florentine period (c.1504-8), although he is also known to have worked in Perugia and Urbino during this time, and he may well have visited Rome. The circular, *tondo* format, which Raphael had employed on at least two previous occasions, was especially popular in Florence. Several drawings by Raphael survive which can be related to this composition (see cat. nos. 6-8), and there is now sufficient evidence to date the painting with some confidence to the years 1506-7.

The rustic setting and presence of the fan palm which gives this painting its title have fostered the notion that the intended subject was the *Rest on the Flight into Egypt*.[1] Although the absence of a familiar attribute of this subject, the donkey, is not proof in itself, the inclusion instead of the wooden paling fence behind the Virgin and what appears to be a classical sarcophagus serving as a seat, argue against this hypothesis. The palm may be present for heraldic reasons, as the similar palm in a later painting of the *Holy Family with the Infant Baptist* from Raphael's workshop quite possibly was (see below).[2]

We know that Raphael went to Florence, probably late in 1504, to learn (*per imparare*),[3] and intense study of the work of other artists triggered in him a highly experimental approach in his own paintings, which is most clearly reflected in the astonishing variety of his Florentine Madonnas and Holy Families. His ability to absorb aspects of the styles of his contemporaries while retaining his individual artistic personality is a remarkable feature of this period of his development. While Raphael's most important Florentine sources of inspiration were undoubtedly the works of Leonardo da Vinci (1452–1519) and Michelangelo (1475–1564), the *Holy Family with a Palm Tree* shows him working in the key of Fra Bartolommeo (1472–1517), whose influence elsewhere in Raphael's work has frequently been noted, principally in connection with the fresco of the *Holy Trinity with Six Saints* in San Severo, Perugia (dated 1505),[4] and with the *Madonna del Baldacchino* of 1507-8 (Palazzo Pitti, Florence).[5]

fig. 38 Fra Bartolommeo *Nativity* (Rome, Galleria Borghese)

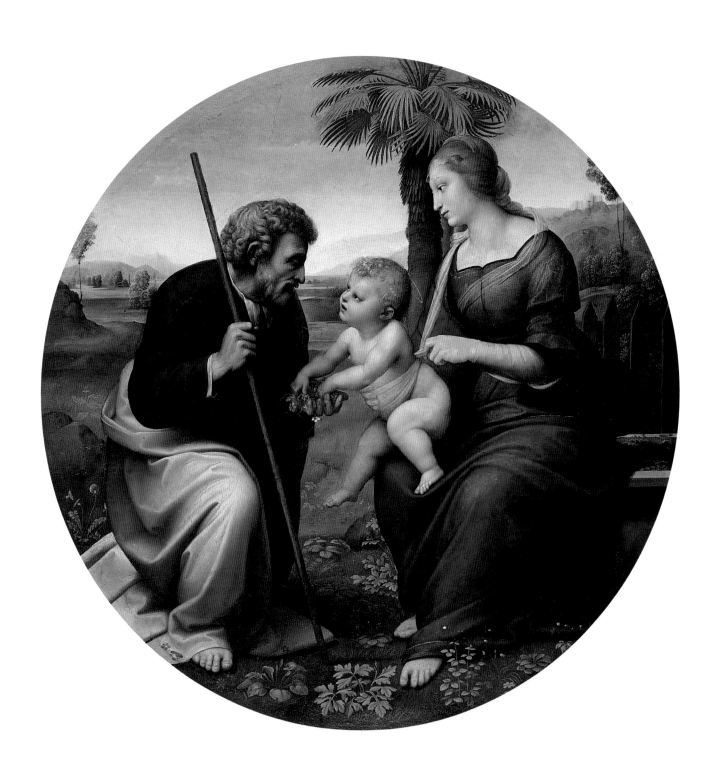

An early panel by Fra Bartolommeo which Raphael certainly knew is the *Nativity* tondo now in the Borghese Gallery (fig. 38), the early provenance of which is unknown, but which must have been in an accessible collection or perhaps still in the artist's workshop at the time of Raphael's Florentine sojourn.[6] The balanced, tripartite division of the composition, the scale of the figures in relation to the landscape, their arrangement within the circular frame, the use of saturated local colours, and even the foreground plants, all anticipate the *Holy Family with a Palm Tree*. Joseph's lower half, swathed in weighty golden fabric, is borrowed with only slight variations from the earlier work. It has been noted how this passage in Fra Bartolommeo's painting recalls drapery studies in tempera on linen made later in his career (in imitation of examples by Leonardo da Vinci and Lorenzo di Credi), and the same observation might apply equally well to Raphael's St. Joseph.[7] A less elaborate type of drapery study, no more than a sketch in black chalk and difficult to interpret, has survived for the Virgin Mary's blue mantle in Raphael's picture (see fig. 41). The x-ray of the Edinburgh tondo (fig. 15) suggests that Joseph may originally have been depicted bald, as he appears in Fra Bartolommeo's picture (and in Raphael's preparatory drawing from the Louvre, cat. no. 8), and that his distinctive silver curls were only added at a late stage in the execution.

In his *Life of Raphael*, Giorgio Vasari described the relationship between the two artists as follows:

While Raphael was in Florence, he had an especially close friendship with Fra Bartolommeo of San Marco, whom he liked very much, and whose use of colour (il suo colorire) he tried hard to imitate. In exchange he taught the good brother (Fra Bartolommeo had taken orders as a Dominican friar in 1500) the techniques of perspective which he had not until then paid much attention to.[8] Vasari clarified this statement in his *Life of Fra Bartolommeo*: *Since Raphael was anxious to paint in the manner of the Frate, and because he liked the way he handled and harmonised colours* (piacendogli il maneggiare i colori e lo unir suo), *he constantly sought his company.*[9] Fra Bartolommeo's *Nativity* is one of the artist's first independent works, usually dated to the early 1490s, and Vasari tells us that he was especially praised as a young man for his use of colour. While the treatment of details such as Joseph's gold cloak in Raphael's picture directly imitate the *Nativity* tondo, the range of colours and the overall blonde tonality of the *Holy Family with a Palm Tree* also find parallels in Fra Bartolommeo's later work.

Two additional, if marginal, pieces of evidence reinforce the link between the *Holy Family with a Palm Tree* and Fra Bartolommeo's Borghese *Nativity*. An etching by Giacinto Paribeni was published in 1662 which reproduced the latter, then in the collection of Cardinal Giulio Rospigliosi, as a work by Raphael.[10] Similarly, a second print (fig. 39), dated 1793, reproduces a variant of the *Holy Family with a Palm Tree* with an attribution to Fra Bartolommeo.[11] The picture, then owned by Count Czernichew, is now in a French private collection and according to the owner it

is the same size as the Sutherland tondo. To judge from photographs, it is unlikely to be a contemporary version of the composition. Raphael's figures are copied fairly accurately, with the exception of Joseph, who is bald and is not in strict profile. Combined with the evidence of the x-ray (see above) and the knowledge of Raphael's principal source for this figure (fig. 38), the implication is that the copyist knew Raphael's full-scale cartoon for the composition, which no longer survives, and reproduced it faithfully. The differences between the Sutherland painting and the copy therefore probably reflect changes made by Raphael after he had drawn the cartoon, on the surface of the original panel itself.

Vasari is quite specific about the moment when the two artists were most closely associated, and this may have some implications for the dating of the *Holy Family with a Palm Tree*. He states that their friendship was interrupted by Raphael's departure for Perugia to execute the *Entombment of Christ*, which is dated 1507 (see cat. no. 67), having completed the cartoon for it in Florence. Taken in conjunction with the evidence of the drapery study in the Lugt Collection (fig. 41), which is on the verso of a drawing for Mary Magdalene in the *Entombment*, a dating of the Sutherland picture to 1506 or early 1507 is reasonable and has found widespread support on stylistic grounds.[12] It should, however, be emphasised that Raphael probably worked concurrently on several different Madonna compositions, at different stages of completion, and any attempt at too precise a dating or too strict a chronological sequence is likely to be misleading. It may have been the Umbrian

fig. 39 Friedrich John *Nativity* engraving after Raphael (London, British Museum)

character of the distant blue-green landscape (fig. 18) – comparison with Raphael's *Mond Crucifixion* of 1503 in the National Gallery, London, is not inappropriate – which led some writers to date the *Holy Family with a Palm Tree* slightly earlier.

Several 19th-century scholars[13] attempted to identify this picture as one of the two works which Vasari tells us Raphael painted for his friend and supporter Taddeo Taddei.[14] The *Terranuova Madonna* in Berlin is now generally considered a more likely candidate. More compelling is the suggestion[15] that the present picture might be the one described in a 1623 inventory of the possessions of the Dukes of Urbino as in the shape of a mirror (*a foggia di specchio*) (see cat. no. 14). Visual evidence to support this hypothesis includes the palm tree itself, an *impresa* (device) of Francesco Maria Della Rovere, Duke of Urbino from 1508;[16] what appear to be two oak leaves, the principal emblem of the Della Rovere family, visible on the sarcophagus beside the Virgin Mary; and the gold and blue-black of Joseph's costume, the heraldic colours of the family. It has furthermore been noted that the arrangement of the figures in the painting, and particularly the projecting knees of Joseph and the Virgin Mary in the lower foreground, generate a sense of curvature which simulates that of a convex mirror.[17] However, forceful – though not conclusive – arguments, based on a comparative appraisal of the surviving 16th and 17th century inventories of the Della Rovere collections, seriously undermine the identification of the Sutherland painting with that mentioned in the 1623 inventory.[18]

Some aspects of the imagery of the *Holy Family with a Palm Tree* are unusual and deserve further investigation. Seldom had the figure of Joseph been accorded so prominent a role in representations of the Holy Family.[19] Not only is he uncommonly well attired and the focus of the gaze of both the other figures, but he interacts directly with the infant Christ by offering him a handful of meadow flowers, which the child fingers delicately with both hands. This charming gesture, occupying the centre of the composition, might well have some symbolic significance.[20] This is one of the most abraded areas of the picture and it is no longer possible to identify the various flowers being offered with any certainty.[21] Given his prominence, it is reasonable to propose that

St. Joseph may have held some particular significance for whoever commissioned the picture.

Among the beautifully described plants in the meadow, almost certainly based on living specimens rather than on a secondary source such as an illustrated herbal, a dandelion, a violet and a strawberry can be readily identified. Such botanical details appear in many other Raphael Madonnas (most famously in the *Belle Jardinière*)[22] – they are, indeed, a common feature of Renaissance Madonnas both north and south of the Alps – but attempts to interpret them symbolically have not been wholly convincing.[23]

In several respects – the abundant floral imagery, the fence (a reference to the *hortus conclusus* or enclosed garden, emblematic of the Madonna's virginity), and the palm tree itself – Raphael's picture finds parallels in the biblical *Song of Solomon* (the *Canticles* or *Song of Songs*). This Old Testament book was generally interpreted as an allegory of the relationship between God and the Church, but its complex imagery was also associated with the cult of the Virgin Mary.[24] The leaf-strewn sarcophagus recalls the flowers that appeared in the Virgin's empty tomb at her Assumption, and the evanescent veil which so enchantingly bonds mother and child in a figure-of-eight while balancing the child's precarious pose might allude prophetically to the winding-cloth in which Christ was entombed.

The connection between the *Holy Family with a Palm Tree* and the *Song of Solomon* was certainly made in the 17th century, as the legend to Rousselet's print demonstrates (see cat. no. 9). While this may be a later interpolation rather than a reflection of Raphael's intentions, the more unusual features of his composition do encourage the modern viewer to seek a textual explanation. On balance, however, it is an idyllic, harmonious mood that prevails, and it is preferable to interpret all the potentially loaded ingredients in the *Holy Family with a Palm Tree* in an allusive rather than an overtly symbolic light, as enriching rather than defining the meaning of the work. It is notable that Vasari, writing only a few decades after they were painted, makes no allusion to symbolic content in his comments on Raphael's Florentine Madonnas.

detail of cat. no. 5 ▸

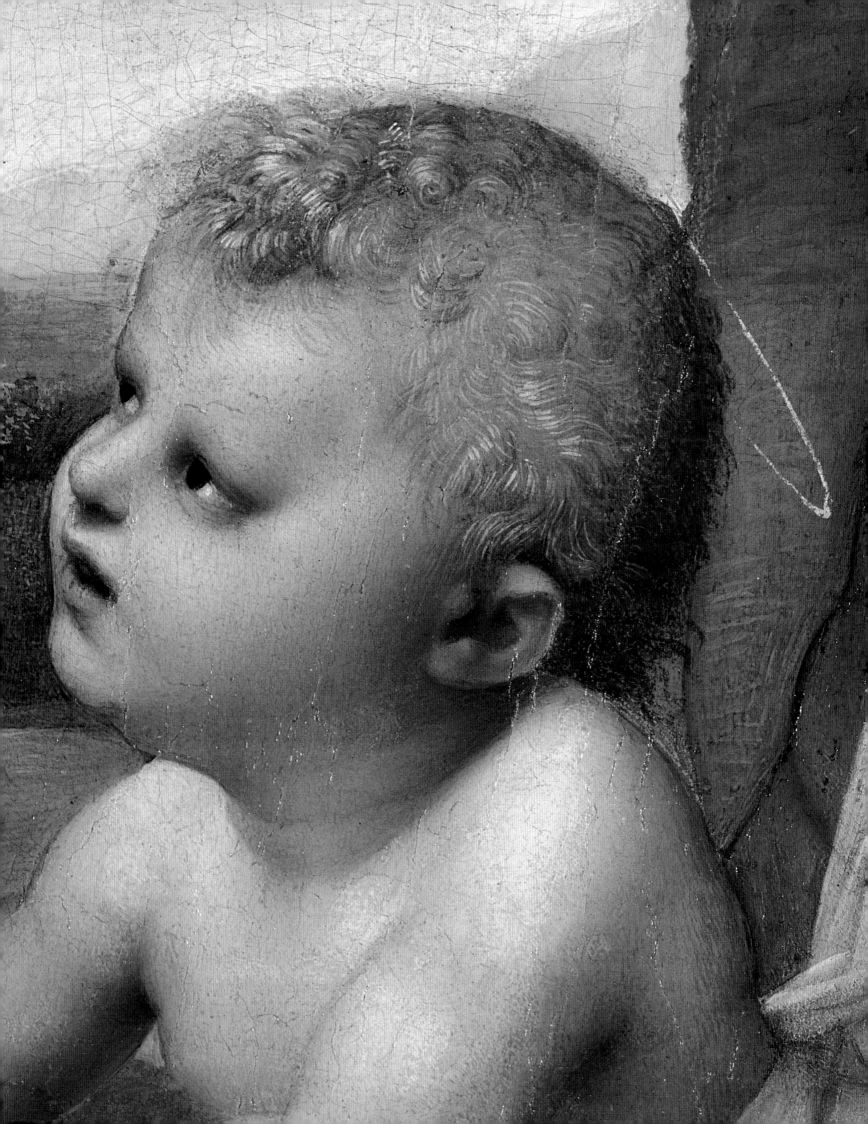

6 *St. Joseph and the Virgin Mary* [recto]
Two Seated Men, after Michelangelo [verso]

Pen and brown ink over traces of black chalk or metalpoint; 20.2 × 14.8 cm
(maximum dimensions); the paper cut irregularly and partially made up.
PROVENANCE: J.-B. Séroux d'Agincourt (before 1814).
REFERENCES: Séroux d'Agincourt, 1823, III, no.2, p.171, VI, pl. CLXXXIII; Passavant,
1860, II, p.480; Fischel, 1919, II, no.81; Joannides, 1983, no.157; Knab, Mitsch,
Oberhuber and Ferino Pagden, 1983, no.159; Vatican, 1984, no.3; Florence, 1984 (2),
p.29, no.15; Vatican, 1985-86, no.2; Rome, 1992, p.88, no.24.

Vatican, Biblioteca Apostolica Vaticana
(Vat. Lat. 13391, folio 1)

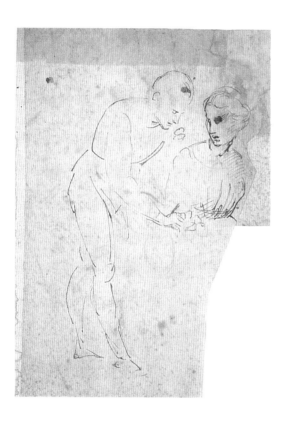

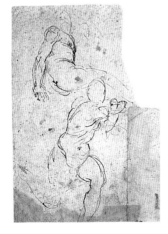

verso

7 *The Holy Family, with a separate study*
of the Virgin and Child [recto]
The Christ Child Standing [verso]

Pen and brown ink over traces of black chalk or metalpoint; 23.9 × 14.5 cm (maximum
dimensions); the sheet is made up of two separate pieces of paper joined together; much
stained and damaged, with numerous repaired losses.
PROVENANCE: J.-B. Séroux d'Agincourt (before 1814).
REFERENCES: Séroux d'Agincourt, 1823, III, nos. 5 and 6, p.172, VI, pl. CLXXXIII; Passavant,
1860, II, p.480; Fischel, 1919, II, nos.137-38; Joannides, 1983, no.156; Knab, Mitsch,
Oberhuber and Ferino Pagden, nos.157-58; Vatican, 1984, no.3; Vatican, 1985-86, no.3;
Rome, 1992, p.89, no.25.

Vatican, Biblioteca Apostolica Vaticana
(Vat. Lat. 13391, folios 2-3)

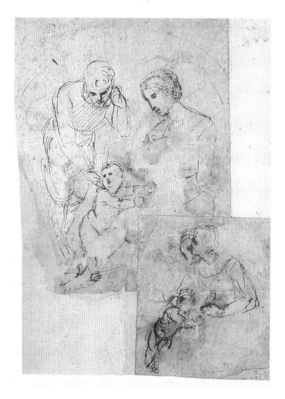

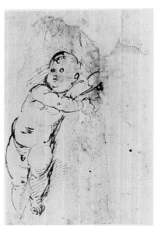

verso

All five sketches on these two sheets were reproduced as a single plate in Séroux d'Agincourt's posthumously published *Histoire de l'art par les monuments*, and they are closely connected stylistically. They were evidently drawn at great speed with an incisive handling of the pen and a summary, shorthand treatment of facial features, hands and feet. Some of the contours have a broken, angular character seldom found in Raphael's drawings.

The recto of no. 6 and both sides of no. 7 are considered by most recent scholars to be *primi pensieri* ('first thoughts') for the *Holy Family with the Palm Tree* (cat. no. 5), although the compositions differ markedly from the final solution. The connection of no. 6 with the painting is especially tenuous, but derives support from its association with no.7 and their shared history. Furthermore, although this area of the drawing is difficult to interpret, Joseph appears to be offering fruit or flowers to the invisible Christ Child, a motif retained in the painting.

The two curved lines in the study for the *Holy Family* (no. 7) – which suggest, perhaps inadvertently, not only the limit of the picture field but its frame as well – confirm what one might in any case have been able to deduce from the arrangement of the figures, that Raphael was envisaging here a circular composition. Joseph's stooping pose as he leans forward on his staff to caress Christ's cheek allows the curved forms of his head, shoulder, hip and thigh to echo those of the frame. The same principle was adopted for the kneeling Joseph in the *Holy Family with a Palm Tree*, while the specific pose was adapted for other works by Raphael, such as the little *Holy Family with the Lamb* (dated 1507) in Madrid,[1] and the *Canigiani Holy Family* in Munich (fig. 72).[2] This is typical of Raphael's flexible approach and of his reluctance to allow a good idea go to waste. Even in an exploratory sketch such as this the draughtsman takes the trouble to define using parallel hatching the fall of light from the left. Compared to the sketch, a more classical, frieze-like arrangement was employed in the painting, possibly inspired by an antique source (see Timothy Clifford's essay). The adult figures are both shown in strict profile, with Christ bridging the gap between them.

In the subsidiary sketch of the Virgin and Child alone, Christ looks more convincingly over his shoulder to where we imagine Joseph must be than he does in the larger one. In a *pentimento* (modification) to the underlying sketch, the Virgin too now gazes at her husband, the first intimation of this feature of the painting, temporarily abandoned in the Louvre drawing (cat. no. 8). The sketch of the Christ child on the verso of no. 7 repeats with insignificant alterations but on a larger scale his pose in the principal study on the recto, and anticipates in the lower half the Christ in the *Belle Jardinière* in the Louvre.

Quite closely related to the Virgin in these sketches is a recently discovered pen and ink drawing of the head and shoul-ders of a woman (fig. 40), which may also, therefore, be loosely associated with the *Holy Family with a Palm Tree*.[3]

The final study in this group, the verso of no. 7, is of considerable interest as the only surviving copy by Raphael after Michelangelo's celebrated cartoon of the *Battle of Cascina* (best known now through the copy at Holkham Hall), news of which, according to Vasari, was one of the main reasons for his move to Florence.[4] The cartoon was probably commissioned late in 1504 and was preparatory for a fresco, never completed, to be painted in the Great Council Hall of the Florentine Republic in the Palazzo Vecchio. Execution of the cartoon took place *in a room in the Dyers' Hospital at Santo Onofrio*.[5] In November 1506 work on the fresco itself had not progressed very far, and two years later the cartoon was still in the Council Hall. Michelangelo seems to have been anxious to keep away prying eyes, and it is not clear where or when Raphael had an opportunity to study it. His copy has been dated as early as 1505.[6] What caught Raphael's eye were two of the most complex figures in the composition, their dynamic, muscular forms twisting backwards into space. There are a few minor discrepancies between the copy and the original, as might be expected from so vital a sketch,[7] and he has summarily completed the head of the uppermost nude, which was obscured by another figure in the cartoon. The relative placement of the two figures on his sheet does not correspond to that in his source. The somewhat confused area of pen lines around the lower nude's right shoulder in fact represents a much smaller and more schematic rendering of the same figure.

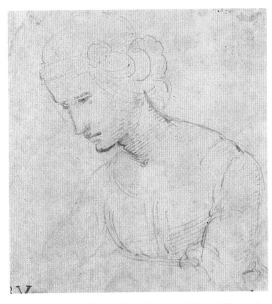

fig. 40 Raphael *Head and Shoulders of a Woman* (Private Collection)

8 The Virgin and Child, with a separate study of the Head of St. Joseph

Silverpoint on pale greyish-pink prepared paper, the Virgin only squared for enlargement; 22.5 × 15.3 cm; the sheet trimmed, at least at top and bottom.
PROVENANCE: J.-B. F. de Meyran, marquis de Lagoy (L.1710); Samuel Woodburn; Thomas Dimsdale (L.2426); Sir Thomas Lawrence (L.2445); William II, King of Holland; his Sale, The Hague, 12 August 1850, lot 33, bought by the Louvre.
REFERENCES: London, 1836, no.21; Passavant, 1860, II, no.328; Fischel, 1922, III, no.139; Joannides, 1983, no.155; Knab, Mitsch, Oberhuber and Ferino Pagden, 1983, no.164; Paris, 1983 (1), no.49; Rome, 1992, no.26.

Paris, Musée du Louvre, Département des Arts Graphiques
(Inv. no. 3861)

This is by far the most fully developed of the surviving preparatory studies for the *Holy Family with the Palm Tree*. It is indicative of the thoroughness of Raphael's preparatory method that, notwithstanding the squaring for enlargement, further significant changes were introduced before he took up his brushes. The Christ Child's unstable pose was reconsidered, perhaps with reference to a roughly contemporary sketch at the lower right of a sheet of studies in Vienna (see cat. no. 21 verso), and the overall effect was a shift from a more lively, dynamic conception to a more static and sober one. Even the folds of the Virgin's drapery are toned down between drawing and painting, a process effected through a black chalk sketch in the Lugt Collection (fig. 41).[1]

The pose of the Madonna and especially of the Child in the present study are directly inspired by a glazed terracotta group by Luca della Robbia known as the *Rovezzano Madonna*, which exists in numerous versions.[2] In the Della Robbia sculpture Christ also stretches out to touch flowers, in this instance lilies which refer to his future Resurrection. Although he never to our knowledge sculpted himself, Raphael was clearly very interested in sculpture and had no problems translating its effects into two dimensions. Both drawings and paintings, particularly from his Florentine period, are brimming with references to contemporary and earlier sculpture (see cat. nos. 4, 15, 19 and 28).

A light pentimento to Christ's right arm in the Louvre drawing, which has in the past been interpreted as representing flowers, shows Raphael experimenting with a gesture of blessing, although this idea was not pursued. The basic pose of the Virgin can be traced back to a much earlier work by Raphael, the *Adoration of the Magi* from the predella of the Oddi *Coronation of the Virgin* in the Vatican,[3] and it reappears in two later drawings, in Lille[4] and in the Uffizi (fig. 44). This strain of continuity in Raphael's work, of taking up and developing ideas explored earlier as if no solution were definitive, is particularly evident in relation to the themes of the Madonna and the Holy Family.

The head of Joseph at the upper left of the sheet, drawn to a different scale to the Virgin and not squared, appears to have been studied from life. It may have resembled more closely the Joseph in the lost cartoon for the *Holy Family with a Palm Tree* than it does the figure in the painting (see cat. no. 5). The head is strongly reminiscent of studies of old men by Leonardo da Vinci[5] and may account for the sheet's having at one time been attributed to that artist (there is an inscription on the verso to that effect). It is likely that Raphael made a study for the entire figure of Joseph, equivalent to that for the Virgin on this sheet and probably concentrating on the drapery, which would explain the detailed focus on the head here.

Raphael used silverpoint for this drawing, a technique demanding great precision which was rapidly going out of fashion by this date in favour of pen and chalk, but which, when handled expertly, could produce extremely beautiful results. Marks were made directly with a silver stylus (lead and even gold were also used) onto paper specially prepared with very finely ground, and often tinted, bonemeal. Raphael was one of its last and, with Leonardo, its most accomplished and versatile exponents in Italy, and he continued to use it well into his Roman period (see cat. no. 36 and fig.58). He here used it with a breadth of handling more usually associated with chalk.[6]

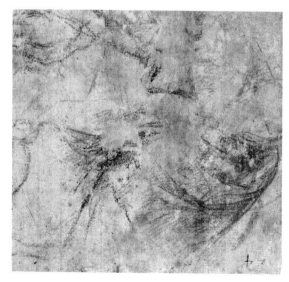

fig. 41 Raphael *Study of Drapery* detail
(Paris, Institut Néerlandais, Frits Lugt Collection)

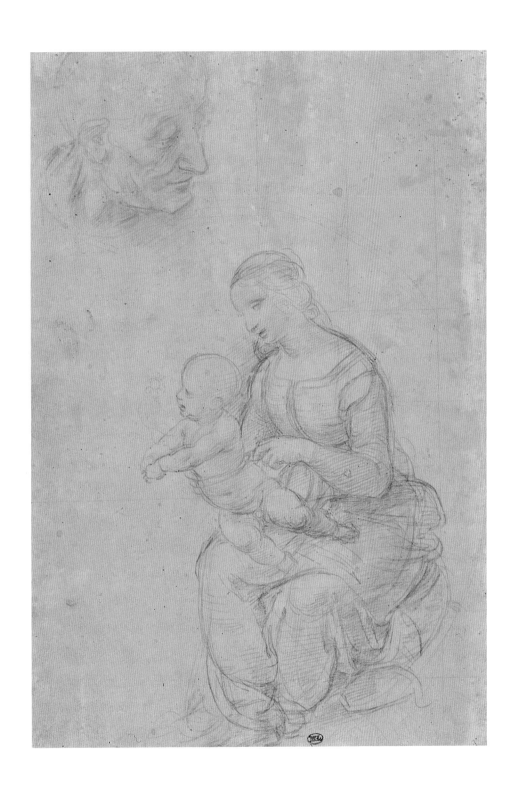

GILLES ROUSSELET (GILLIS, AEGIDIUS)
1610/17–1686

9 The 'Holy Family with a Palm Tree' (after Raphael)

Engraving, in reverse; 45.5 × 42 cm.
INSCRIPTIONS: *Raphael d'Urbin pinxit/Aegid. Rousselet sculp. et ex. c. priv Reg. 1656*/ FLORES
APPARVERUNT IN TERRA NOSTRA. *Cant. 2.*
REFERENCES: Crozat, 1729, I, p.11, no. XXIII; Nagler, 1835-52, XV, p.267, no.24;
Passavant, 1860, II, p.38, no.39; Paris, 1983 (3), no.361; Rome, 1985, pp.186-87.

London, The Trustees of the Victoria and Albert Museum (Acc. no. Dyce 2449)

This is the earliest and the finest of the reproductive engravings of
the *Holy Family with a Palm Tree*. It is not clear whether the painting
was still in the collection of the Abbé de La Noue when the
engraving was made, for according to one source he died 'before
1657'.[1] The decorative laurel wreath surround in the print may
reflect the way the painting was framed at the time: it is made to
cast a shadow as if it were real.

The reference in the legend ('Flowers appear on the earth') is
to the *Canticles* (the *Song of Solomon*, 2:12), a useful pointer as to how
the imagery of the painting was interpreted in the 17th century
(see cat. no. 5). The text of this book speaks of a Shulamite woman,
understood by many as a prefiguration of the Virgin Mary, who is
likened to 'a garden inclosed' (4:12) and to a palm tree (7:7).

Another, larger version of this print by Rousselet is known,
which includes an expanded title and a credit to the publisher
Nicolas Poilly. Rousselet also produced fine engravings after
Raphael's *Belle Jardinière* and *Holy Family of Francis I*, both in the
Louvre.

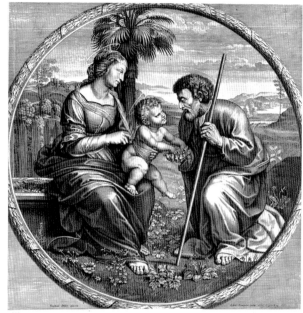

FLORES APPARVERVNT IN TERRA NOSTRA

JEAN RAYMOND
c.1695–c.1766

10 The Holy Family with a Palm Tree (after Raphael)

Engraving, in reverse; 38.3 × 33 cm.
INSCRIPTIONS: *La Sainte Vierge/d'Apres le Tableau de Raphaël, qui est dans le Cabinet de
Monseigneur le Duc d'Orleans./le Diametre du Rond 3.pieds 2. pouces, peint sur bois, gravé par Jean
Raymond/23.*
REFERENCES: Crozat, 1729, I, p.11.

Edinburgh, National Gallery of Scotland (Acc. no. P2882)

This engraving is plate 23 from J. A. Crozat's *Recueil d'Estampes
d'après les plus beaux Tableaux et d'après les plus beaux Dessins qui sont en
France*, published in Paris in 1729. This collection included all
three of the Sutherland Raphaels (see cat. nos. 5, 18 and 37) among
a total of no less than 45 works by (or then attributed to) him.

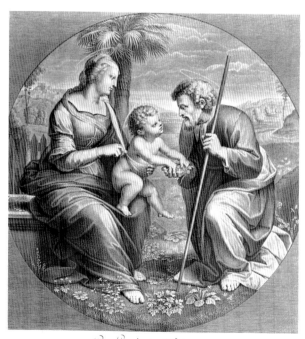

La Sainte Vierge

d'Après le Tableau de Raphael qui est dans le Cabinet de Monseigneur le Duc d'Orleans

ATTRIBUTED TO JEAN MASSARD
1740-1822

11 The 'Holy Family with a Palm Tree' (after Raphael)

Etching and engraving; 41.8 × 26.9 cm.
INSCRIPTIONS: R. S. Urbino pinx.t/Lerouge aqua forti/R. v. Massard Sculp./LA SAINTE FAMILLE au Palmier/De la Galerie du Palais d'Orléans/ÉCOLE ROMAINE/XIe TABLEAU DE RAPHAËL SANZIO/Peint sur un panneau de bois de forme ronde ayant trois pieds de diametre/La Vierge assise près d'un palmier a fait du voile qui la couvroit une ceinture pour soutenir son fils, et favoriser ses jeux enfantins. Elle prend plaisir à le voir se pencher et prendre les fleurs que St. Joseph un genou en terre et la main appuyée sur un baton lui présente d'un air respecteux. Le fond du tableau est orné d'un paysage simple mais agréable et les devants sonts couverts de plantes variées et étudiés avec soin./L'on attribue à la seconde manière de Raphael cette production toujours recherchée avec empressement à cause de sa beauté. Les noms de ses heureux possesseurs encore cités de nos jours sont consignés dans les ouvrages de Félibien et de Crozat. Tous deux ont remarqué que M.me la Marquise d'Aumont la vendit cinq mille livres à M.r Delanoue, et l'obligea en meme temps de lui en donner une copie pour etre mise dans l'Eglise de Port Royal à Paris. Philippe de Champeigne fut chargé de ce travail. Malgré les talens réels que le distingoient, cet artiste imitateur exact mais froid de la nature, fit passer peu des beautés de l'original dans la copie, il n'en retraça guères que la composition./Gal. Palais Royal.
REFERENCES: Nagler, 1835-52, IX, p.417, no.2; Brigstocke, 1993, p.129, n.29.

London, The Trustees of the British Museum
(Acc. no. 1855-6-9-231)

This print is a plate from the *Galerie du Palais Royal gravée* published in Paris in 1786. The Palais Royal housed the impressive collection formed largely by the Régent, Philippe Duc d'Orléans (1674 – 1723).[1] The print is usually attributed to Jean-Baptiste-Raphaël-Urbain Massard, but since he was born only in 1775, this is not likely. It seems probable that it is in fact by his father Jean, and that the latter also used the 'Raphaël-Urbain' pseudonym (hence the R.V. initials in the credit). The copy of the *Holy Family with a Palm Tree* by Philippe de Champaigne referred to in the caption to the print was last recorded in 1810 and can no longer be traced. With its pair, a *Christ and the Samaritan Woman* designed by Philippe de Champaigne himself (now in the Musée des Beaux-Arts at Caen), the copy flanked a *Last Supper*, also by Champaigne, in the church of Port Royal in Paris, with which the Marquise d'Aumont was closely associated.[2]

ACHILLE LOUIS MARTINET
1806-1877

12 The 'Holy Family with the Palm Tree' (after Raphael)

Engraving; 54 × 43 cm.
INSCRIPTIONS: LA VIERGE/AUX PALMIERS/Raphael Sanzio pinxit/Tiré de la Galerie de Lord Francis Egerton/Achille Martinet Delineavit & Sculpsit/PARIS, publié par Goupil & Vibert/15 Boulevart Montmartre & 7 Rue de Lancry/Berlin Verlag von L. Sachse & Cie/Imprimerie de Bougeard/London, Published the 1st May 1844./By the Anaglyphic Company. 25 Berners St. Oxford St.

London, The Trustees of the Victoria and Albert Museum
(Acc. no. 21469)

P. JEAN
ACTIVE C.1650–AFTER 1660

13 The Holy Family with a Palm Tree (after Raphael)

Enamel; 6.2 × 7.5 cm.
INSCRIPTIONS: Signed and dated on the back: *P. Jean fecit./ 1660*
REFERENCES: Paris, 1983 (3), pp.256-57, no.381.

Paris, Musée du Louvre, Département des Arts Graphiques
(Inv. no. 35.758)

This is an early example of the translation of the design of the *Holy Family with a Palm Tree* into another medium. Raphael's painting was presumably in the collection of the Antoine Tambonneau at the time this enamel was copied from it. No attempt was made by the copyist to compress or adapt the circular composition to the new oval format: details at top and bottom, including most of the palm leaves, are simply cut off. The copy is otherwise faithful, with the exception of the omission of the garden fence. The recent cleaning of the Sutherland painting has done much to recover the brilliance of colour reflected in the enamel.

Nothing is known about Jean's life, although he is presumed to be French on account of his name. Two other miniature enamels by him are known, one signed and dated 1653, the other a copy after Pierre Mignard.

14 A Mirror Frame with Allegorical Figuration

Walnut wood, parcel gilt; diameter 48.2 cm.
PROVENANCE: Alfonso I d'Este , 3rd Duke of Ferrara (1486-1534); Jules Soulages,
Toulouse, from whom purchased for the South Kensington Museum in 1861.
REFERENCES: Pollen, 1874, pp.185-87; Detroit, 1985, pp.154-55, no. 42b.

London, The Trustees of the Victoria and Albert Museum
(Acc. no. 7694 – 1861)

The circular form of this mirror, one of the most elaborate to have
survived from this period, lends support to the identification of
Raphael's *Holy Family with a Palm Tree* with the picture descibed as
'in the shape of a mirror' in an early 17th century inventory (see
Introduction and cat. no. 5). Of course, not all Italian mirrors of
that period were round, but many examples represented in
paintings could be cited, among them the two that feature in
Giovanni Bellini's *Woman at her Toilet* in Vienna,[1] and
Parmigianino's memorable *Self-Portrait in a Convex Mirror* in the same
collection.[2]

 The mirror now enclosed in the frame is modern. The original
for which it was carved, of burnished bronze with a relief of the
Madonna and Child with Angels on the back, also belongs to the
Victoria and Albert Museum, and is catalogued as in the 'Style of
Luca della Robbia'.[3] The frame was almost certainly carved for
Alfonso I d'Este, Duke of Ferrara, since his principal *impresa*
(personal device), a flaming bombshell, appears at the top centre,
highlighted in gold (one of Alfonso's favourite hobbies was
casting cannon). Other Este emblems, such as the eagle, also
feature. It has been suggested that the frame may have been
carved in Alfonso's own workshops located within the Castello
Estense in Ferrara. If the tradition that both mirror and frame
once belonged to Alfonso's wife Lucrezia Borgia is correct, the
frame must predate her death in 1519.

 Two branches with scroll-shaped foliage emanate from a large
letter Y at the bottom of the frame. These symbolise the two
possible paths in life, good and evil, and this meaning is made
explicit by the gilt letters interlaced amongst the leaves on either
side, which make up the words BONVM (good) and MALVM (evil)
respectively. Various creatures appropriate to each quality are
carved with the greatest of delicacy and attention to detail. The
'good' side is presided over at the top by an angel, and the
prospect of eternal salvation, the 'evil' side by a skeleton, repre-
sentative of death and damnation. It has been pointed out that
from the point of view of the image appearing in the mirror (the
face of Alfonso or of Lucrezia, we imagine), the 'good' branch
would be on the right side and the 'evil' one to the left, an

arrangement that is also symbolic. It is no coincidence that these
reflections on the course of life should appear on the frame to a
mirror, which is itself a *vanitas* symbol (implying both 'vanity', and
the idea of the futility of human endeavour in the face of the
inevitability of death). Rarely are we given so explicit an insight in
the visual arts into the Renaissance tendency to symbolic and
allegorical interpretation, a trait that was especially highly
developed at the sophisticated court of Ferrara.

15 Copy after Michelangelo's 'David' seen from Behind

Pen and brown ink over traces of black chalk; 39.3 × 21.9 cm.
PROVENANCE: William Young Ottley.
REFERENCES: Passavant, 1860, II, p.496, no.452; Pouncey and Gere, 1962, p.13, no.15;
London, 1983, p.61, no.39; Joannides, 1983, no.97; Knab, Mitsch, Oberhuber and
Ferino Pagden, 1983, no.226; Florence, 1984 (1), pp.38-39; Florence, 1984 (2), pp.17-
21, no.4; Ames-Lewis, 1986, pp.41-42.

London, The Trustees of the British Museum
(Acc. no. Pp. 1-68)

The block of marble from which Michelangelo was to carve the
David was delivered to him in August 1501, and he undertook,
unrealistically, to complete the figure within two years. The
commission came from the Operai (Board of Works) of the Florence
Duomo (the Cathedral of Santa Maria del Fiore), and only during
the course of execution was it decided by a special committee to
locate the statue instead outside the Palazzo della Signoria (the
Town Hall) where it became a great symbol of the Florentine
Republic. The figure was completed in March 1504, was trans-
ferred to the Piazza in June of that year, was finally lifted onto its
base and unveiled in September.[1]

Raphael, as was his habit (see cat. no. 19), made a number of
adjustments to his source in this copy, affecting mainly the
proportions of Michelangelo's figure. Most notably, the enor-
mous hands and feet of the statue were scaled down in the
drawing. Whereas Michelangelo's David is unmistakably at rest,
Raphael's rendition of it from behind conveys a sense of incipient
motion, with its taut leg muscles and sinews and the left knee
bent as if taking a step. This slight shift of emphasis is of interest
in relation to another of Raphael's derivations from the David, also
in the British Museum, where the figure is actively walking
forward.[2] In view of the discrepancies between the copy and the
original, and because, once erected, the statue could not actually
be seen from the angle represented in this drawing, it has been
argued that Raphael may have been working instead from a
terracotta or wax bozzetto (preparatory model) for the David,[3]
although this explanation makes little allowance for imagination
on the copyist's part.

The firm contours and careful hatching are tighter than is
usual for Raphael's Florentine pen drawings, and this reflects the
discipline imposed by copying, albeit with adjustments.[4] The
smooth gradations of the marble, which inevitably appear as more
sudden transitions in the linear technique of the copy, may have
been accentuated by nearly four centuries of weathering endured
before the statue was moved to its present location in the
Accademia in 1873.

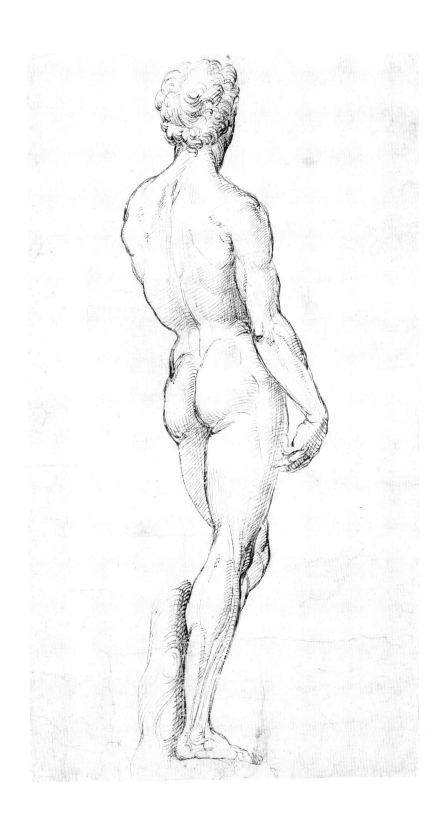

16 The Madonna of the Pinks ('Madonna dei garofani')

Oil (probably) on panel; 29 × 23 cm
PROVENANCE: Private Collection, France, by 1817 (it had probably been in France since the 17th century); bought by Vincenzo Camuccini in Paris, c.1828; Camuccini collection, Rome; sold by Giovanni Battista Camuccini to Algernon, 4th Duke of Northumberland, in 1853.
REFERENCES: Passavant, 1860, II, pp.62-64, no. 49; Crowe and Cavalcasselle, 1882-85, I, pp.343-44; Penny, 1992, pp.67-81.

Alnwick Castle, The Duke of Northumberland Collection

This little panel is unquestionably the most important Raphael discovery – or rather rediscovery – to have been made in recent years. The composition was once very famous and was repeated in many copies, variants and reproductive prints, but since the latter part of the 19th century Raphael's original was considered lost. When in the Camuccini collection in Rome the Alnwick picture was highly prized as the autograph version, and was bought as such by the 4th Duke. Recent cleaning and technical examination have proved this to have been a sound purchase. Not only is it certainly by Raphael, but it is among the best preserved of all his paintings.[1]

One of the reasons why the panel may have been overlooked by Raphael scholars for so long is that it is in several respects not entirely typical of him, notably in the bright but generally cool colour scheme[2] and the crisp, somewhat metallic sheen of the fabrics. The metalpoint underdrawing (fig. 23) revealed by infra-red reflectography is characteristic in terms of handling, but reveals none of the signs of having been transferred from a cartoon that appear in most other Raphael paintings examined in this way.

These anomalies can be to a large extent explained, however, by the fact that Raphael based the Madonna of the Pinks closely on an early picture by Leonardo da Vinci, the *Benois Madonna* in St. Petersburg, probably painted in the late 1470s, and in an accessible Florentine collection in Raphael's day (fig. 42).[3] Some details were even closer to the Leonardo at the underdrawing stage than in the finished work. The model would have largely obviated the need for compositional studies on Raphael's part, although a sketch on a sheet of studies in Vienna may be related (see cat. no. 21). The connections between the two paintings, including the colour scheme, are too numerous and self-evident to require listing here. So close are they that it is not unreasonable to suggest that Raphael may have been specifically commissioned to paint a version of the earlier work. Even the Virgin's dress in the *Madonna dei garofani* is more characteristic of the early 1480s than of the period in which it was painted.[4]

The compositional scheme of the *Benois Madonna*, with an

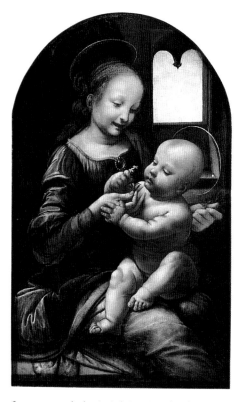

fig. 42 Leonardo da Vinci *The 'Benois Madonna'* (St. Petersburg, Hermitage)

arched window at upper right, was clearly one that Raphael liked, for he experimented with it on several other occasions. What he was evidently not particularly impressed by were Leonardo's early physiognomic types, and he recast these into his own idiom. A silverpoint drawing which bears a striking resemblance to the Christ Child's head in Raphael's picture (fig. 43), and even more so to the underdrawing for it (where the mouth seems to be slightly open), is however likely to be a later recollection.[5] The connection would be more compelling were it not for the fact that the other studies on the sheet are associated with works painted several years later in Rome, although the head of the child has itself not been linked with any other painting. Its Leonardesque character has, however, been commented upon.

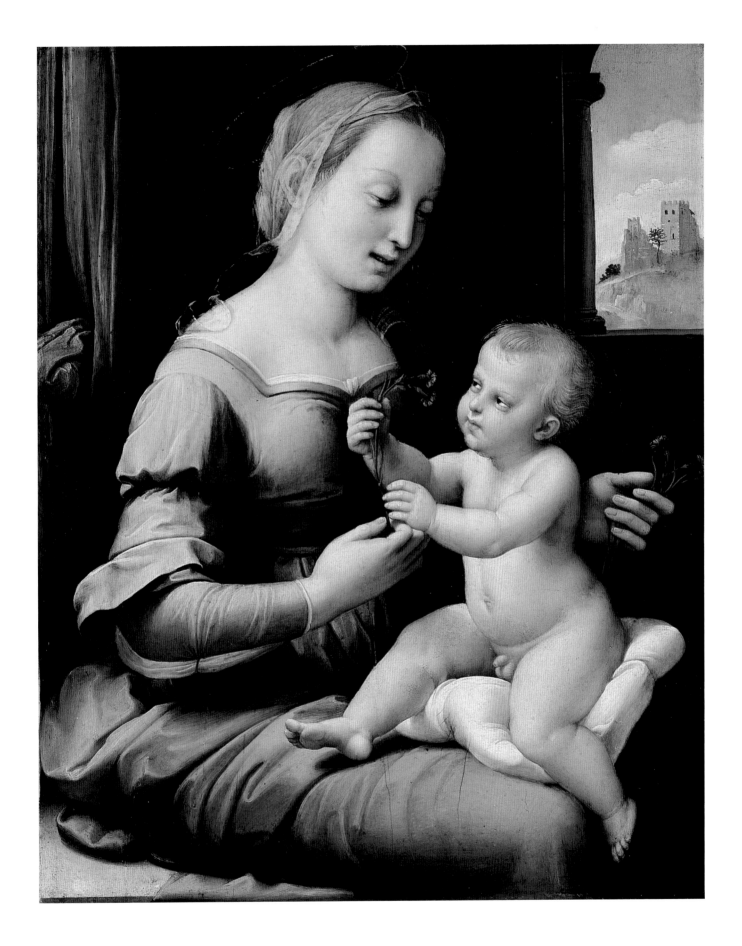

17 The Virgin and Child, Profiles and other Sketches [recto] Three Studies of the Virgin and Child [verso]

Metalpoint (mainly leadpoint) with some pen and ink on pink prepared paper
20 × 15.3 cm.
INSCRIPTIONS: *in principio era* (recto, lower right); *iesus e v(ergine)* (recto, upper right).
PROVENANCE: Sir Thomas Lawrence (L. 2445); Samuel Woodburn; Sale, 8th June 1860, (lot 1056), bought by the British Museum.
REFERENCES: Popham, 1946, pp.28-30; Popham and Pouncey, 1950, p.60, no.100; Clark, 1967, pp.30-33; Gould, 1975 (1), pp.36-41; Kemp, 1981, pp.53-57.

London, The Trustees of the British Museum
(Acc. no. 1860-6-16-100)

Both technical and stylistic evidence points to a date of *c*.1507 for the *Madonna of the Pinks*. The only other Madonna by Raphael which shares the same facial type appears in the equally diminutive *Holy Family with a Lamb* in Madrid, which is dated 1507, and the x-radiographs of these two works are similar in character.[6] Despite the difference in scale, each of them also has features in common with the *Canigiani Holy Family* (fig. 72), probably largely executed in the same year.

The exquisite, miniaturistic execution of the Alnwick panel is typical of a category of small-scale pictures which Raphael produced throughout his career.[7] Such works seem to have been particularly highly prized at the court of Urbino and had the great attraction of being easily portable. In a letter of 1508 to his uncle in Urbino, Raphael refers to a cover he is painting for a Madonna he had already delivered to the Prefettessa, Giovanna Feltria della Rovere, no doubt to protect it when it was being carried around.[8] Surviving examples of such picture covers attributed to Raphael are in the Uffizi and in the Louvre,[9] the latter probably executed by his pupil Giulio Romano.

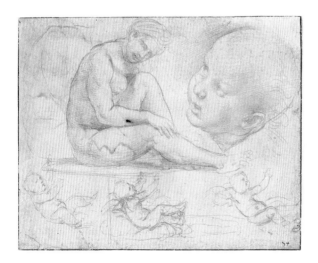

fig. 43 Raphael *A Seated Nude Woman and Sketches of an Infant* (Cleveland, Museum of Art, J. H. Wade Fund)

The verso of this sheet is exhibited here because the main sketch is a study for Leonardo's *Benois Madonna* in the Hermitage (fig. 42), the source for Raphael's *Madonna of the Pinks* (cat. no. 16). Leonardo's Madonna has usually been regarded as one of two 'Virgin Marys' mentioned in a note dated 1478 on a drawing by him in the Uffizi, although some scholars have questioned this connection.[1] The painting and the study for it must in any case date from before Leonardo's departure from Florence to work at the Milanese court in 1482.

The larger sketch on the verso of this sheet, surrounded by an arched frame, shows the Virgin full-length rather than knee-length as she appears in the painting, but it otherwise corresponds closely to the panel. The second pen study on this side is a variant of the first, while the metalpoint sketch below has been related to a more problematic Leonardesque picture, the *Madonna Litta*, also in the Hermitage. The main study on the recto is also probably connected with the *Benois Madonna*, and shows an alternative arrangement of the two figures, viewed from a different angle and with the Virgin's arm outstretched. The remaining sketches of profiles and contraptions are characteristic Leonardo doodles.

The *Benois Madonna* is by no means the only composition by Leonardo that Raphael studied carefully. Works from his Florentine years are marked by a consistent stream of references to the older artist's paintings and cartoons, and technical and stylistic evidence makes it highly likely that Raphael had access to drawings by him.[2] Leonardo returned to Florence after an eighteen year absence in 1500 and remained until 1506, and during the year or so that he and Raphael coincided there it is probable that the two artists became acquainted, although Vasari does not tell us as much. This is the simplest explanation for Raphael's direct knowledge of Leonardo's drawing style.

While less exciting and exploratory than Leonardo's roughly contemporary studies for a composition of a *Virgin and Child with a Cat*[3] – the contours are, in fact, untypically hesitant and broken for him – this informal sheet of sketches, including (on the recto) numerous pentimenti, has many qualities that Raphael would have found instructive. It is likely to have been from sheets such as this that Raphael learnt the technique of reinforcing metalpoint studies with pen and ink[4] (see cat. no. 21).

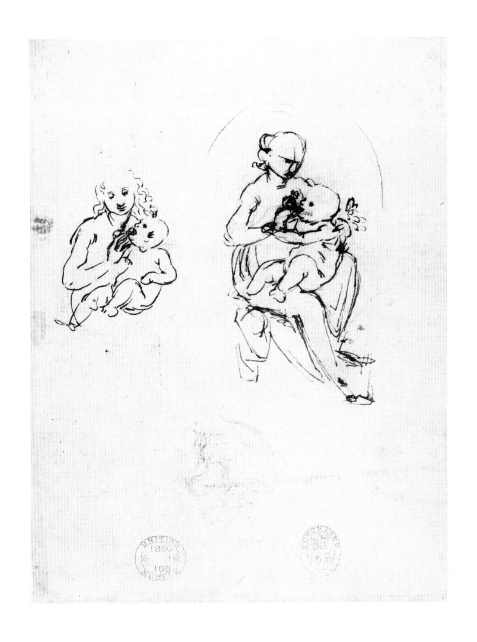

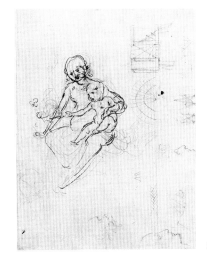

recto

18 The 'Bridgewater Madonna'

Oil on canvas, transferred from panel; 82 × 57 cm.
PROVENANCE: Jean Baptiste Colbert, Marquis de Seignelay, Paris, by 1685;[1] Laurent le Tessier de Montarcy; André Rondé; Louis, Duc d'Orléans, by 1727; by descent to Louis Philippe Joseph, Duc d'Orléans (Philippe Égalité), by whom sold in 1791 to Viscount Walchiers, Brussels; François de Laborde de Méréville; Sale, Bryan's Gallery, London, 1798 (lot 64), reserved for the 3rd Duke of Bridgewater; thence by descent.
REFERENCES: Crozat, 1729, I, p.10; Passavant, 1860, I, p.152, II, pp.119-20; Crowe and Cavalcaselle, 1882-85, I, pp.345-49; Pouncey and Gere, 1962, pp.15-17; Pope-Hennessy, 1970, pp.188-90; Dussler, 1971, p.23; Oberhuber, 1982, pp.42-44, 48; Jones and Penny, 1983, pp.33-36; Cordellier and Py, 1992, pp.84-85; Brigstocke, 1993, pp.129-33.

Edinburgh, National Gallery of Scotland
(Duke of Sutherland loan, 1945)

The *Bridgewater Madonna* is in many respects the culmination of Raphael's Florentine Madonna and Child compositions. Its genesis as it can be traced in preparatory drawings was evidently more protracted and more complex than that of any other small painting by him. Although some features of the picture can be shown to derive from Michelangelo and Leonardo, they are so fully subsumed into the overall harmony of the composition as to be scarcely detectable. There is a sense of naturalness, almost inevitability, about the compositional balance achieved here which completely belies the care and planning which brought it about. As one well-known art historian put it: *Raphael's greatest paintings seem so effortless that one does not usually connect them with the idea of hard and relentless work.*[2] This sense is combined in the *Bridgewater Madonna* with the most moving portrayal of maternal love and tenderness.

Paradoxically, this is at the same time one of Raphael's most animated Virgin and Child compositions. This is due principally to the dynamic twisting pose of Christ, which can be traced back ultimately to Michelangelo's *Taddei Tondo* (fig. 45). The sense of movement is enhanced by the restless interplay of the diagonal and curved forms which articulate the design, to which the arched alcove in the background and the ellipses of the haloes (that of Christ now scarcely visible) contribute.

The overall arrangement, with a knee-length Virgin seated at an angle to the picture plane, is adapted from Leonardo's early *Benois Madonna* (fig. 42). The Virgin here has a more graceful, serpentine pose, generated by the contrapposto set of her head in relation to her shoulders, a trick also learnt from Leonardo, although from his more mature works.[3] Her drapery, especially the blue mantle, has a thick velvety texture very different from the *Madonna of the Pinks* (cat. no. 16). Christ's unusually large body stretches diagonally across his mother's lap, spanning the width of the composition. It would have been even more elongated were it not for the foreshortening of the legs. The deep blue curtain which serves as a foil in the left background of the *Bridgewater Madonna* has further darkened with time to the point where it is almost invisible. It would once have played a more active role in the limited but very rich colour harmonies so successfully retrieved by the recent cleaning of the picture.

Technical examination has established that there was once a view through what is now the blind arch at upper right into a landscape – a device borrowed again from the *Benois Madonna* – but that Raphael himself chose to paint this out. Initially the whole background may have been envisaged as a landscape (see John Dick's essay). A similar change affected a slightly earlier picture by Raphael, the *Madonna del Granduca* in the Palazzo Pitti in Florence.[4] In both cases the alteration removed a possible source of distraction for the eye, and forces the viewer's attention to focus on the figures. Raphael may also have felt that the geometry of an architetural setting would more effectively contain the dynamism of the figure group. The principal lines of the interior are incised into the underlying layers using stylus, ruler and compass (visible in raking light and in the x-radiograph). As one would expect, the contours of the figures must have been more or less fixed at this stage, since hardly anywhere do the incised lines invade them. Quite what the brown form at top right is meant to represent is ambiguous, and may have been left unresolved. Raphael was perhaps mainly concerned that it should echo the shape of the niche next to it and the colour of the ledge at lower left.[5]

It comes as some surprise to discover how little of Christ's body actually rests on, and is supported by, that of his mother. He is portrayed in mid-twist, his left arm and leg moving freely in an instantaneous and unsustainable pose. He clutches the Virgin's veil for balance, a prop Raphael had already found useful in the *Holy Family with a Palm Tree* (cat. no. 5). It is using purely visual devices such as the Virgin's parallel hands which frame Christ's torso that Raphael stabilises his pose. This arrangement does not appear in the most advanced of the preparatory drawings (cat. nos. 20-21), where the child is given much more in the way of physical support, and therefore must have been a late and deliberate change on Raphael's part. Christ's poignant gaze into his mother's eyes intimates some knowledge of his destiny, and it has been suggested that his agitated pose might be explained by his having just woken from a dream about the Passion.[6] Similar though

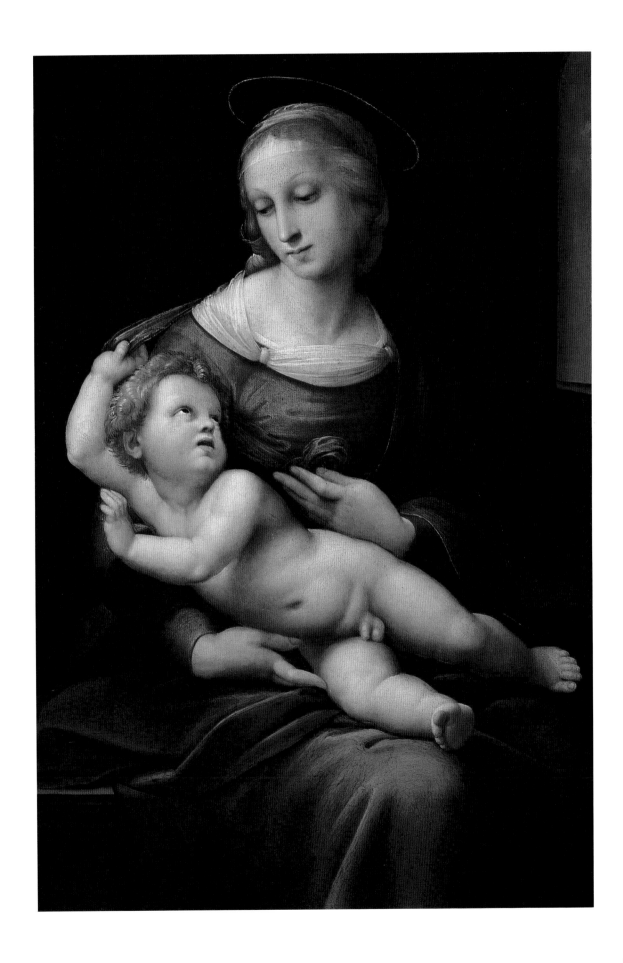

usually more explicit omens appear elsewhere in Raphael's representations of the Infant Christ (see cat. no. 4).

Writers on Raphael have consistently disagreed about the date of the *Bridgewater Madonna*. Opinions have ranged from 1506-7[7] to 1512,[8] a wide span in the context of Raphael's rapid development. Some have suggested that the painting was begun in Florence and completed later in Rome.[9] Purely stylistic considerations aside, the evidence hinges largely on the related drawings. The problem here involves separating those which are truly preparatory from those which are later reworkings of the theme, and this was a picture from which Raphael continued to draw ideas until the end of his career.[10] Some drawings once associated with the *Bridgewater Madonna* are now more correctly linked with the later *Madonna di Loreto* now at Chantilly (fig. 47), which despite the markedly different end result seems in some respects to have evolved directly out of the *Bridgewater Madonna*. One particluarly problematic sheet in the Uffizi (fig. 44) includes a reversed variant of the compostion which was long regarded as a preparatory study for it, but is now widely accepted as a slightly later development.[11] One of the studies on the verso is related to Raphael's first Roman project, the *Disputà* fresco in the Stanza della Segnatura of the Vatican.

However, almost all of the most recent Raphael publications have agreed in placing the *Bridgewater Madonna* in his last Florentine years, and support for this is supplied by a drawing in the Uffizi by Raphael's friend Fra Bartolommeo (fig. 11).[12] The Christ Child in this study has already been linked to the *Madonna of the Pinks* (cat. no. 16). The Virgin's pose repeats that of the *Bridgewater Madonna* which must, therefore, have been largely if not wholly complete before Raphael left Florence. Fra Bartolommeo's drawing was first used by his partner Mariotto Albertinelli for a composition dated 1509. A dating of the *Bridgewater Madonna* to 1507-8 seems on balance the most convincing. The picture with which it has most in common stylistically is the *St. Catherine* in the National Gallery, London, which is also dated to these years.[13]

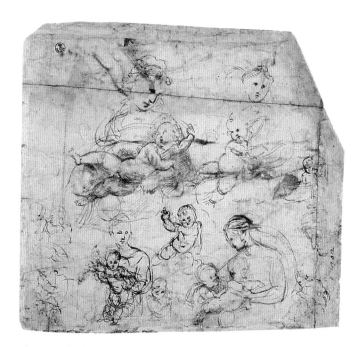

fig. 44 Raphael *Studies of the Virgin and Child*
(Florence, Uffizi)

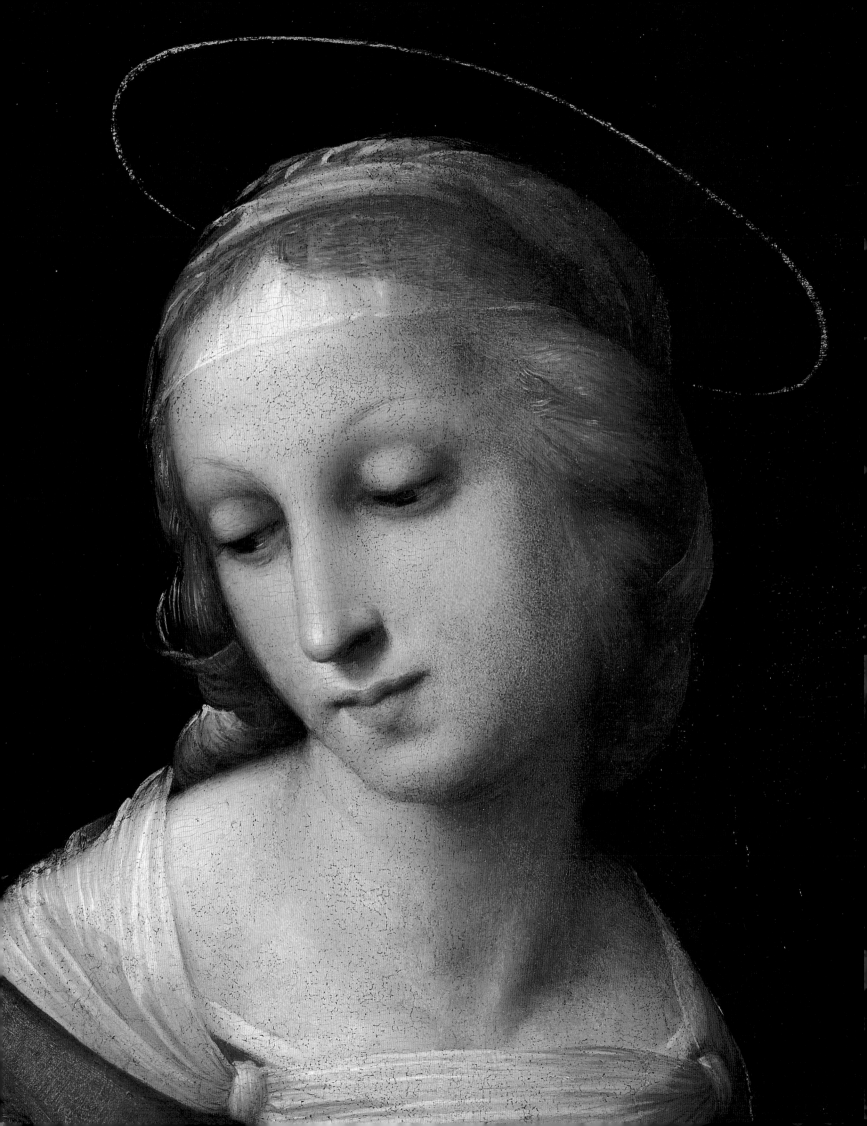

19 A Battle of Nude Men ('The Siege of Perugia') [recto] Two Studies of the Virgin and Child [verso]

Pen and brown ink with traces of stylus, the framing lines on the verso in black chalk; the paper stained, damaged and repaired in places, especially at the edges; 26.7 × 40.5 cm.

INSCRIPTIONS: The words PERVSIA AVGVST... are written in ink on the building in the background of the recto.

PROVENANCE: Charles Pierre J.-B. Bourgevin Vialart de Saint Morys, by 1783; claimed for the nation in 1793.

REFERENCES: Passavant, 1860, II, p.467, no.327; Paris, 1983 (1), pp.202-04, nos.36-37; Joannides, 1983, no.93; Knab, Mitsch, Oberhuber, and Ferino Pagden, 1983, nos.133-34; Rome, 1992, pp.80-85; Cordellier and Py, 1992, pp.45-48, nos.34 and 37.

Paris, Musée du Louvre, Département des Arts Graphiques (Inv. no. 3856)

The less elaborate verso of this drawing is exhibited here because of its connections with the evolution of the *Bridgewater Madonna* composition. The group at the right of the sheet, with the Virgin in strict profile and a lively Christ Child straddling her knee, is closely related to Michelangelo's marble relief known as the *Taddei Tondo* (fig.45), now owned by the Royal Academy in London, although it is not an exact copy from it.[1] The relief was one of several sculptures which Michelangelo was carving more or less simultaneously around the time Raphael arrived in Florence late in 1504, having just completed the *David* (see also cat. nos. 4 and 15). Although probably not finished, Michelangelo gave or sold the tondo to Taddeo Taddei, in whose home Raphael would certainly have had many opportunities to study it.[2]

In common with many other 'copies' by Raphael (see cat. no. 15), the artist has here made some significant alterations to his model. The addition of the Virgin's right arm, which is scarcely hinted at in the sculpture, is an understandable completion on Raphael's part. The puzzling, looping drapery may represent a veil wrapped round her arm. There is an implied criticism, however, in his correction of Christ's left arm, which in the relief lies limp and somewhat detached from his body. Raphael's Christ is altogether more lively and alert, and the change in his glance indicates that the artist may already have been contemplating here a two-figure composition. While the Virgin's profile was soon abandoned, the pose of Christ with splayed legs and raised arm was explored in other drawings associated with the *Bridgewater Madonna* (see following two entries) and was incorporated, in reverse and with some refinements, into the final picture.

The adaptations of the source evident in this drawing and in other so-called copies raise some interesting questions as to Raphael's method. It is tempting to suggest that he was copying from a lost model for the tondo rather than from the original, although this unnecessarily complicates the issue. He may instinctively have modified other works as he copied them, in accordance with his own stylistic preferences or in search of a solution to a specific problem. Or he may have made the copies from memory rather than in front of the object.

A larger and more loosely handled version of this drawing is on the verso of cat. no. 2. It is marginally more faithful to Michelangelo's original and may therefore have preceded the present study.

The other Virgin and Child on this sheet, viewed frontally, has no direct connection with any painted Madonna by Raphael, although a closely related group appears in a contemporary drawing in Vienna.[3] It is unclear why the two groups should have been enclosed in a rectangle together, since they were patently not intended to form part of a unified composition. The framing lines might be a later addition.

The *Battle of Nude Men* on the recto of this sheet is usually linked on account of the inscription with the bloody factional power struggle taking place in Perugia in the early years of the 16th century, although its precise subject remains enigmatic. The main adversaries in the battles were the Baglioni and the degli Oddi families, both of whom were patrons of Raphael (see cat. no. 67). The drawing is an early instance of Raphael's interest in the male nude in combat, a theme popularised in Florence by the Pollaiolo brothers, and one he was to explore more fully a year or two later. A related study for the three soldiers at the foot of the ladder is in Vienna.[4]

The sheet is unanimously dated very early in Raphael's Florentine period. The handling of the pen on the verso is close to cat. nos. 1 and 2, also datable to about 1505.

fig. 45 Michelangelo *The 'Taddei Tondo'* (London, Royal Academy of Arts)

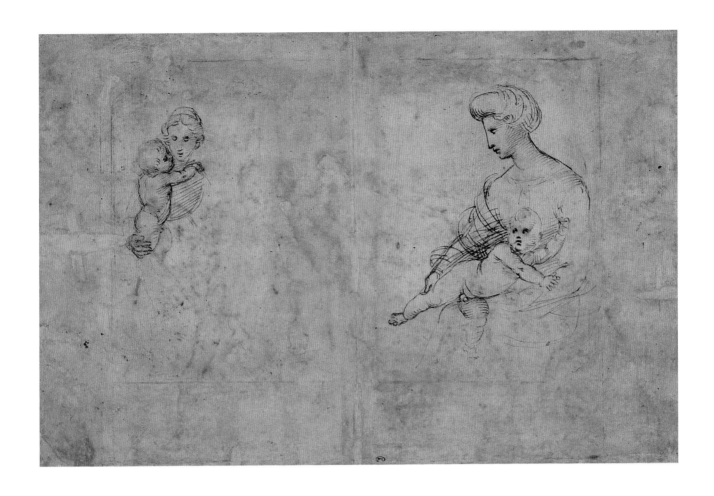

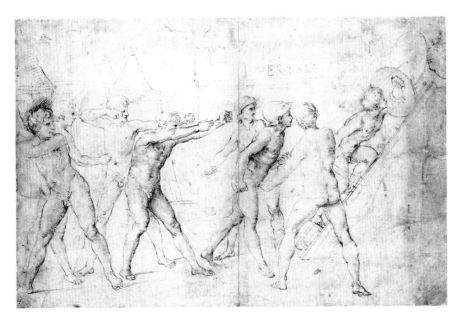

recto

20 *A Sheet of Studies of the Virgin and Child*

Pen and brown ink with faint traces of red chalk; 25.4 × 18.4 cm.
INSCRIPTIONS: *Pond's Sale 1759*, on the verso.
PROVENANCE: Arthur Pond; his sale, Langford, London, 2nd May 1759, probably lot
77; Rev. C. M. Cracherode (L. 606 and date *1786* on verso); his Bequest to the British
Museum, 1799.
REFERENCES: Crowe and Cavalcaselle, 1882-85, I, pp. 272 n. and 347; Fischel, 1922,
III, no.109; Pouncey and Gere, 1962, pp. 15-17, no.19; Pope-Hennessy, 1970, pp.175-
77; Joannides, 1983, p.70 and no.180; Knab, Mitsch, Oberhuber and Ferino Pagden,
1983, no.161; London, 1983, pp.107-08, no.84; Jones and Penny, 1983, p.29; Ames-
Lewis, 1986, pp.62-65; New York, 1987, no.12.

London, The Trustees of the British Museum
(Acc. no. Ff 1-36)

This very vital sheet of studies is justly one of Raphael's best
known pen drawings. In a matter of perhaps half an hour of
concentrated creativity, he has jotted down in rapid succession
ideas for at least four Madonna groups. That the Christ Child has
such an active pose in the two largest of these may itself have
stimulated the frenzy of exploratory pen lines. Raphael could only
have learnt this method of *pentimento* drawing (with many
corrections and alterations) from Leonardo, and particularly from
early sheets by him such as the studies for an unexecuted *Virgin and
Child with a Cat* (see also cat. no. 17).[1] With so many simultaneously
generated ideas on a single sheet, and many more in a closely
related drawing from Vienna (see following entry), the futility of
attempts to establish a rigid chronological sequence for Raphael's
Florentine Madonnas becomes obvious. Apart from the largest
study, which is clearly related to the *Bridgewater Madonna*, ideas
explored here can be linked with Raphael's *Colonna Madonna* in
Berlin (centre right),[2] the *Tempi Madonna* in Munich (top centre,
reversed)[3] and possibly the *Small Cowper Madonna* in Washington
(top left, reversed).[4]

The Infant Christ in the study for the *Bridgewater Madonna* has
clearly evolved from Raphael's interpretation of the *Taddei Tondo*
(see previous entry). His pose is reversed and he now gazes back
over his left shoulder into his mother's eyes as he does in the
picture. This is the one feature of the composition about which
Raphael seems to have had no hesitations. With the important
exception of the placement of her arms, the Virgin's pose is more
or less finalised. To judge from the nest of *pentimenti*, the position
of Christ's lower left leg and its relation to the Virgin's hand above
caused particular difficulty. The child is firmly supported by his
mother's right arm and knee, in contrast to the looser arrange-
ment in the final painting.

It has been argued that sheets of studies such as this and the
verso of the following one from Vienna are not strictly speaking
preparatory, in the sense that when he drew them Raphael did not
necessarily have a finished painting in mind.[5] This may be true for
some of the sketches, but not for those relating to the *Bridgewater
Madonna*, whose step-by-step evolution can be traced over several

sheets and into the painting itself. The fertility of invention
displayed here explains how Raphael managed to create a succes-
sion of painted Madonnas which never repeat each other, and each
of which has distinct and individual features. It was his studious
avoidance of repetition and consequent pursuit of *varietà* and
originality which led to some of his most daring and surprising
inventions, including the *Orléans Madonna* (fig. 46), the *Bridgewater
Madonna* itself, and the *Madonna di Loreto* (fig. 47). Raphael's experi-
mental approach may have been partly a reaction to his early
experience in Pietro Perugino's studio, where working practice was
somewhat repetitive and formulaic.[6] By the end of his Florentine
period Raphael may have felt that he had largely exhausted the
possibilities of two-figure Madonna compositions, since he
thereafter usually tackled three or more figures. The only excep-
tion seems to have been the *Mackintosh Madonna* (see cat. no. 28).

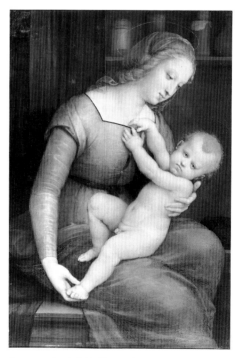

fig. 46 Raphael *The 'Orléans Madonna'* (Chantilly, Musée Condé)

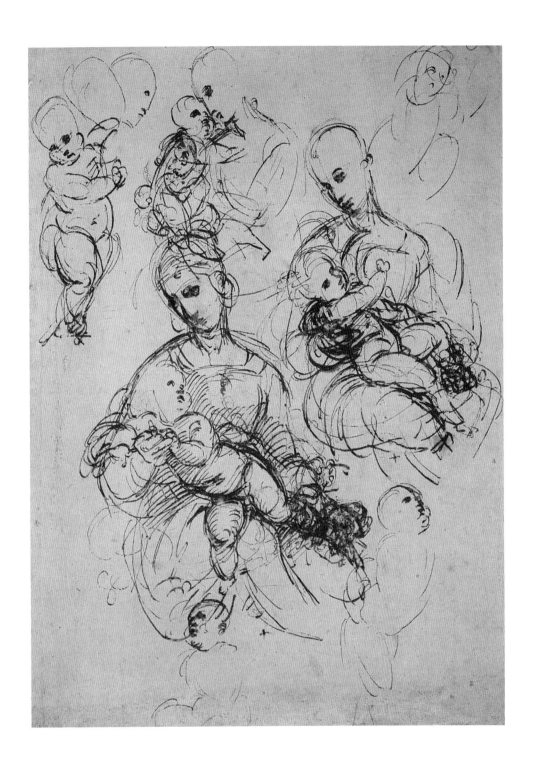

21 *Study of the Virgin and Child* [recto]
Sheet of Studies of the Virgin and Child [verso]

Pen and brown ink over silverpoint on pale pinkish-orange prepared paper, the lower left corner made up (recto); pen and brown ink and red chalk (verso); 25.5 × 18.8 cm.
PROVENANCE: Viti-Antaldi (L. 2245); Pierre Crozat; Marquis de Gouvernet; Julien de Parme; Prince de Ligne; Albert von Sachsen-Teschen (L. 174).
REFERENCES: Passavant, 1860, II, p.435, no.191; Crowe and Cavalcaselle, 1882-85, I, p.347; Fischel, 1922, III, no.10; Paris, 1975, p.72, no.28; Vienna, 1983, pp.46-51, nos.11-12; Joannides, 1983, no.181; Knab, Mitsch, Oberhuber and Ferino Pagden, 1983, nos.162-63; Ames-Lewis, 1986, pp.63-64; Stockholm, 1992, p.40, no.24; Birke and Kertész, 1992, pp.121-22.

Vienna, Graphische Sammlung Albertina (Inv. no. 209)

The large study on the recto is the most advanced of the surviving studies for the *Bridgewater Madonna* and is developed directly from the British Museum sketch (cat. no. 15).[1] Raphael's main focus is again on the child. The Virgin's shoulders and torso are only lightly indicated and lack animation in comparison with the British Museum study. The main changes between the two affect the arms and hands of both figures. The upward pointing arm of Christ which featured in the adaptation of the *Taddei Tondo* (cat. no. 19) is reintroduced here. The Virgin's left hand has moved across to rest on Christ's hip, and the observation that it may grip the end of a summarily indicated veil passing under Christ's left arm is supported by the break in the reinforcing pen and ink contours at that point. Raphael probably learnt this method of clarifying the preferred solution among numerous possibilities from Leonardo (see cat. no. 17). Seldom had silverpoint been used so freely and for such exploratory purposes as here. Some horizontal framing lines at the bottom of the sheet cut the composition at approximately the same level as in the painting.

The verso of the sheet is also closely related to the British Museum drawing (although they never formed part of one and the same sheet as has been claimed), and has the added colouristic interest of combining red chalk and pen and ink studies on the same page. Raphael had only occasionally used red chalk before, and the switch in media may reflect his discomfort with it for this type of drawing. Two of the studies from the earlier sheet, those reminiscent of the *Colonna* and *Tempi Madonnas*, are repeated here in the different medium (top left and top centre respectively). A larger red chalk sketch of the child in the latter appears in the centre of the sheet. The pen sketch at centre right has been connected with the *Madonna of the Pinks* (cat. no. 16),[2] an idea supported by the indication of a spray of flowers in the Virgin's left hand (compare cat. no. 17), but undermined by the fact that Christ appears to be suckling. The group in the lower right corner is sometimes linked to the *Holy Family with a Palm Tree* (cat. no. 5), but the sketch is conceived as a two-figure composition and Christ holds what appears to be a yarn-winder. The pose of the child in the Sutherland painting may nevertheless have been

borrowed from here. A variant of his pose in red chalk appears further up on the page, just below the sketch at top centre. Finally, the group at lower left resembles in many respects the *Orléans Madonna* (fig. 46) at Chantilly, while that directly above it was used for the *Large Cowper Madonna* now in Washington.[3] All these pictures are datable to the latter part of Raphael's Florentine period, which argues for a dating of both this drawing and that in the British Museum to 1506-7.

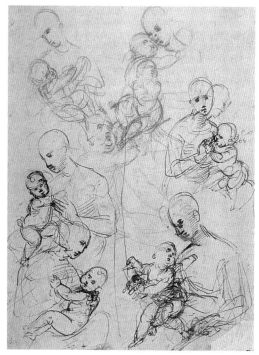

verso

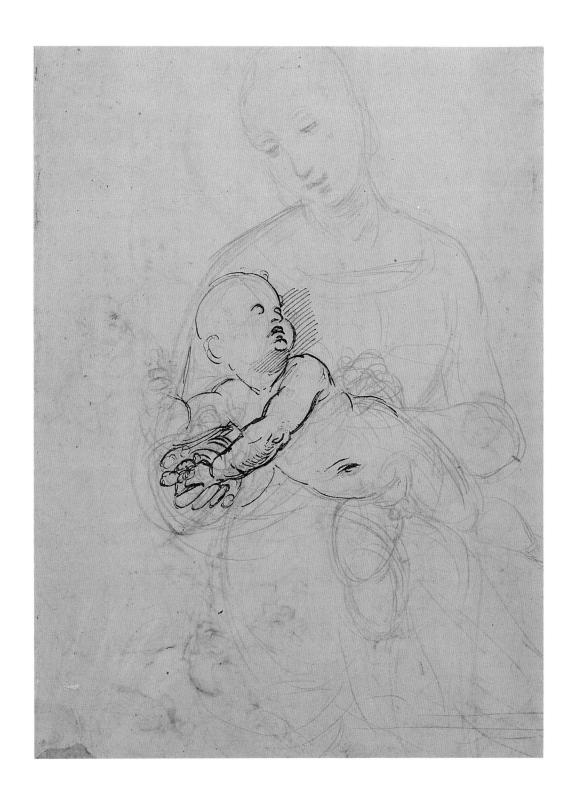

22 Studies for an Infant Christ

Silverpoint on pink prepared paper, the framing lines in pen and ink;
16.8 × 11.9 cm.
INSCRIPTIONS: Numbered 22 at top centre and 81 at top right.
PROVENANCE: W. Y. Ottley; his sale, London, T. Philipe's, 21st June 1814, lot 1594;
Richard Payne Knight; his Bequest to the British Museum, 1824.
REFERENCES: Passavant, 1860, II, p.495, no.445; Crowe and Cavalcaselle, 1882-85, II,
p.110; Fischel, 1939, p.187; Pouncey and Gere, 1962, pp.19-20, no.23; London, 1983,
p.143, no.116; Joannides, 1983, no.271; Knab, Mitsch, Oberhuber and Ferino
Pagden, 1983, no.415; Ames-Lewis, 1986, p.17; Brigstocke, 1993, p.130.

London, The Trustees of the British Museum
(Acc. no. Pp. 1-72)

In terms of technique, subject matter and date, this drawing is
closely associated with seven others (including cat. no. 23). It has
been argued that they once formed part of a sketchbook ('The
Pink Sketchbook'), which is quite possible, even if the initial
reasons advanced for grouping them in this way were suspect.[1]
Although certainly very lively, the idea that they were drawn from
a living child seems impractical.

These sketches are associated in the Raphael literature with
either the *Bridgewater Madonna* (cat. no. 18) or the *Madonna di Loreto*
(fig. 47), or with both. The two paintings are related thematically,
although they were probably painted two or three years apart.[2]

The evidence of the present drawing and of the following one
suggests that Raphael's conception of the Christ Child in the later
picture grew directly out of the earlier one. As a development of
his wriggling pose in the *Bridgewater Madonna*, Christ has managed
to detach himself completely from his mother in the *Madonna di
Loreto*. It is this physical independence which may have induced
Raphael to study the child separately from his mother in the
drawings: he almost always treated his Virgin and Child groups as
an organic whole. Furthermore, the infant in all these sketches is
reclining on a flat surface, not on a lap, and is propped up on a
pillow as Christ is in the Chantilly painting.

The sketch which corresponds most closely to the *Bridgewater
Madonna* is just below the centre of the sheet. In the remaining
studies, and in most of those on the Lille sheet (not to mention
three more in fig. 43), we witness Raphael progressively twisting
the pose round in his imagination until Christ is eventually, at the
top of the Lille drawing, lying on his back waving his arms in the
air. Final adjustments were made in a more highly finished study
on another sheet in this group, also in Lille, which corresponds
exactly with the painted figure.[3]

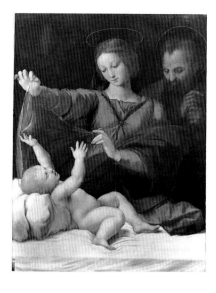

fig. 47
Raphael *The 'Madonna di Loreto'*
(Chantilly, Musée Condé)

23 *Studies for an Infant Christ and a Lunette with Two Figures*

Silverpoint on pink prepared paper; 16.7 × 11.8 cm.
PROVENANCE: Jean-Baptiste Wicar; A. Fedi; Jean-Baptiste Wicar; his Bequest to the
city of Lille, 1834.
REFERENCES: Passavant, 1860, II, p.483, no.380; Crowe and Cavalcaselle, 1882-85, II,
pp.109-10; Fischel, 1939, p.187; Pouncey and Gere, 1962, p.20; Chantilly, 1979,
pp.22-23; Paris, 1983 (1), p.278, no.96; Jones and Penny, 1983, p. 88; Joannides, 1983,
no.272; Knab, Mitsch, Oberhuber and Ferino Pagden, 1983, no.416; Brigstocke,
1993, p.130.

Lille, Musée des Beaux-Arts (Inv. no. Pl. 438)

The studies of the child are related to the Infant Christ in the
Madonna di Loreto (fig. 47). Like the British Museum sheet, the
lowest sketch in this drawing has also in the past been related to
the *Bridgewater Madonna*, and the two paintings were thought to
have evolved simultaneously.

The sketch of the lunette with a spandrel above it is not
related to any executed project by Raphael, although an echo of
Michelangelo's lunettes in the Sistine Chapel, with their paired
figures, can be detected. Tentative links with either the *Loggia di
Galatea* in the Villa Farnesina, or with the Cappella Chigi in Santa
Maria del Popolo, have been suggested.[1]

JEAN BOULANGER (OR BOULLANGER)[1]
1607/13–1680

24 The 'Bridgewater Madonna' (after Raphael)

Engraving, in reverse; 43.2 × 31.1 cm.
INSCRIPTIONS: On the ledge at lower right: *De Poilly ex. C.P.R.* In the lower margin: *Raph. Urbin.o in. De Poilly ex. CPR. Rue St. Jacques al' Image St. Benoist./ JBoulanger Sculps.* (the J and the B in monogram)/ *Dilectus meus mihi, et ego illi. Cant 2.0.*
PROVENANCE: Rev. C. M. Cracherode; his Bequest to the British Museum, 1799.
REFERENCES: Nagler, 1835-52, XVI, p.394, no.397; Rome, 1985, p.186, no.11; Brigstocke, 1993, p.131, n.3.

London, The Trustees of the British Museum
(Acc. no. V4 – 88)

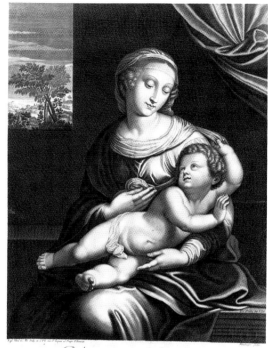

Dilectus meus mihi, et ego illi ...

The quotation ('My beloved is mine and I am his') is from the Song of Solomon (see cat. no. 9). The same line was used for the legend of a 17th century French print by Jean Couvay after the *Madonna of the Pinks.*[2]

The inclusion of a landscape background in this engraving, the earliest reproductive print after the painting, helped to foster the idea that the landscape once planned for the *Bridgewater Madonna* (as revealed by x-rays) had been painted out by a 17th century hand rather than by Raphael himself. The curtain in Boulanger's print also differs from that in the picture, and Christ's genitals are now prudishly masked by an extension of the veil. In making these changes the engraver was probably exercising artistic licence, perhaps because the background of the painting was already by that date difficult to make out (but see cat. nos. 25-27, which reproduce it accurately). Alternatively, he may have been working from a later variant of the picture rather than from Raphael's original.[3] The engraving in turn spawned a number of painted versions, mainly French, which feature a landscape.[4]

Boulanger was one of the pioneers of a technique of engraving using dots and flecks of the burin (the main engravers' tool) to produce effects which anticipate those of stipple, developed a century later.

NICOLAS IV DE LARMESSIN
1684–1756

25 The 'Bridgewater Madonna' (after Raphael)

Engraving, in reverse; 31.5 × 22.2 cm.
INSCRIPTIONS: *La Sainte Vierge/ D'après le Tableau de Raphael qui est dans le Cabinet de Mgn.r le Duc d'Orléans/ haut de 28. pouces. peint sur bois, gravé par Nicolas de Larmessin./ 21.*
REFERENCES: Brigstocke, 1993, p.131.

Edinburgh, National Gallery of Scotland (Acc. no. P2880)

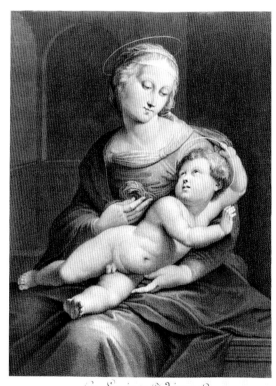

La Sainte Vierge
D'après le Tableau de Raphael qui est dans le Cabinet de Mgn.r le Duc d'Orléans. haut de 28. pouces. larg. de 22. pouces. peint sur bois, gravé par Nicolas de Larmessin.

This engraving was Plate 21 in Crozat's first volume of prints after the most beautiful paintings in France, which included all three of the Sutherland Raphaels.

ANTOINE LOUIS ROMANET
ABOUT 1742–1810

26 *The 'Bridgewater Madonna' (after Raphael)*

Engraving, in reverse; 41.5 × 28.6 cm.
INSCRIPTIONS: *Peint par Raphaël Sanzio d'Urbin/Dessiné par Vendenberg/Gravé par A. Romanet./*LA VIERGE ET L'ENFANT JESUS: *De la Galerie de s.a.s. Monseigneur Le Duc d'Orléans/*ÉCOLE ROMAINE./VI*e* TABLEAU DE RAPHAEL SANZIO D'URBIN./*Peint sur Bois, ayant de hauteur 2 Pieds 4 Pouces, sur 1 Pied 6 Pouces de large./Ce tableau est très bien conservé et se fait remarquer, nonseulement par la pureté et le grand caractère de Dessin, mais encore par la fraicheur du Coloris et le beau Pinceau. La S.te Vierge tient l'Enfant Jesus sur ses genoux et le regarde avec tendresse. La Noblesse, la Candeur et la Sainteté sont exprimées d'une manière sublime dans les traits de cette chaste Mère. Ce beau Tableau a passé du Cabinet du M.r De Seigneley dans celuy de M.r de Montarsis et dans celuy de M.r Rondé Joaillier du Roi, de qui feu S. A. R. M.gr Le Duc d'Orléans Regent l'avoit acheté./Gal. Palais Royal.*

London, The Trustees of the British Museum
(Acc. no. 1855-6-9-277)

This engraving is a plate from the *Galerie du Palais Royal gravée*, Paris, 1786 (see also cat. nos. 11 and 40).

The credit given to Vendenberg would have been for making an accurate drawn copy of the painting, which then served as the model for the engraver. We learn from the caption that at this date the painting was still on its original panel and in very good condition. We can only lament that within a few years the decision was taken to transfer it to canvas, a procedure then considered to be in the best interests of paintings on panel, but one which probably caused some damage to the paint surface.

CONSTANT LORICHON
BORN 1800

27 *The 'Bridgewater Madonna' (after Raphael)*

Engraving; 46 × 33.5 cm.
INSCRIPTIONS: RAPHAEL PINXIT/ LORICHON SCULPSIT/ VIERGE DU PALAIS DE BRIDGE-WATER/ D'APRÈS LE TABLEAU ORIGINAL EXPOSÉ, JADIS DANS LA GALERIE DU PALAIS ROYAL, MAINTENANT À LONDRES DANS CELLE DU MARQUIS DE STAFFORD/ *Déposé à la Direction et Publié à Paris, en 1832, chez l'Auteur, Quai de l'Horloge, 55.*

London, The Trustees of the Victoria and Albert Museum
(Acc. no. 21489)

This engraving was made when all three Sutherland Raphael's were in the collection of the Marquis of Stafford, on display and accessible to the public at Bridgewater House in London. It testifies to the enduring popularity of the composition in France. In the same way that painted copies often, with time, reveal characteristics typical of the age in which they were made, this print has an unmistakably 19th-century flavour.

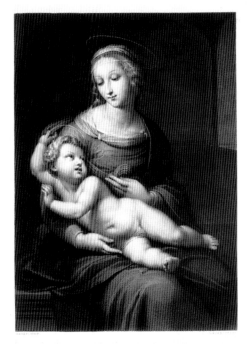



28 Cartoon for the 'Mackintosh Madonna'

Black chalk with white heightening, the outlines pricked and partly indented; the sheet consists of two pieces of paper joined horizontally, with a strip approximately 4.5 cm wide added at the left edge; the surface creased and rubbed; 71 × 53.5 cm.
PROVENANCE: G. B. Ceccomani, Perugia, by 1784; Charles Brocky (he acquired it from a gilder who had bought it at auction for £1); Colnaghi, London, 1842; W. Coningham; Sale: Christie's, 9th June 1849 (lot 19); Col. Stirling of Glentyan, London, by 1860; George Donaldson.
REFERENCES: Passavant, 1860, II, pp.120-21; Crowe and Cavalcasselle, 1882-85, II, pp.131-33; Pouncey and Gere, 1962, pp.22-23, no.26; Pope-Hennessy, 1970, pp.214-15; Gould, 1975 (2), p.219; London, 1983, p.145, no.119; Joannides, 1983, no.277; Knab, Mitsch, Oberhuber and Ferino Pagden, 1983, no.323.

London, Trustees of the British Museum (Acc. no. 1894-7-21-1)

The use of cartoons was an integral part of Raphael's working procedure, but unfortunately none of those relating to the pictures by Raphael exhibited here survives. The present drawing was made in connection with the *Mackintosh Madonna* (fig. 48), also known as the *Madonna of the Tower* or the *Rogers Madonna*, which is now in the National Gallery in London.[1] Reservations were already expressed about the picture's condition in the early 18th century, when it was in the Orléans collection together with the three Sutherland Raphaels (cat. nos. 5, 18 and 37). It was subsequently transferred from panel to canvas and it is now irretrievably damaged and largely repainted. It is likely, however, that the composition as we see it now records fairly accurately that of Raphael's picture, and this is supported by evidence furnished by this cartoon.

In the context of painting practice, a cartoon is a full-size preparatory drawing, the design of which can be directly transferred by a variety of means to the surface of the panel, canvas or wall to be painted. A commonly employed method was to perforate the principal contours of the drawing with a sharp point (known as 'pricking'), and then to force powdered chalk or charcoal through the holes ('pouncing'), thereby copying the basic design onto an underlying blank surface. Alternatively, the outlines could be incised with a sharp instrument and the image thus registered as indentations on the surface below. Or the back of the cartoon could be blackened with chalk, and the drawing on the front then gone over to transfer the design in a manner similar to carbon paper. Evidence of which method was used can sometimes be detected on the painted surface with the naked eye, but tends to be much clearer in x-radiographs or particularly using infra-red reflectography. Raphael appears to have been inconsistent and flexible in his precise method, and for some paintings seems to have dispensed with the cartoon stage altogether (see cat. nos. 16 and 53). In the case of the much-damaged *Mackintosh Madonna*, the cartoon for which is both pricked and partially indented, there is no longer any trace of *spolveri* (dotted pounce marks), indentation, or indeed underdrawing of any kind.[2]

Although still relatively few, a greater proportion of Raphael's cartoons have survived than for any other major 16th century Italian painter, among them the famous series of the *Acts of the Apostles* now in the Victoria and Albert Museum, and the cartoon for the *School of Athens* in the Stanza della Segnatura, the largest cartoon of any kind to survive from this period (it now belongs to the Biblioteca Ambrosiana in Milan). Since cartoons are of their nature functional, and more likely than not to be destroyed or badly damaged during use, we might infer that Raphael took special steps to preserve them. He certainly considered three cartoons of sufficient artistic worth to send them to the Duke of Ferrara as surrogates for a picture he did not have the time (or inclination) to paint, one of which he freely admitted was the work of an assistant.[3] One way of saving a cartoon which Raphael probably employed was not to use it directly, but to make a copy or 'substitute' cartoon from it by pricking the design through both the original and a second, blank sheet of paper.[4] The latter

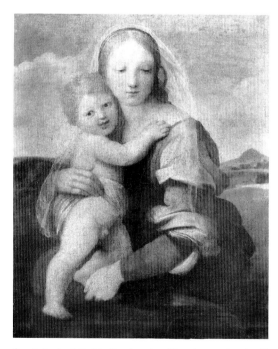

fig. 48 Raphael *The 'Mackintosh Madonna'* (London, National Gallery)

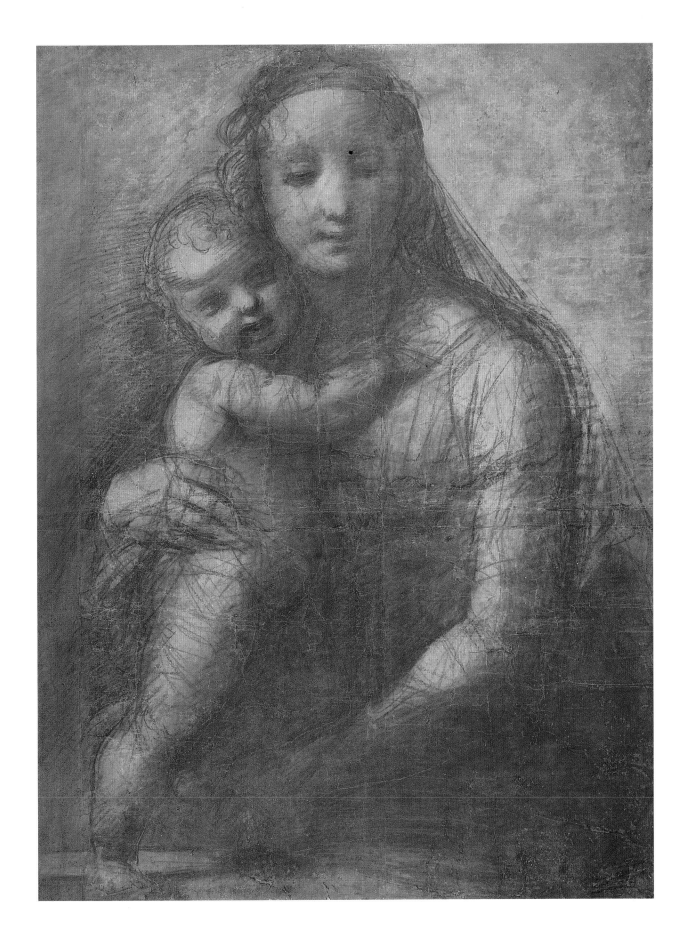

could then be used for the damaging process of transfer and the drawing itself be preserved intact.

One puzzling aspect of the present cartoon is that in precisely the area where it differs most from the painting, namely in the treatment of the Virgin's left sleeve, the pricked lines depart from the simple contours fixed in the drawing and match instead the more elaborate folds visible in the painting[5] (the pricking is difficult to detect in this cartoon under normal viewing conditions). This change was presumably studied in a separate drawing and pricked from this directly through the cartoon at the transfer stage. Raphael may have felt that further alterations added to an already densely worked cartoon would not have registered clearly. The position of the Virgin's veil has also been shifted in the painting relative to the drawing but – and irrespective of whether the present veil corresponds to Raphael's original – this detail would probably not have been transferred from the cartoon since Raphael would have painted it as a thin glaze over the underlying paint layers.

The composition of the *Mackintosh Madonna* is based closely, in reverse, on a glazed terracotta group of the *Virgin and Child in a Niche* by Luca della Robbia, which is known in two versions: the *Bliss Madonna* in the Metropolitan Museum of Art, New York (fig. 49), and the *Shaw Madonna* in the Museum of Fine Arts, Boston.[6] The placement of the Virgin's hands, one of which cups Christ's foot, is a particularly distinctive detail which Raphael derived from the earlier work. Raphael clearly admired Della Robbia's terracottas, since he had adapted their designs on other occasions (see cat. no. 8).[7]

Its poor state of preservation makes the painting difficult to date. The upright, frontal presentation of the Virgin (the one feature, incidentally, not borrowed from the Della Robbia relief) and the inclusion of the ledge parallel to the base of the picture lend to this half-length group a sense of simplicity and monumentality which has frequently been commented upon. It shares these characteristics with the Virgin and Child in the *Madonna of the Fish* of about 1513 (see following entry) and, if the 'restorer' of the National Gallery painting is to be relied upon, the facial type of the Virgin is similar in both. The cartoon has a mass of exploratory chalk lines with many pentimenti, and a tonal richness which is very different from the clarity of cartoons such as the *St. Catherine* of c.1507-8 in the Louvre,[8] a contrast which itself suggests that they were drawn some time apart. It is as if Raphael here condensed two stages of his usual preparatory procedure into one drawing, with much of the final resolution of the composition being worked out on the surface of the cartoon itself. Once the design had been transferred, the cartoon, in view of its strongly tonal character, may well have

been referred to again to help establish the system of *chiaroscuro* (light and shade) in the painting.

Other considerations suggest that the *Mackintosh Madonna* may have been painted a few years earlier than the *Madonna of the Fish*. The features of Christ in the cartoon are strikingly like those in the *Large Cowper Madonna* in Washington,[9] which is dated 1508, and also find close parallels in two drawings, one of them from the so-called pink sketchbook.[10] Furthermore, the smoky (*sfumato*) softness of the black chalk in the cartoon, which has probably been accentuated by subsequent rubbing, is similar to Fra Bartolommeo's handling of this medium,[11] an influence detectable in other drawings from Raphael's earliest years in Rome.[12] All things considered, the most convincing date for both the *Mackintosh Madonna* and its cartoon is about 1510.

fig. 49 Luca della Robbia *The 'Bliss Madonna'* (New York, Metropolitan Museum of Art, Bequest of Susan Dwight Bliss, 1966)

FERRÉOL (OR FÉRÉOL) BONNEMAISON
1766–1826

29 The 'Madonna of the Fish' (the Virgin and Child Enthroned with the Archangel Raphael and Tobias and St. Jerome), after Raphael

Oil on canvas; 216 × 160 cm.
PROVENANCE: Commissioned from Bonnemaison by the Duke of Wellington, and delivered in 1818; presented to the Wellington Museum, Apsley House, by the 8th Duke of Wellington in 1980.
REFERENCES: Bonnemaison COPY: Passavant, 1836, I, p.173; Sutton, 1973, pp.166-67; Kauffmann, 1982, pp.32-33, no.10. Raphael ORIGINAL: Vasari, ed. Milanesi, 1878-85, IV, p.348; Passavant, 1860, I, pp.190-92, II, pp.124-27; Crowe and Cavalcaselle, 1882-85, II, pp.222-26; Dussler, 1971, p.38; Pope-Hennessy, 1970, pp.216-18; Madrid, 1985, pp.14, 116-120, 138; Cordellier and Py, 1992, pp.196-97.

London, Apsley House, Wellington Museum, the Trustees of the Victoria and Albert Museum
(Acc. no. WM 3-1980).

It was not possible to borrow for this exhibition Raphael's *Madonna of the Fish* (*Madonna del pesce* or *del pez*) from Madrid (fig. 52), for which the National Gallery of Scotland's recently acquired drawing is preparatory (cat. no. 31), and this good quality and faithful copy is exhibited in its place. It is one of four full-size copies by Bonnemaison (all now at Apsley House) after altarpieces by Raphael from the Spanish royal collection which had been brought to Paris by Joseph Bonaparte in 1813 and placed in the Musée Napoléon. They were restored in Bonnemaison's studio in Paris before they were returned to Spain, and he enlisted the services of Monsieur Hacquin, the recognised expert in this field, to transfer them from their wooden panels to canvas.[1] Bonnemaison was a colourful figure in the Parisian art world of this period.[2] As a painter he specialised in portraiture, but he was also a restorer who in 1816 was appointed Director of restoration of paintings at the Musée Royal, and was very active as a picture dealer. He amassed in the process a very impressive private collection and on at least one occasion acted as an agent for the Duke of Wellington. One rather alarming anecdote concerning his cleaning of the Spanish Raphaels was circulated by Jacques Louis David, to the effect that Bonnemaison literally scrubbed their surfaces with a sponge dripping with potentially very damaging spirits of turpentine.[3] Bonnemaison nevertheless received the Cross of the Légion d'Honneur from Louis XVIII in December 1814 in recognition of his successful restoration of the Raphaels, and he subsequently published a series of reproductive engravings after them,[4] in addition to his painted copies. The duller colours of Raphael's original when compared to the copy may reflect the adverse long-term effects of this over-cleaning and of the transfer.

Raphael's panel was painted, probably about 1513, for the altar of the family chapel of Giovanni Battista del Doce (or del Duce) in the church of San Domenico in Naples. The side walls were occupied by marble monuments to Giovan Battista himself, who died in 1519, and to Rainaldo del Doce (the latter was moved to the north transept of the church in the 18th century when the del Doce chapel was refurbished). The del Doce were a noble family with a minor dukedom and numerous baronetcies to their name, spread throughout the kingdom of Naples.[5] The earliest mention of the altarpiece is in a letter of 1524 addressed to the Venetian Marcantonio Michiel, who was planning a book on the arts in Italy, where it is described simply as *the Angel and Tobias from the hand of Raphael of Urbino*.[6] In 1638 the picture was removed from the church, not without some scandal, by the Spanish viceroy, the Duke of Medina de las Torres, and by 1645 it had been given as a present to the art-loving Spanish king, Philip IV.

The del Doce chapel is in a desirable location as one of three flanking the Cappella del Crocifisso, which in turn opens off the south aisle of the church. As Vasari affirms, the Cappella del Crocifisso was of special importance to the Dominicans, for it housed the miraculous crucifix which had reputedly spoken to one of the patron saints of the order, Thomas Aquinas. The sense of movement from left to right in Raphael's altarpiece, generated jointly by the forward motion of the Archangel and Tobias and by the folds of the curtain behind, would have echoed that of a worshipper approaching the altar in the main chapel, although this effect may have been fortuitous. It is more pronounced in the preparatory drawings (cat. nos.30 and 31), where the throne and dais are seen from an angle.

The fish of the title is an attribute of Tobias, who according to the Biblical account was instructed to catch it by his guardian, the

Archangel Raphael. Later in the story it transpired that its entrails had miraculous healing powers. The composition is arranged as a traditional, if impressively monumental, *Sacra conversazione*, in which the Virgin and Child are enthroned on a raised dais and interact with flanking figures. The sweeping green curtain is an early instance of a compositional device that became very popular in the following century. The classical balance of the design is underscored by the emphatic frontality of the Virgin, her throne and the platform. The uprights of the throne, with their lyre-shaped mouldings, are in fact adapted from an antique source, a colossal figure of *Jupiter Enthroned* then in the Ciampolini collection in Rome, and now in the Museo Archeologico in Naples.[7]

Supported by his mother, Christ is about to step across her lap to welcome Tobias. It is a moot point whether the figure of Tobias is also a portrait,[8] but so keenly does the Archangel Raphael recommend him, and so eagerly is he received by the Christ Child, that the altarpiece was probably intended to have some protective or votive function. The Archangel Raphael, accompanied by Tobias, was frequently invoked for his healing powers, particularly in relation to diseases of the eyes, and was also believed to offer protection to travellers. His cult was very popular during the latter part of the 15th century, especially in Tuscany.[9] By placing his hand on St. Jerome's bible, Christ is implicitly endorsing Jerome's sanction of the Book of Tobit (which recounts the story of Tobias and the Angel) as a legitimate part of the Christian canon.[10]

In the 19th century the *Madonna of the Fish* was among Raphael's most admired paintings. It was described by the portrait painter and avid collector of Raphael drawings Sir Thomas Lawrence as the only one of the Madrid Raphaels that did not disappoint him, and the Scottish painter Sir David Wilkie, visiting Madrid in 1828, observed that *of all the pictures in the Escurial, none is more beautiful or more striking than the Madonna del Pesce, in the Old Chapel.*[11] More recently the *Madonna of the Fish* has widely been regarded as partially if not largely executed by one of Raphael's assistants. Giulio Romano has been mentioned in this connection, although this is improbable since he was only about fifteen at the time it was painted. Raphael's other slightly older assistant Gianfrancesco Penni is a more likely candidate (see cat. no. 53). Raphael himself probably added the finishing touches, especially to the heads, and the two preparatory drawings for the altarpiece are certainly from his own hand (cat. nos. 30 and 31). St. Jerome's pose is loosely anticipated, in reverse, in a sheet of studies in Vienna (fig. 50), probably drawn two or three years before the *Madonna of the Fish* was painted.[12] We might imagine that Raphael would have taken special interest in representing his own name-saint in this altarpiece, although a drawing in

Berlin sometimes thought to be his study for the Archangel's head (fig. 51) is probably by Mariotto Albertinelli and connected with his large *Annunciation* now in the Accademia in Florence.[13]

The first secure point of reference we have for dating the *Madonna of the Fish* is a Venetian woodcut dated 1517 (cat. no. 33). It has been argued, however, that it must have been installed in Naples by about 1514, when its influence can be detected in a painting there by Andrea Sabatini.[14]

fig. 50 Raphael *Various Figure Studies* (Vienna, Albertina)

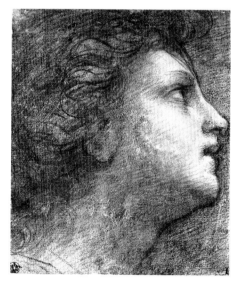

fig. 51 Attributed to Mariotto Albertinelli *Head of an Angel* (Berlin, Kupferstichkabinett)

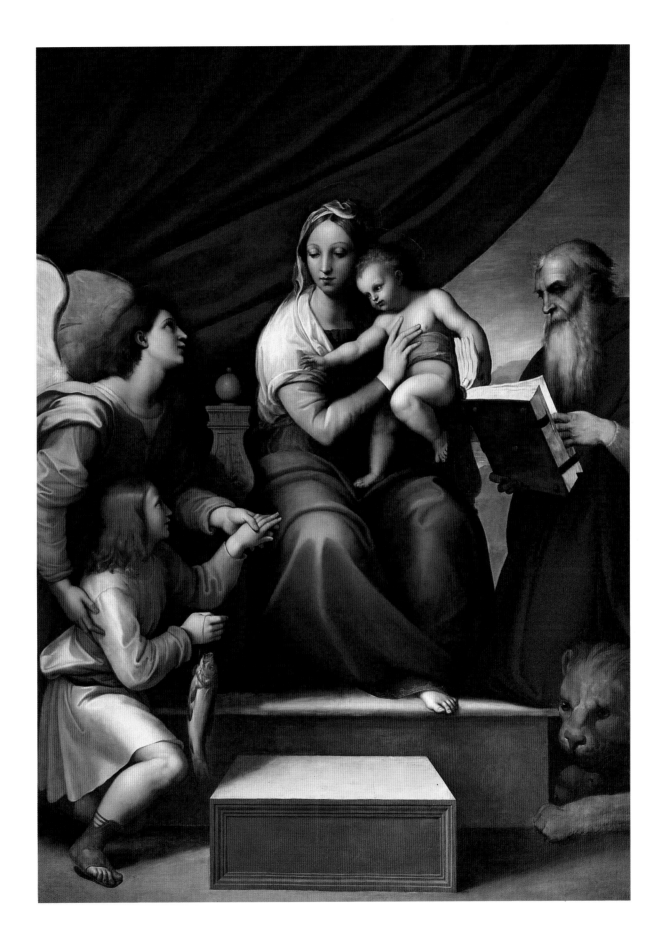

30 *Study for the 'Madonna of the Fish'*

Red chalk over traces of black chalk; incised framing line about 1.5 cm from the left edge; framing line in red chalk at left; 26.8 × 26.4 cm.
INSCRIPTIONS: On step: *Raf. Urb.o.*
REFERENCES: Passavant, 1860, II, p.127; Crowe and Cavalcaselle, 1882-85, II, pp.225-26; Fischel, 1948, p.139; Pope-Hennessy, 1970, pp.217-18; Florence, 1983, pp.364-65, no.49; Joannides, 1983, no.351; Knab, Mitsch, Oberhuber and Ferino Pagden, 1983, no.458; Petrioli Tofani, 1986, pp.234-35.

Florence, Gabinetto Disegni e Stampe degli Uffizi
(Inv. no. 524 E)

The authenticity of this marvellously fresh and incisive drawing was inexplicably questioned by one or two earlier Raphael scholars,[1] but it is now universally accepted as a study by Raphael for the *Madonna of the Fish* (fig. 52). Raphael posed four of his studio assistants (*garzoni*) as a *tableau vivant* on a temporary stage erected in the studio, and established fairly definitively the disposition of the figures in the final painting. The Archangel's wings, Tobias' fish and a hint of a landcape between the heads of the Virgin and St. Jerome are very lightly sketched in. The youth representing the Virgin Mary is seated on a type of folding stool known as a Savonarola chair and clutches a bolster or roll of cloth in place of the Infant Christ. The use of *garzoni* in this way was a practice Raphael had adopted for even his very earliest commissions, although then mainly for studying and refining individual poses.[2] The method was possibly used here as a time-saving device. Raphael could pose and rearrange his assistants at will until he arrived at a solution he was satisfied with, which he could then record directly, thus by-passing the need for exploratory pen studies. He already had a good idea for the Archangel and Tobias, the most original and eye-catching group in the composition, in a drawing he had made some ten years earlier, but apparently never used (fig. 53).[3]

The handling of the red chalk in this drawing is very close to Raphael's studies for the tapestry cartoon of *Christ's Charge to St. Peter*, particularly the offset at Windsor Castle,[4] and this argues strongly for a dating of the *Madonna of the Fish* later rather than earlier within in 1511-14 range variously proposed. The poses of the two apostles nearest to Christ in the Windsor drawing also echo those of Raphael and Tobias in the present study.

fig. 52 Raphael *The 'Madonna of the Fish'* (Madrid, Prado)

fig. 53 Raphael *The Anti-Pope Felix V Blessing his Sons* or *St. Benedict Receiving Mauro and Placido* (Private Collection)

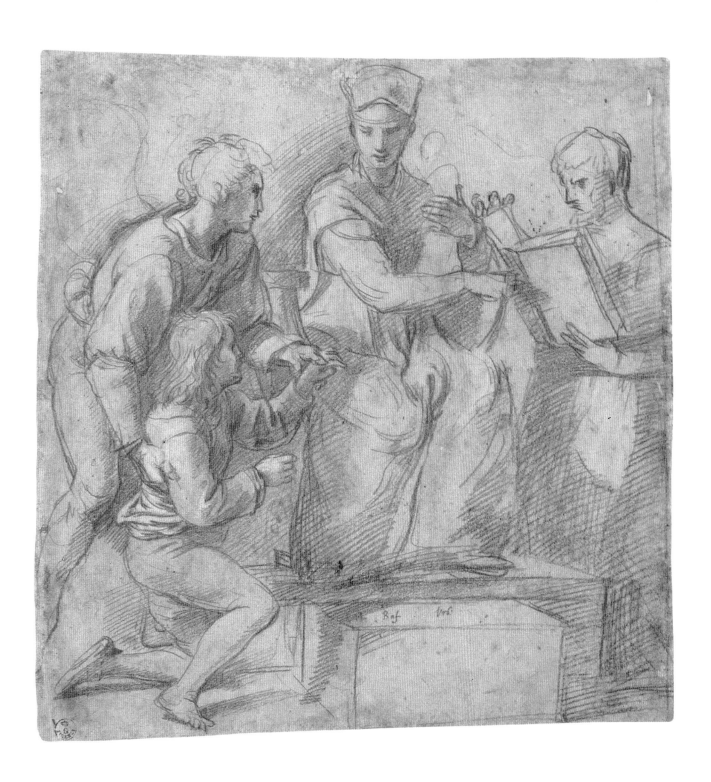

31 *Study for the 'Madonna of the Fish'*

Brush and brown wash, heightened with white, over black chalk; 25.8 × 21.3 cm.
PROVENANCE: Commendatore Genevosio (alias Gelozzi or Gelosi, L.545, see
Appendix); Sir Thomas Lawrence (L.2445a); Samuel Woodburn; Willem II, King of
the Netherlands; his sale, The Hague, 12th August 1850, lot 32, bought by the
dealer L. C. Enthoven; Grand Duke Alexander of Saxe Weimar; P. & D. Colnaghi,
London; Lt. Col. Norman R. Colville. Purchased 1993 by the National Gallery of
Scotland with funds from the estates of Keith and Rene Andrews and with the
assistance of the National Art-Collections Fund and the National Heritage
Memorial Fund.
REFERENCES: Passavant, 1860, II, p.127; Crowe and Cavalcaselle, 1882-85, II, p.226;
Fischel, 1948, p.140; London, 1960, p.209, no.525; Forlani Tempesti, 1969, p.425;
Pope-Hennessy, 1970, pp.218 and 289, n.77; London, 1983, p.166, no.136;
Joannides, 1983, no.352; Knab, Mitsch, Oberhuber and Ferino Pagden, 1983,
no.459.

Edinburgh, National Gallery of Scotland
(Acc. no. D5342)

There are relatively few drawings by Raphael executed like this
one almost entirely with the point of the brush over a light black
chalk sketch. He did, however, make a similarly elaborate
modello, now at Chatsworth,[1] for the altarpiece which most
directly anticipates the *Madonna of the Fish*, the unfinished *Madonna
del Baldacchino* in the Palazzo Pitti, Florence.[2] Raphael may have
chosen this technique for the modello because it allowed him to
study effects of light and shade equivalent to those that might
prevail in the dark, windowless chapel for which the *Madonna of the
Fish* was destined, a consideration which may also have influenced
the bold and monumental design. This is not to suggest that
Raphael had been to Naples to see the intended site, but he
probably enquired about this verbally. In addition to its tonal
possibilities, the fine brush allowed Raphael to achieve great
precision of detail in this drawing, and this would have been
useful if he were delegating the subsequent work to an assistant.[3]

It is this complete and very detailed aspect of the present sheet
which may have led several scholars in the past to doubt its
authenticity.[4] This may reflect a certain nervousness on Raphael's
part, for this was possibly the first occasion that he had allowed,
presumably due to pressure of work, most of a major altarpiece to
be painted by his pupils. The more or less contemporary *Madonna
di Foligno* (Vatican) and *Sistine Madonna* (Dresden) both reveal much
more of Raphael's own touch.[5] His perception of the importance
of a commission or its patron were presumably the main factors
determining the extent of his personal participation. Within a few
years he had become much more relaxed about the delegation of
projects to his increasingly efficient team, to the point where
much of the preparatory work, and possibly even some of the
ideation, was carried out by members of his workshop (see p.95).

The present drawing develops logically from the life-drawing
in the Uffizi (see previous entry), with which it corresponds
closely, although the figures here have been appropriately
idealised. The only area of the composition which remained to be
resolved was the position of the Christ Child (who had been
represented by an inert bundle in the earlier study), and his
precise relation to both the Virgin and to St. Jerome. It is only in
these parts that the present modello has a nest of exploratory
chalk underdrawing, which has since been rubbed so that it now
rather discolours the overlying wash. A visible *pentimento* in the
underdrawing reveals that Jerome was at one stage relegated to a
position further back. The placement of Christ's left hand on his
bible integrates him more fully into the composition.

In common with other wash drawings by Raphael, this sheet
has probably faded slightly and the tonal contrasts softened as a
result (see also cat. no. 3). Overexposure to light is to blame for
this. When David Wilkie saw this drawing with others by Raphael
in the King of Holland's collection in The Hague in 1840, they
were framed and on permanent display.[6] The lead white has also
oxidised in places, so that the fish has now all but vanished (it was
always a tiddler compared to the fish in the altarpiece). An x-ray of
the drawing (fig. 54) taken with a view to finding a watermark in
the paper had the effect of greatly enhancing the white heighten-
ing and emphasised the extreme refinement of its application,
notably in the hair and draperies of Tobias and Raphael and in the
Virgin's gown. As if to make absolutely certain that his intentions
would not be misunderstood, Raphael used a film of white
heightening to mask the alteration in St. Jerome's position,
although this has now become almost completely transparent.

The major difference between the *garzone* study and the
modello on the one hand, and the altarpiece in the Prado on the
other, is the perspective of the throne, platform and step, which in
the picture are viewed frontally (the Savonarola chair has in the
process been upgraded to an *all' antica* throne). This change was
made at a late stage on the surface of the panel itself, for in infra-

fig. 54
x-radiograph of cat. no. 31

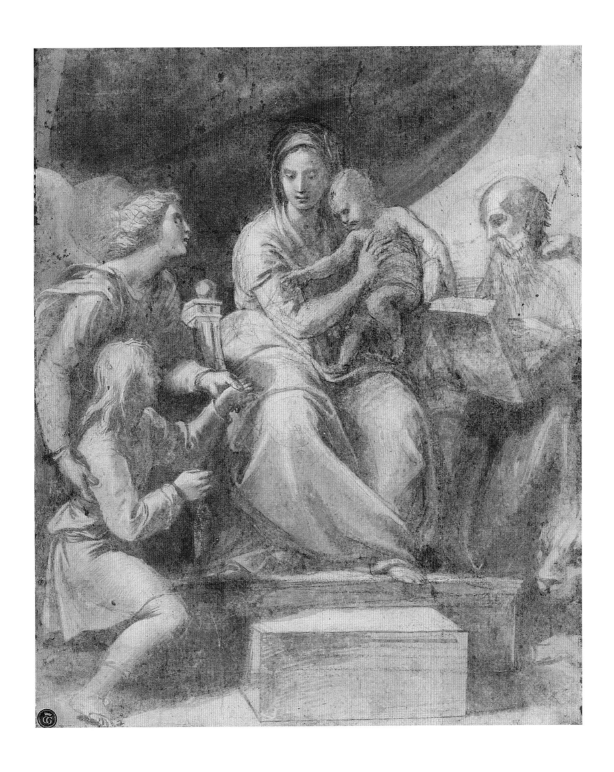

red reflectograms (which can reveal the underdrawing) the receding perspective lines of the throne are just visible, corresponding to those in the drawings (fig. 55).[7] While the execution of the painting may have been left largely to assistants, Raphael himself must at least have supervised such an important alteration to the composition.

Once this drawing had served its purpose in the preparation of the painting, it was sufficiently precise to be handed over to Marcantonio Raimondi, the printmaker with whom Raphael established a working relationship which amounted to a commercial partnership, under whose supervision it was engraved by one of his assistants (see following entry).

fig. 55
Raphael
infra-red detail of
The 'Madonna of the Fish'
(Madrid, Prado)

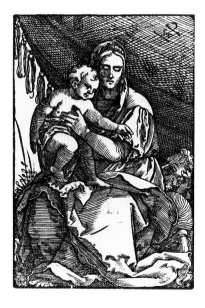

fig. 56
Hans Sebald Beham
Holy Family
woodcut (London,
British Museum)

32 The 'Madonna of the Fish' (after Raphael)

Engraving, first state; 26 × 21.4 cm.
REFERENCES: Bartsch, 1803-21, XIV, pp.61-63, no.54 (Illustrated Bartsch, Vol.26, 1978, p.80, no.54); Paris, 1983 (1), p.366, no.55; Geneva, 1984, pp.31-32, nos.31-32; Rome, 1985, p.199.

London, The Trustees of the British Museum
(Acc. no.1862-12-13-43)

This engraving must have been made very shortly after Raphael's painting was dispatched to Naples. It was certainly based on the preparatory modello now owned by the National Gallery of Scotland (see previous entry), rather than on the painting itself. The print is very close in scale to the drawing and, allowing for the difference in medium and the inexperience of the engraver, reproduces most of its details faithfully. The area where the printmaker took greatest liberties with Raphael's design, namely in the Virgin's features and headdress, is the least successful passage in the print.

The engraving exists in four different versions ('states'), involving one major reworking of the original copper plate and two subsequent minor additions. Three of these (the exhibited first state is the exception) include a little tablet with the initials of Marcantonio Raimondi, indicating that the engraving was produced in his studio, and it is listed among his prints by the artists' biographer Vasari.[1] The great collector Mariette in the early 18th century was the first to recognise that the engraving technique is too awkward to be by Marcantonio himself, and his suggestion that it is an early work by Marcantonio's pupil Marco Dente has been widely accepted.[2]

Because it could be printed in numerous impressions, Marco Dente's engraving was certainly the main vehicle by which knowledge of Raphael's Madonna of the Fish composition was disseminated, and it proved to be a very popular design, as the few examples included in this exhibition testify (cat. nos. 33-35). The print had soon carried Raphael's composition over the Alps (fig. 56) and in the mid-17th century it was still being used as a source by as great an artist as Poussin.[3]

A slightly later copy of this print, engraved on a different plate, introduced a fringed pelmut above the curtain at the top of the composition and numerous other minor changes.[4]

32

33

33 Virgin and Child with Saints John the Baptist and Gregory the Great

Woodcut, from a single block; 53.4 × 39.2 cm.
INSCRIPTIONS: *Gregorius de gregoriis/ excusit*. M.D.XVII. and signed LA* in monogram at the base of the arch.
PROVENANCE: Friedrich August; Sale, Boerner's, Leipzig, 4 – 6th May 1927 (lot 1022), bought Colnaghi.
REFERENCES: Nagler, 1919, IV, p.265; Dreyer, 1971, pp.41-42, no.2; Venice, 1976, p.85, no.13.

London, The Trustees of the British Museum (1927-6-14-176)

This impressive if eclectic woodcut by Lucantonio degli Uberti,[1] published in Venice by Gregorio de' Gregori in 1517, is included in this exhibition because the Virgin and Child are borrowed directly from Marco Dente's engraving after Raphael's *Madonna of the Fish*, one of the earliest adaptations of the compostition. Raphael's group has been reversed by the printing process and the unattractive head of the Virgin in Dente's print has been modified. The other elements in the woodcut are also adapted from printed sources. The two saints and the architectural structure are all borrowed (without reversal) from different woodcuts by Albrecht Dürer,[2] whose prints had an enormous influence in Venice and who had twice stayed in the city (1494-5 and 1505-7). No direct sources for the three musical angels have been found, but these are likely to have been Venetian since they find close cousins in paintings by Giovanni Bellini and his followers.

The disparate sources are quite cleverly integrated in the woodcut. What is now Christ's right hand holds the Baptist's cane cross instead of resting on St. Jerome's bible, thus retaining symbolic significance, while the Baptist points forcefully to his lamb, which nestles up against a musical angel (in Dürer's woodcut he is pointing instead to the artist's own monogram). The gesture of Christ's other arm, which is one of welcome rather than of blessing, is less meaningful in relation to the static St. Gregory than to the approaching Tobias of Raphael's composition. The prominent placement of the credit to the publisher above his name-saint in this woodcut was perhaps considered too obtrusive, for it was removed in a subsequent state of the print. Unlike Lucantonio's monogram at the base of the arch, it at least has the virtue of supporting rather than denying the perspective of the architecture.

The design of this woodcut has in the past been attributed to Titian himself, and although its highly derivative character makes this extremely unlikely, it was cut and published by a team who certainly knew his work in this field. The head of St. John the Baptist is a particularly Titianesque type.

This highly derivative print produced in Venice furnishes the earliest certain date by which the *Madonna of the Fish* and Marco Dente's engraving after it must have been completed.

CASTEL DURANTE *c.1525*

34 *An Istoriato (Figurated) Dish with the Design of the 'Madonna of the Fish'*

Maiolica (tin-glazed earthenware); 29 cm diameter.
PROVENANCE: Ford Collection; Sale, Christie's, London, 18th May 1911.
REFERENCES: Rackham, 1940, p.196, no.583.

London, The Trustees of the Victoria and Albert Museum
(Acc. no. C.108 – 1937)

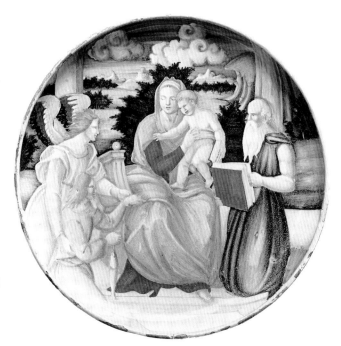

This dish is painted by an anonymous artist known as the *In Castel Durante* painter from the manner in which he signed several pieces dated 1524, 1525 and 1526. He was previously misleadingly nick-named 'Pseudopellipario', on account of the similarity of his style to that of another, highly talented maiolica painter who signed himself Nicola, who was identified as Nicola Pellipario. It has relatively recently been shown that the latter is in fact Nicola da Urbino, one of the most important figures in the development of the *istoriato* style in several Marchigian maiolica centres. He certainly influenced the work of the *In Castel Durante* painter, although the latter's style remained distinctive.[1]

Castel Durante, renamed Urbania in the 1636, is a small town not far from Urbino in the Italian province of the Marche. Maiolica production in the town dates back to the 14th century, but it was during the 16th century that it really flourished as one of the most productive centres in Italy for *istoriato* wares (that is, pottery decorated with figurative scenes). Many painters from Castel Durante also worked in the ducal capital of Urbino and elsewhere.

From about 1520 engravings by Marcantonio Raimondi and his school after designs by Raphael and his pupils became the most popular source for *istoriato* maiolica, particularly in the duchy of Urbino. The decoration of the present dish is based on the print attributed to Marco Dente after Raphael's *Madonna of the Fish* (see cat. no. 32). The painter has been rather ruthless with some parts of the composition, notably Tobias' legs and the dais, making no attempt to adapt the square design to the new circular shape. The neutral backdrop of the curtain has been replaced by a landscape view with the swirly clouds characteristic of this painter, framed by double columns. Based as it is on a monochrome print, the colouring of the dish understandably bears little relation to that of Raphael's original.

The dish was probably painted little more than a decade after Raphael's altarpiece was completed, and demonstrates the receptivity of maiolica decorators to the designs made available to them through reproductive prints, a new phenomenon in Italy to which Raphael and his partner Marcantonio Raimondi had made a fundamental contribution. A maiolica plaque also from Castel Durante, based on the same Raphael design as this dish, is in the Louvre.[2]

35 A Bishop Saint Enthroned with Tobias and the Angel and St. Dorothea

Pen and brown ink and wash; 21.1 × 20.6 cm.
INSCRIPTIONS: On the mount: recto, in black chalk, *Albano*; verso, in ink, *Domenico Campagnola* (cancelled).
PROVENANCE: David Laing; his Bequest to the Royal Scottish Academy, 1878.
REFERENCES: Andrews, 1968, I, p.147.

Edinburgh, National Gallery of Scotland,
on loan from the Royal Scottish Academy, 1966
(Acc. no. RSA 262)

The Tobias and Archangel Raphael in this attractively naïve drawing have their origins ultimately in Raphael's *Madonna of the Fish*, albeit in bastardised form. So completely have the grace and psychological penetration of Raphael's group been lost that the draughtsman's source was probably not Marco Dente's engraving (cat. no. 32), but a derivation from it at least one remove further from the original. The Archangel now holds a rather elaborate vessel containing the miracle-working entrails of the fish. The bishop saint looks like one of the Fathers of the Church, and may be St. Ambrose, who wrote a commentary to the Book of Tobit.[1] St. Dorothea, an early Christian martyr, is identified by her basket of roses and apples and her martyr's palm.

The drawing is probably the work of an artist from Venice or (more likely) a more provincial centre in the Veneto. The compositional type, with the strip of cloth behind the bishop and the outdoor setting, was popular in this region early in the 16th century, but the style of the draughtsmanship points to a later date.

36 A Woman Reading and Embracing a Child Standing by her Side

Silverpoint heightened with white on grey prepared paper; 19 × 14 cm
PROVENANCE: Sir Peter Lely (L.2092); William, 2nd Duke of Devonshire (L.718).
REFERENCES: Passavant, 1860, II, pp.515-16, no.566; London, 1983, pp.168-69,
no.137; Joannides, 1983, no.320; Knab, Mitsch, Oberhuber and Ferino Pagden,
1983, no.444; Joannides, 1985, p.29; Ames-Lewis, 1986, pp.18-20; London, 1993,
p.112, no.120.

Chatsworth, The Duke of Devonshire and
the Trustees of the Chatsworth Settlement
(Inv. no. 728)

This beautiful drawing is closely related to another sheet executed in the same combination of media in the Ashmolean Museum (fig. 57).[1] Both were engraved, in the same direction, in the studio of Marcantonio Raimondi, although neither print is thought to be by the master himself.[2] Their subject matter and compositions are very similar, with one scene tranquil and the other more *mouvementé*, but they were not conceived as a strict pair, for the sizes of both drawings and prints are different, and the latter were engraved by different hands.

The unbroken popularity of Raphael's Madonnas over the centuries since they were painted is due in no small measure to their intimate and accessible portrayal of reciprocated love between mother and child. The present drawing encapsulates this depiction of the divine in human terms to such a degree that it is no longer clear whether the subject is sacred or secular. The dress of the child, in particular, appears to be contemporary, and neither figure has a halo. On the other hand, the compact, isolated group with the woman absorbed in reading and the child distracted, and details such as the curtain in the left background (much clearer in the engraving), echo imagery often used in Madonna compostions.[3] A particularly domestic example by Raphael himself is the *Orléans Madonna* at Chantilly (fig. 46), where the Virgin is seated on a simple wooden bench and a row of utensils is visible on a shelf in the background. A figure who we are presumably to identify as Joseph was lightly sketched through a doorway at the upper right of the present drawing, and might have helped to clarify the subject were he not subsequently suppressed, and a shuttered window inserted in the print instead.[4] This suggests that an element of ambiguity may have been deliberate on Raphael's part. Once the idea of a doorway had been discarded, Raphael rethought the dimensions of the room. Comparison with the engraving establishes that the horizontal line which runs through the child's legs marks the new junction between the floor and the wall behind the figure group.

This drawing and its companion in Oxford were evidently made specifically to be engraved. The three-tone technique, with its strong highlights and extensive use of parallel hatching, was well suited for this purpose. A few rogue strokes of the silverpoint around the profile of the woman's legs were either covered with white heightening or literally scraped off the surface of the drawing to ensure that the engraver should not reproduce them. The generally accepted date for this drawing of *c.*1512-14 is based partly on parallels with the mother-and-child groups in the *Mass of Bolsena* fresco in the Stanza d'Eliodoro of the Vatican.

fig. 57 Raphael *Woman and Child*
(Oxford, Ashmolean Museum)

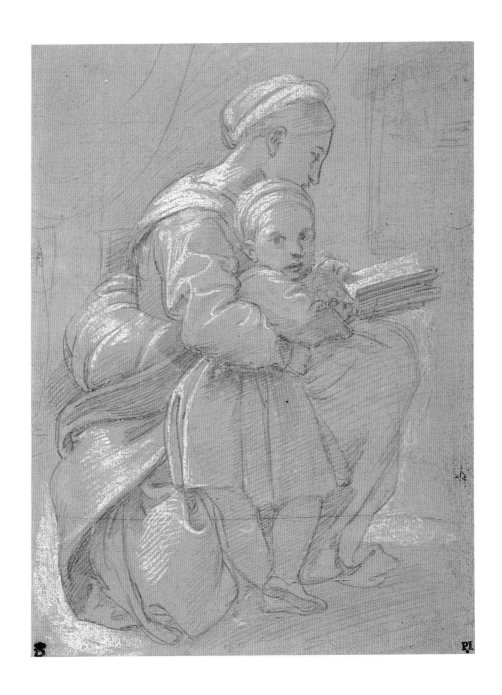

37 The 'Madonna del Passeggio'

Oil on panel; 90 × 63 cm.
INSCRIPTIONS: No.228. DIRAFFEL : D'VRBINO, on the back.[1]
PROVENANCE: Cardinal Pietro Aldobrandini, by 1603; given by Olimpia
Aldobrandini to Cardinal Ludovico Ludovisi in 1621; possibly Philip IV, king of
Spain; Queen Christina of Sweden, Antwerp, by 1656, and in her collection in
Rome by c.1662; by inheritance to Cardinal Dezio Azzolino; Marchese Pompeo
Azzolino; Prince Livio Odescalchi; Prince Baldassare Odescalchi-Erba; sold by him
to the Régent, Philippe Duc d'Orléans in 1721; by descent to Louis Philippe Joseph,
Duc d'Orléans (Philippe Égalité); sold by him in 1791 to Viscount Walchiers,
Brussels; François de Laborde de Méréville; sale, Bryan's Gallery, London, 1798 (lot
31), reserved for the 3rd Duke of Bridgewater; thence by descent.
REFERENCES: Crozat, 1729, I, p.10; Passavant, 1860, II, pp.331-32, no.271; Crowe and
Cavalcaselle, 1882-85, II, p.552; Dussler, 1971, pp.45-46; Pope-Hennessy, 1970,
p.221; Joannides, 1985, p.42, n.14; Cordellier and Py, 1992, pp.293-94; Brigstocke,
1993, pp.133-35.

Edinburgh, National Gallery of Scotland
(Duke of Sutherland loan, 1945)

The present title of this painting, which in fact dates back only to the 1830s and can be translated as the 'Madonna of the Walk' (or 'of the Promenade'), gives a clue as to its real subject, for the scene represented is clearly the legendary meeting of the young St. John the Baptist with Christ and his family on their return journey from Egypt. Joseph, carrying a traveller's bundle tied to the end of a pole, has walked a little ahead down the winding path, and looks back to see what is keeping Mary and Jesus. The Baptist, dressed in an animal skin and holding his long cane cross and a banderole with the words *Ecce Agnus Dei* ('Behold the Lamb of God'), has just appeared on the scene and is greeting Christ with a deferential, genuflecting pose. The two infants are united in a complex interlocking group and are further bonded together by the placement of the Virgin's hands. Their poses recall those familiar from representations of the Visitation of the Virgin Mary to her cousin Elizabeth, an appropriate enough reference, since Elizabeth was the mother of John the Baptist, and the visit was a celebration of the joint pregnancies of the two cousins.

The painting is extremely well preserved for a work of its age and was fortunately spared the transfer from its original panel to canvas suffered by the other two Sutherland Raphaels (cat. nos. 5 and 18) when they were in the Orléans collection. Paradoxically, the good condition of the panel leaves us in no doubt that its execution is not quite impressive enough to be by Raphael himself, although for most of its history it has been highly prized by a succession of discriminating collectors as an autograph work. It was only in the 19th century that the opinion was advanced that the *Madonna del Passeggio* was painted by Raphael's pupil Gianfrancesco Penni[2] to the master's design, a view that has since received widespread endorsement.[3] Penni's responsibility for the painting hinges on perceived similarities between its landscape and that in the copy of Raphael's *Transfiguration* (see cat. no. 68) now in the Prado in Madrid. The latter is described by Vasari as

having been painted by Penni for the church of S. Spirito degli Incurabili in Naples,[4] and is one of very few works which can be attributed to him with some degree of confidence. The connection between its landscape and that in the *Madonna del Passeggio* is, however, not a compelling one.

The idea that the assistant who painted the picture was following quite closely a fully resolved design for the main figure group is supported by the evidence of underdrawing revealed by infra-red reflectography. The contours of the figures in the underdrawing are clearly defined, with only very slight adjustments, and the subsequent paint layers follow them closely. This gives the group a somewhat flat and template-like appearance in relation to the landscape, an effect only partially offset by the strong shadows cast by the figures. Parallel hatching in the underdrawing is too crude and mechanical to be by Raphael himself (see fig. 32). The assistant was evidently allowed greater freedom of invention in the landscape, stylistically the most distinctive part of the picture. The fig tree and rocky outcrop at the right are particularly impressive (see detail p.88). There is evidence of a major pentimento in the left background, discernible even to the naked eye, which affects the distant buildings and the profile of the horizon (see figs. 29 and 30).

That the modello or cartoon used for the main figure group was actually by Raphael himself is questionable, for several features of the design are perhaps not what we would expect from him, even late in his career. Most uncharacteristic are the facial type of Christ, his strangely mannered, balletic posture, with one thigh crossed over the other,[5] and his chunky musculature. It is not quite clear how the Virgin's right hand, resting on the head of St. John, could be comfortably attached to her body.

Unfortunately, there are no surviving drawings directly preparatory for the *Madonna del Passeggio* which might have helped to clarify the evolution of the design. A nude study in silverpoint

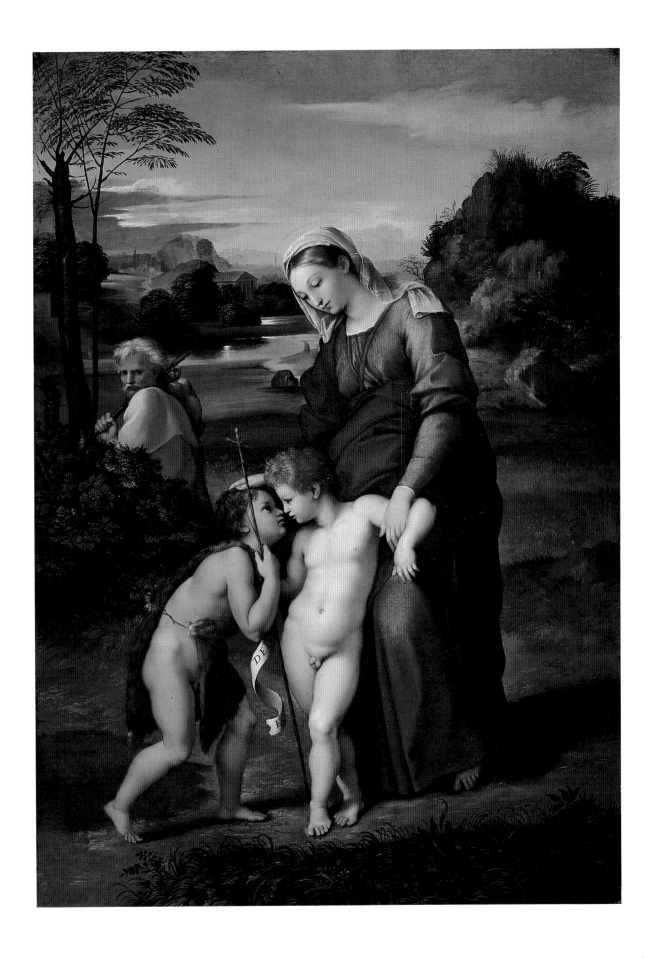

by Raphael, which was probably made in connection with the Psyche Loggia in the Farnesina but was never used there, may have suggested the basic pose of the Virgin (fig. 58).[6] A sheet of red chalk studies of infants in a private collection (fig. 59)[7] includes two sketches which are certainly related to a Raphael workshop *Holy Family with the Infant Baptist* in Vienna,[8] but the third, at the lower left corner, may be loosely associated with the *Madonna del Passeggio*.[9] The connection in the case of both drawings is, however, too remote to constitute evidence of Raphael's responsibility for the composition.

So heavily did Raphael come to rely on assistants at this period that the distinction between autograph works and those produced by his studio must have become increasingly blurred. While Raphael would have retained overall control and responsibility, his personal creative input into some projects may have amounted to little more than a few quick pen sketches. It is probable that in some instances Raphael allowed his most talented pupils a free hand in both the design and the execution of works which were to leave the studio bearing his own name. The *Madonna del Passeggio* may have been just such a work. Nevertheless, in view of the changes revealed in the underdrawing, there can no longer be any doubt that the Sutherland panel is the prime version of what proved to be a very popular and much copied composition.[10]

The analogies, albeit tentative, with the *Loggia di Psiche* and the Vatican *Logge* suggest a date of about 1518-20 for the *Madonna del Passeggio*. If the painting is by Penni, it provides a fascinating contrast with the roughly contemporary treatment of a similar theme by Raphael's other principal assistant, Giulio Romano (cat. no. 54).

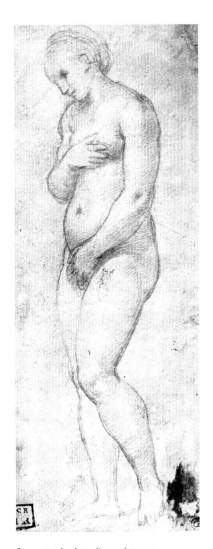

fig. 58 Raphael *Standing Nude Woman* (Budapest, Szépmüvészeti Múzeum)

fig. 59 Raphael *Studies of Infants* (Private Collection)

JEAN PESNE
1623–1700

38 The 'Madonna del Passeggio' (after Raphael)

Etching and engraving, in reverse; second state; 44.1 × 33.2 cm.
INSCRIPTIONS: *Raphael Pinxit/J. Pesne Sculpsit cum Privil. Regis.*
PROVENANCE: Rev. C.R. Cracherode; his Bequest to the British Museum, 1799.
REFERENCES: Nagler, 1835-52, XII, p.300, no.95; Le Blanc, 1854-90, II, p.177; Paris,
1983 (3), p.215, no.312; Brigstocke, 1993, p.133.

London, The Trustees of the British Museum
(Acc. no. V4–121)

38

This is the earliest reproductive print after the Sutherland panel.
It is the second of a total of six existing states of the print. The first
state faithfully reproduced the painting, without the drapery
masking the Christ Child's genitals which appears here. Changes
affecting subsequent states involved only additions and altera-
tions to the caption.

Pesne is known to have visited Italy, where he is supposed to
have been in touch with Poussin, many of whose works he
reproduced. It was presumably there that he made this print of
the *Madonna del Passeggio*, which moved with Queen Christina from
Antwerp to Rome. Pesne developed a new technique of combin-
ing etching and engraving on the same plate with a view to
improving the reproductive printmaker's ability to capture the
overall spirit, as well as the forms, of the works he was copying.

39

NICOLAS IV DE LARMESSIN
1684–1756

39 The 'Madonna del Passeggio' (after Raphael)

Engraving, in reverse; 45.9 × 29.7 cm.
INSCRIPTIONS: *La Sainte Vierge/ D'après le Tableau de Raphaël, qui est dans le Cabinet de Mgn.r
le Duc d'Orléans./ haut de 2. pieds 9. pouces, large d'un pied 11. pouces./ peint sur bois, gravé par
Nicolas de Larmessin/ 20.*
PROVENANCE: Sir Robert Witt.
REFERENCES: Crozat, 1729, I, p.10; Passavant, 1860, II, p.331; Brigstocke, 1993, p.134,
n.5.

London, Courtauld Institute Galleries (Witt Collection)
(Ref. no. Art. It.VI.4)

This engraving is plate 20 from J. A. Crozat's *Recueil d'Estampes*,
published in Paris in 1729 (see also cat. nos. 10 and 25).

40

HEINRICH GUTTENBERG (OR GUTTEMBERG) 1749–1818

40 The 'Madonna del Passeggio' (after Raphael)

Engraving, in reverse; 41.5 × 28.1 cm.
INSCRIPTIONS: *Peint par Raphaël Sanzio d'Urbin/ Dessiné par Beaudoin/ Gravé par H.re Guttemberg./* SAINTE FAMILLE/ *De la Galerie de S. A. S. Monseigneur Le Duc d'Orléans/* ÉCOLE ROMAINE/ VIIe TABLEAU DE RAPHAEL SANZIO D'URBIN/ *Peint sur bois, ayant de hauteur 2 Pieds 9 Pouces, sur 1 Pied 11 Pouces de large./ Raphael avoit fait avec beaucoup de soin ce Tableau pour le Duc d'Urbin, qui le donna au Roi d'Espagne: le Roi d'Espagne en fit présent à Gustave Adolphe, Roi de Suede, Pere de la Reine Christine, dans le Cabinet de la quelle il tenoit le premier rang. Les Connoisseurs trouvent dans ce Tableau toutes les parties de la Peinture; et ils conviennent que Raphael y à joint a la pureté et au grand caractère de Dessin, le Coloris et cette intelligence de lumière et de Clair-obscur qu'on admire dans les meilleurs Peintres Venitiens. La Reine Christine de Suede faisoit une si grande estime de ce Tableau, qu'il a toujours été sous une Glace jusqu'au tems qu'il a passé dans le Cabinet de Monseigneur le Duc d'Orléans./ Gal. Palais Royal.*
REFERENCES: *Galerie du Palais Royal gravée,* 1786; Brigstocke, 1993, pp.134-35, n.23.

London, Trustees of the British Museum (Acc. no. 1855-6-9-278)

Since the Aldobrandini-Ludovisi provenance has now been firmly established, the references in the legend to the Duke of Urbino and the King of Spain having once owned the *Madonna del Passeggio* are misleading, and probably refer to a different painting. Several other paintings passed from the Ludovisi collection into that of Queen Christina of Sweden.[1] The care taken by Queen Christina and her heirs to protect the surface of the painting with glass may in part account for its excellent state of preservation.

PELTRO WILLIAM TOMKINS 1760–1840

41 The 'Madonna del Passeggio' (after Raphael)

Engraving; 31 × 21.8 cm.
INSCRIPTIONS: LA BELLE VIERGE/ From the original Picture by Raffaello in the Collection of/ THE MOST NOBLE MARQUIS OF STAFFORD/ Drawn and Engraved, with Permission, by P.W. Tomkins, Historical Engraver to Her late Majesty/ LONDON Published Jan.y 31st 1820, by Longman, Hurst, Rees, Orme & Brown;/ Cadell & Davies, & P.W. Tomkins, 54 New Bond Street.
REFERENCES: Ruland, 1876, p.82.

Edinburgh, National Gallery of Scotland (Acc. no. P2881)

PIETRO ANDERLONI 1785–1849

42 The 'Madonna del Passeggio' (after Raphael)

Engraving; 70.2 × 46.7 cm.
INSCRIPTIONS: *Raffaele d'Urbino dipinse/ Il quadro originale esiste nella Galleria del Marchese Stafford a Londra/ Pietro Anderloni incise./* LA SACRA FAMIGLIA/ *A S.A.S. il Principe Carlo Egone di Fürstenberg etc etc./ Lissant impresse/ Pubblicata a Mannheim da Artaria & Fontaine./ Artaria & Fontaine D.D.D.*
REFERENCES: Ruland, 1876, pp.81-82.

London, The Trustees of the Victoria and Albert Museum (Acc. no. 21508)

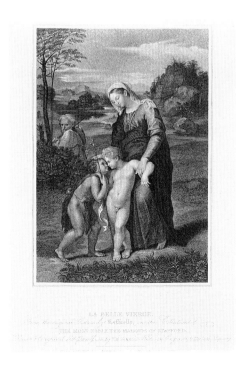

41

42

43 *The Holy Family with the Young St. John the Baptist in a Landscape*

Oil on copper; 34.3 × 23.5 cm.
PROVENANCE: Sale, Sotheby's New York, 15th January 1993 (lot 145).

London, Michael Simpson Ltd.

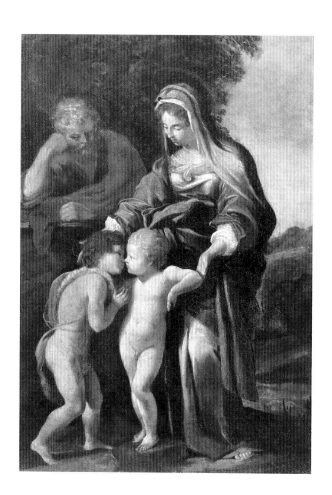

This little copper, the composition of which is clearly derived from Raphael's *Madonna del Passeggio*, first appeared on the art market in 1993 with a tentative attribution to Lanfranco's Parmese friend and compatriot Sisto Badalocchio (1585 – after 1620).[1] It has since been assigned instead to Lanfranco himself, a suggestion supported by the existence of a study by him in the Uffizi for the figure of St. Joseph.[2] That Lanfranco should have taken the trouble to make a life-drawing for this figure is somewhat surprising in view of the fact that he borrowed it fairly directly (although reversed) from another Raphael composition, the *Holy Family of Francis I* in the Louvre. Badalocchio and Lanfranco were fellow pupils in Annibale Carracci's Roman studio during the first decade of the 17th century, and their painting styles were at times very similar. Carracci must have encouraged them both to look carefully at the works of Raphael, for when their master was later taken ill, they jointly produced a volume of etchings after the biblical scenes in Raphael's Vatican *Logge*, and dedicated it to him as a token of affection and esteem.[3]

The ways in which Lanfranco has modified his Raphaelesque source here are interesting, for they clearly reflect the naturalistic bent of his training. The poses of the children are less artificial, the gestures of the Virgin more relaxed and natural, and Joseph is more closely involved in events instead of scowling in the background. The passion for voluminous, agitated draperies, flickering light effects and lively brushwork that was to make Lanfranco one of the seminal figures of Italian Baroque painting is in evidence even in this small-scale and derivative work. One might have expected this kind of adaptation to have dated from early in an artist's career, but both the style of the copper and the evidence of the drawing suggest that Lanfranco painted it about 1615-16.

The *Madonna del Passeggio* was at that time still in the Aldobrandini collection in Rome. It may have been through G. B. Agucchi, *major domo* and librarian to Cardinal Pietro Aldobrandini, that artists from Annibale Carracci's studio gained access to that collection.[4] Agucchi was a close friend of Annibale and of another of his pupils, Domenichino, and it was he who had drawn up the

inventory of paintings in the Aldobrandini collection referred to in the entry on the *Madonna del Passeggio* (cat. no. 37).

A second autograph version of this picture, slightly larger and also on copper, has even more recently come to light in a private collection in London.[5] It seems to be that painting rather than the present one that served as the direct model for the reproductive etching by Stefanoni (see following entry).

44 The Holy Family with the Young St. John the Baptist in a Landscape (after Giovanni Lanfranco)

Etching; 44 × 28.7 cm.

INSCRIPTIONS: At the lower right: R.V. in. Dated 1632 at lower centre. In the margin:
*Dic Vates quae verba refers, quae poscis Joseph/ Mirantur Mater, Caelica Sacra Viris./ Per ILL.ri et
Admodum R.o Capto. S. Mariae Rotondae de Vrbe. D. Nicolaus Verdura Finariensis Praesby/ ter
Savon. Dicavit. Raphael Vrbinas Inventor, cuius ossa in Eccl. eiusdem honorifice servantur./ Romae
apud Carolus Losi 1774./ Romae Superior. permissu Anno. M.D.C.XXXII./ Originale apud ipsum
Verdura.*

REFERENCES: Passavant, 1860, II, p.332; Ruland, 1876, p.82; Rome, 1985, pp.203–04.

The Royal Collection (lent by Her Majesty the Queen from
the *Windsor Raphael Collection*, on deposit at the British
Museum, Ref. no. A.XLIII.5a)

The exact status of this etching is rather complicated. Without
knowing the precise source, the 19th century Raphael scholar
Passavant guessed fairly accurately that it reproduced a variant of
Raphael's *Madonna del Passeggio* painted by a pupil of Guido Reni,
who, like Lanfranco, had been taught by Annibale Carracci. It is in
fact based quite closely on the painting by Lanfranco now in a
private collection in London (see previous entry, n.5). The caption
of the print nevertheless credits the invention of the design to
Raphael himself, no doubt a good selling point in view of the god-
like status accorded to Raphael by 17th century artists and
collectors.

We learn from the print that in 1632 the painting was in the
collection of a certain Nicola Verdura. In 1621 Verdura had
himself published an etching after his picture, which reverses the
design.[1] That the Stefanoni print is again in the same sense as the
painting suggests that he may have based it on Verdura's etching
rather than directly on the Lanfranco copper.

The present impression of the etching was published in Rome
in 1774 by Carlo Losi. He must have acquired the original copper
plate etched in 1632 by Stefanoni,[2] burnished out the latter's
name and inserted his own instead, and then printed impressions
from it. It is therefore effectively a second state of Stefanoni's
etching, produced nearly a century-and-a-half after the first.
These various prints, all purporting to reproduce a work by
Raphael himself, testify to the enduring popularity of the *Madonna
del Passeggio* composition, albeit in corrupted form.

The Psyche Loggia
in the Villa Farnesina

The following four drawings were all made in connection with the fresco decorations illustrating the story of Cupid and Psyche in the entrance loggia to Agostino Chigi's suburban villa on the banks of the Tiber in Trastevere (fig. 60). The villa was acquired by the Farnese family at the end of the sixteenth century and has been known since then as the Farnesina. Agostino Chigi was an extremely wealthy Sienese banker who served three successive popes and was a personal friend of two, Julius II and Leo X. He was not a particularly erudite man, but he liked to entertain and was a great lover of the arts who showed both discrimination and largesse in his patronage. At his villa, intended as a place of retreat and relaxation, he recreated an ancient Roman style villa with a garden accomodating classical statues and inscriptions. As his architect, Chigi chose his compatriot Baldassare Peruzzi, who was later also involved in the fresco decoration of the interior. Other artists employed on this project included another Sienese, Sodoma, the Venetian Sebastiano del Piombo, and Raphael himself, whom both Vasari and Pietro Aretino describe as a very close friend of the banker, and who around 1512 contributed his celebrated fresco of *Galatea*, which gave its name to the second loggia in the villa. It was about five years later, after many delays, that Raphael undertook to paint the principal loggia. In the meantime he had remodelled and decorated family chapels for Chigi in two important Roman churches, Santa Maria della Pace and Santa Maria del Popolo.

For the first time in his career Raphael here had an opportunity to tackle a narrative cycle drawn from classical literature. This happily coincided with a time when he was deeply immersed in the classical world in his official capacity as supervisor of ancient Roman monuments, and he was pursuing a most ambitious project for an accurate scientific reconstruction of the whole of ancient Rome. The main literary source for the fable of Cupid and Psyche was Lucius Apuleius' *Metamorphoses*, or *Golden Ass*, but it has been shown that Raphael or his literary advisors also drew on more recent interpretations of the story.[1] His decorations were never completed. Several crucial episodes in the story which do not feature in the loggia were certainly planned for the lunettes

(see cat. no. 47), and it is possible that further scenes were envisaged for the lower walls. It is probable in any case that the frescoes were not simply illustrative, but were also intended to allude allegorically to events in Agostino Chigi's personal life, notably his long-standing affair with a Venetian woman, Francesca Ordeasca, which was legitimised by Leo X in a ceremony which took place at the villa itself shortly after the loggia decorations were unveiled. This may have determined to some extent which scenes from the fable were included and which omitted.[2]

From a design point of view, Raphael faced the tricky problem of accomodating a sequence of episodes from the narrative intelligibly in the awkward picture fields of the loggia, which consisted of a flat vault pierced at the sides by lunettes, with spandrels above them and pendentives to either side. Raphael clarified this structure by using it as the framework for a pergola, made up of swags of flowers and fruit painted by his specialist assistant Giovanni da Udine, which effectively demarcates the individual picture fields. The two principal multi-figured scenes on the vault, the *Council of the Gods* and the *Wedding Feast of Cupid and Psyche* (see fig. 63), are painted in the form of simulated tapestries suspended from the pergola to form an awning. The pendentives are occupied by large and for the most part naked gods and goddesses seen agaist a background of open sky, while flying putti sporting the attributes of assorted pagan deities are painted in the spandrels. The overall light and airy atmosphere is most appropriate for a suburban retreat.

Raphael must have been personally responsible for the design of the decoration as a whole, which would have been worked out in some detail before any painting began. It was recognised very soon after their unveiling, however, that the frescoes themselves did not come up to Raphael's usual high standard of execution. Vasari commented that the nudes lacked Raphael's *characteristic grace and sweetness*, and he attributed this to the fact that they had been *to a large extent coloured by others following his designs*.[3] In their present condition, after much deterioration and numerous restorations, it is impossible to ascertain the degree of Raphael's own participation, but so heavily committed was he elsewhere

that it seems perfectly possible that he left the execution entirely to assistants.

About twenty or so preparatory drawings, the majority in red chalk, can be related to the *Loggia di Psiche*, and very many more must once have existed. There have been endless arguments in the Raphael literature over the attribution of the surviving sheets alternatively to Raphael himself or to one of his principal assistants Giulio Romano or Gianfrancesco Penni. This is probably the most intractable of all Raphael connoisseurship problems. The authorship of no single drawing in this group has met with universal agreement, and perhaps no more than half a dozen are by Raphael himself. The uncertainty in itself bears witness to Raphael's skills as a teacher and manager. He was good at delegating and ran a very well-organised workshop, and he had trained his best pupils to imitate both his drawing and his painting styles to perfection. The problem is complicated by the fact that during his last years, when delegation of even important tasks became standard practice in his studio, Raphael's own art continued to change and evolve, at times in unexpected directions. So the issue centres as much on defining Raphael's own late style as it does on distinguishing the hands of various members of his studio. No attempt has been made in the following entries to cite for each drawing the full range of attributional opinions advanced in the literature, an unenviable task which has thankfully been admirably performed elsewhere.[4]

A letter from Leonardo Sellaio to Raphael's great rival Michelangelo in Florence, dated 1st January 1519 (it actually reads 1518, but Sellaio was probably following the Florentine calendar, according to which the year ended in March), establishes that the Psyche Loggia had just been unveiled. He predictably denigrated the frescoes as *something disgraceful for a great master*.[5]

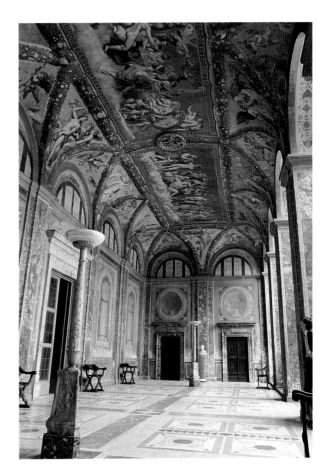

fig. 60 The *Loggia di Psiche*, Rome, Villa Farnesina

GENERAL REFERENCES: Bellori, 1695; Passavant, 1860, I, pp.258-59, II, pp.281-287; Crowe and Cavalcaselle, 1882-85, II, pp.414-23; Shearman, 1964, pp.59-100; Pope-Hennessy, 1970, pp.169-73; Dussler, 1971, pp.97-99; Rome, 1983 (3), pp.25-73; Joannides, 1983, pp.24-25; Jones and Penny, 1983, pp.183-89; Oberhuber, 1983, pp.189-207; Marek, 1983, pp.209-16; Harprath, 1985, pp.407-33; Ames-Lewis, 1986, pp.117-124; Rome, 1992, pp.219-20; Cordellier and Py, 1992, pp.362-64.

45 *Psyche Presenting the Vase to Venus*

Red chalk over stylus underdrawing; 26.4 × 19.8 cm.
INSCRIPTIONS: Numbered in ink at the lower right corner: 4. On the fragment of
Mariette's mount, in his hand: *Fuit Comitis C. Malvasia, deinde D.i Crozat nunc P.J. Mariette*
174[?]/ Psychen divinae formosit. Pyxide/ Veneri offerentem/ Discipulis suis in oedibus Aug. Chigi
Roma/ exprimendam,/ RAPHAEL URB. DELINEABAT.
PROVENANCE: Conte Carlo Cesare Malvasia, Bologna; Pierre Crozat; Sale, Paris, 10th
April 1741 (part of lot 117); Pierre-Jean Mariette (L.1852); Sale, Paris, 15th November
1775 (part of lot 699), bought for the Cabinet du Roi (Louvre museum marks L.1899
and L.2207).
REFERENCES: Passavant, 1860, II, p.284; Shearman, 1964, pp.80–81; Pope-Hennessy,
1970, pp.172–73; Paris, 1983 (1), pp.298–300, no.110; Joannides, 1983, no.414; Knab,
Mitsch, Oberhuber and Ferino Pagden, 1983, no.550; Oberhuber, 1983, pp.192 ff;
Harprath, 1985, pp.417–18; Ames-Lewis, 1986, pp.120–23; Rome, 1992, p.222, no.87;
Cordellier and Py, 1992, p.372.

Paris, Musée du Louvre, Département des Arts Graphiques
(Inv. no. 3875)

The drawing represents the scene from the fable of Psyche in
which Psyche has successfully accomplished one of the near-
impossible tasks which Venus set her as punishment for winning
the love of her son Cupid. Psyche has just returned from the
source of the River Styx bearing a polished crystal jar full of its
water, which she presents to an astonished Venus. The figures
correspond closely to one of the frescoed pendentives in the *Loggia*
di Psiche in the Farnesina (fig. 61), although in the fresco Psyche is
more fully draped and Venus has been given some attributes in
the form of a crown, earrings, an armband and two white doves.
Careful thought was clearly given to the relationship of the
interlocked figures to the inverted triangle of the pendentive, one
border of which is lightly indicated beside Venus.

Although this superb drawing has in the past sometimes been
attributed to Giulio Romano,[1] it is one of the few sheets con-
nected with the Farnesina now unanimously considered to be by
Raphael himself. The figure representing Venus was certainly
drawn first (only she is underdrawn with the stylus), and Psyche
superimposed afterwards, perhaps from the same model in a new
pose, her jar and brow overlapping Venus' left arm. Both figures
certainly give the impression of having been studied from life, an
occurrence by no means common at this date, presumably on
account of restrictions and taboos about artists drawing directly
from naked female models. Vasari recounts a story which may be
relevant in this context, to the effect that Raphael was so infatuated
with his mistress that the only way Agostino Chigi could persuade
him to concentrate on his work was to install her in the villa, but
he skirts round the issue of life-models.[2] The monumental
conception of these mythological figures may to some extent
reflect Raphael's study of classical statuary, but the lovingly
rendered nuances of light and shade playing across their surfaces
suggest living skin and flesh rather than marble. Raphael here

uses an extremely subtle range of delicate hatching strokes to
model the forms.

The time and care involved in producing a chalk drawing with
this high degree of finish might appear self-indulgent in an artist
with so many commitments, but sheets like this may in fact have
saved time by combining several stages of the preparatory process
in one drawing (see also cat. no. 30). In this particular instance we
know that Raphael had already jotted down his first thoughts for
the pendentive in a pen and ink *pensiero* sketch (fig. 62), which is
lively enough in execution but evidently unsatisfactory as a
composition.[3] The present life study may have followed on
directly from this sketch, and in turn served as the model for the
painter. No cartoons have survived for the Psyche Loggia and none
are mentioned in the early sources, so it is possible that this time-
consuming stage of the preparatory process was here by-passed,
especially in relation to the large scale figures in the pendentives.
The restoration campaign currently underway in the Loggia will
hopefully furnish evidence to clarify this issue.

fig. 61
Raphael and assistants
Psyche Presenting the Vase to
Venus fresco
(Rome, Villa Farnesina)

fig. 62
Raphael *Psyche Presenting the Vase*
to Venus
(Oxford, Ashmolean Museum)

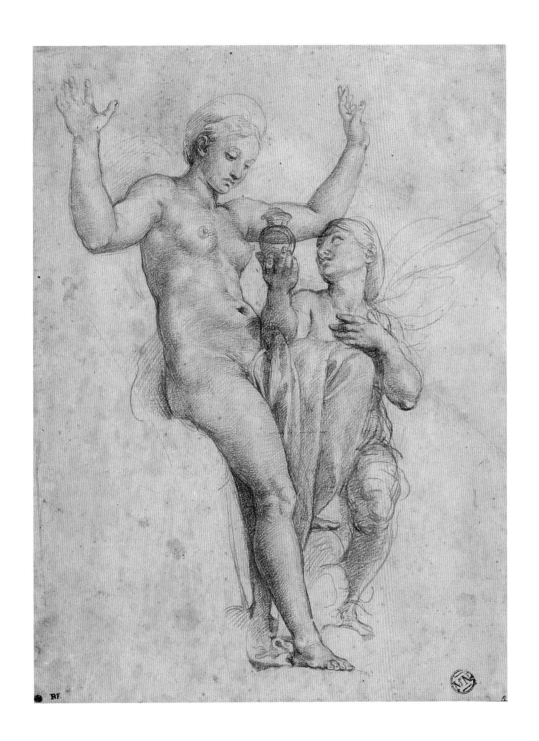

46 Hebe and Proserpina

Red chalk over stylus underdrawing; 25.7 × 16.4 cm.
INSCRIPTIONS: In pen an d ink at the lower left: *Rafael.durbino.*
PROVENANCE: Possibly Joachim von Sandrart; Pieter Spiering van Silfvercroon;
Queen Christina of Sweden; Cardinal Dezio Azzolino; Marchese Pompeo Azzolino;
Don Livio Odescalchi; acquired by the museum in 1790 (L.2392).
REFERENCES: Hartt, 1958, I, pp.32-33, p.288, no.25; Shearman, 1964, p.94;
Joannides, 1983, no.402; Shearman, 1983, p.54; Florence, 1983 (2), p.146, no.62;
Oberhuber, 1983, p.193; Harprath, 1985, p.414; New York, 1989, pp.40-43, no.12.

Haarlem, Teylers Museum (Inv. no. A62)

The two young women in this study correspond to the figures of Hebe and Proserpina seated at table in the fresco of the *Wedding Feast of Cupid and Psyche* on the vault of the *Loggia di Psiche* in the Farnesina (fig. 63). Seen from the back, Hebe, goddess of youth, is placed next to her husband, the deified mortal Hercules, while Proserpina behind accompanies her spouse Pluto, god of the underworld. That the relative positions of the two figures correspond exactly to those in the fresco suggests strongly that the draughtsman here posed his figures in accordance with a fully resolved preparatory modello for the whole composition. This is confirmed by the seven other surviving studies for the scene, all of which focus on single figures or closely related groups of two or three, and all of which were incorporated without significant change into the fresco. There is no trace of such a modello, but it may have resembled one attributed to Giulio Romano which survives for half of the pendant scene of the *Council of the Gods.*[1]

For the scenes on the vault of the Loggia, painted as they are as if woven on the flat surface of a tapestry, Raphael has avoided spatial illusionism in favour of a relief- or frieze-like arrangement. The model for Hebe has been deliberately posed in imitation of a figure in a once-famous classical relief which no longer survives.[2] Without sacrificing naturalism or sensuality, every effort has been made to arrange her component parts as parallel as possible to the picture plane, with support in the form of pillows provided where necessary. A similar pose is used for one of Cupid's servants (alternatively identified as the Three Graces) in a pendentive just below the *Wedding Feast*, a figure considered to be so beautiful by the 17th century writer Bellori that he thought her the only part of the whole decoration painted by Raphael himself. It is likely that the *Wedding Feast* was planned in detail, if not actually painted, relatively early in the project, for one of the Horae scattering flowers at the top of the scene had been transposed into the *Holy Family of Francis I* (Louvre) before May 1518, when that painting was completed.

In terms of attribution, this study is what might reasonably now be termed a classic borderline case in the context of the Farnesina drawings. Critical opinion as to its author is fairly evenly divided between Raphael himself and Giulio Romano, and both arguments have their strengths and their weaknesses. The following observations, which only brush the surface, point to some of the attributional dilemmas involved in connection with this whole group of drawings. The sensitivity shown here in the handling of the red chalk to capture the softness and suppleness of the model's body matches that of Raphael's *Venus Presenting the Vase to Psyche* study (see previous entry), and is hard to parallel in drawings certainly by Giulio. On the other hand, the subsidiary areas of the sheet are less successful. In both execution and expression Proserpina in the drawing lacks incisiveness and conviction. The hatching of the background around Hebe's legs is rather mechanical, and seldom if ever did Raphael devote so much attention to an accessory as the cushions receive here. Comparison with the other preparatory drawings for this scene mentioned above is of relatively little help. The only one certainly by Raphael is a stunning study at Windsor for the Three Graces at the upper right which is unmatched in terms of quality by any of the other Farnesina drawings.[3] The drawings most securely attributable to Giulio, such as that in Berlin for the figure of Pluto, exhibit different qualities to the Haarlem study.[4] The sheet with which the Hebe and Proserpina has most in common in terms of execution is an otherwise much inferior, unattractive study for the poorly articulated figure of Ganymede, to Hebe's right in the fresco, a drawing which has recently been reassigned to Raphael himself.[5] It is not easy to envisage any evidence coming to light which could resolve definitively these thorny, and in the final analysis largely subjective, attributional problems.

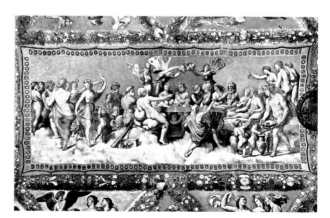

fig. 63 Raphael and Assistants
The Wedding Feast of Cupid and Psyche fresco (Rome, Villa Farnesina)

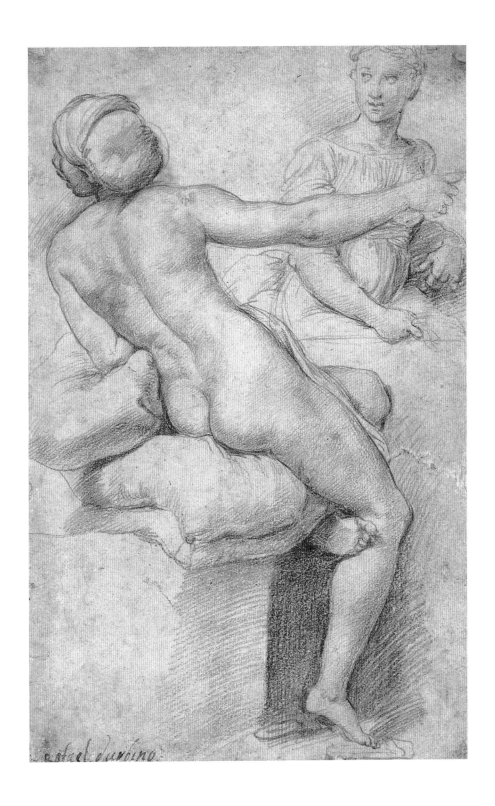

47 *A Kneeling Nude Woman with her Left Arm Raised*

Red chalk with touches of black chalk and traces of stylus underdrawing;
27.9 × 18.7 cm.
PROVENANCE: Sir Peter Lely (L.2092); William, 2nd Duke of Devonshire (L.718);
purchased by the National Gallery of Scotland by private treaty sale from the Trustees
of the Chatsworth Settlement, with the help of grants from the National Heritage
Memorial Fund, the National Art-Collections Fund, and the Pilgrim Trust, 1987.
REFERENCES: Crowe and Cavalcaselle, 1882-85, II, p.262; Shearman, 1964, pp.70, 90;
London, 1983, pp.201-02, no.161; Rome, 1983 (2), pp.176-79; Joannides, 1983, no.420;
Knab, Mitsch, Oberhuber and Ferino Pagden, 1983, no.548; Harprath, 1985, pp.413-
14; New York, 1987, pp.136-38, no.35; Davidson, 1987, pp.510-11; Washington, 1990,
p.30, no.5; Rome, 1992, p.228, no.91.

Edinburgh, National Gallery of Scotland (Acc. no. D5145).

This study from the nude, and the following one from the Louvre, can be related to a composition of the *Toilet of Psyche* planned but almost certainly never executed for the Psyche Loggia. The connection was first made on the strength of a derivative engraving by Giulio Bonasone (cat. no. 50), which includes two maidservants posed in analogous fashion, although in reverse.[1] It was then confirmed by the discovery of a late 16th century copy of the whole composition (cat. no. 49). This shows that the present drawing is a nude study for a figure that in the final composition would have been quite fully draped. The way that the five women in the copy are arranged would have fitted very well into a semi-circular picture field, and it is indeed for one of the lunettes in the *Loggia di Psiche*, rather than lower down on the wall, that this scene was probably intended. The only slight complication with this hypothesis is one of relative scale, for the only other drawing definitely connected with the unexecuted lunettes (it includes summary indications of the arch and base) shows, if we ignore two small putti, a single figure of *Psyche Transported by the Breezes* occupying the entire picture field.[2]

The character of the modelling in this study is freer and more spontaneous than in the Louvre *Venus and Psyche* (cat. no. 45), and there is a delicacy and hesitancy about some of the contours which is absent from that more polished drawing. It shows Raphael working in a slightly different mode. Some of the hatching strokes on the hip and thigh are directional to help generate a sense of the roundness of the forms. The small touches of black chalk on her head are apparently by Raphael himself, since the red chalk hatching used to indicate the girl's elaborate plaits (compare cat. no. 49) overlie them, but the marks on her nipple and belly are later additions. The model may be the same as the one studied in the Haarlem drawing (see previous entry), her hair now plaited. The face and hands of the second woman sketched at the right of the Edinburgh drawing (the sheet has clearly been trimmed on this side) might reasonably be related to the servant visible in the copy arranging Psyche's hair, or to the model holding the mirror, viewed from a different angle.

As in the case of the *Hebe and Proserpina* (see previous entry),

a detailed modello for the whole composition is likely to have preceded the more specific studies from the living model. It may have been this lost drawing which served as the basis for Alberto Alberti's copy. The various drawings for the *Toilet of Psyche* lunette were perhaps made at the time when the flanking pendentives (which relate to it narratively) were being painted, rather than after the completion of the entire vault of the loggia. The present study is stylistically very similar to a life-drawing in the Louvre for the pose of the Virgin Mary in the *Holy Family of Francis* I, painted in the first half of 1518.[3]

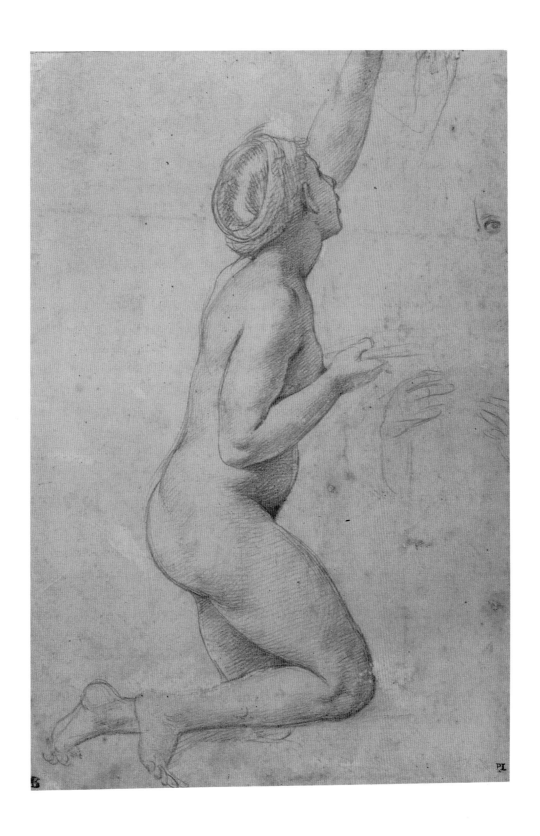

48 Jupiter and Cupid [recto]
A Young Woman Holding a Mirror [verso]

Red chalk with traces of stylus underdrawing (recto only); 36.4 × 25.2 cm.
INSCRIPTIONS: Numbered at the lower right: *21* (recto) and *22*, changed from *21*
(verso), each number accompanied by the paraph of Dezallier Dargenville (see
Provenance). On the mount, in pen and ink, possibly in the hand of Padre
Sebastiano Resta: *Si vede in opera nella Loggia di Ghigi alla Lungara* (recto); RAFAELLO/
Disegno dal vero la sua donna per formarne la Psiche nel consiglio degli Dei (verso).
PROVENANCE: Possibly Padre Sebastiano Resta (L.2992 ?); Pierre Crozat; Sale, Paris,
10th April 1741 (part of lot 110), bought Nourri; A.- J. Dezallier Dargenville
(L.2951); Sale, Paris, 11th January 1779 (part of lot 35); Cabinet Aubanel; Sale,
Nîmes, 1842; Jules de Canonge, Paris (copied by Ingres in 1853 when in this
collection); his bequest to the Louvre, 1870.
REFERENCES: Passavant, 1860, II, pp.284, 480–81; Shearman, 1964, pp.68–70; Paris,
1983 (2), pp.25–26, no.21; Rome, 1983 (2), pp.176–79; Jones and Penny, 1983, pp.184,
188–89; Shearman, 1984, p.402; Harprath, 1985, pp.416–17; Ames-Lewis, 1986,
pp.121–24; Davidson, 1987, pp.510–11; Rome, 1992, p.224, no.88 and p.230, no.92;
Cordellier and Py, 1992, pp.372–74, no.550, p.388, no.603.

Paris, Musée du Louvre, Département des Arts Graphiques
(Inv. no. MI 1120)

The verso of this drawing is exhibited here since, like the Edin-
burgh *Kneeling Nude*, it represents a study relating to the unex-
ecuted lunette fresco of the *Toilet of Psyche* (see previous entry). The
nude corresponds exactly with the maidservant holding a mirror
at the right of the recently discovered copy of this composition by
Alberto Alberti (see following entry). The drawing on the recto of
the sheet relates closely to the pendentive in the Loggia which
depicts Jupiter consenting – rather passionately – to Cupid's
request to marry Psyche. The features and hair of the studio
models in the drawing have simply been modified to better suit
the deities in the fresco.

The drawing presents another extremely difficult problem of
connoisseurship. Regarded until not long ago by many Raphael
scholars as one of his finest surviving studies for the *Loggia di Psiche*,
both sides of the sheet are now widely, and probably correctly,
regarded as excellent and very faithful copies made in Raphael's
studio, after lost drawings by Raphael himself. In this respect the
very fine verso has been tarred with the same brush, so to speak, as
the slightly weaker recto, where the signs that the drawing may be
a copy are more in evidence. The drawings on both sides certainly
appear to be by the same hand, but this is unlikely to have been
that of either of Raphael's best known assistants, Giulio Romano
or Gianfrancesco Penni, since their workload was surely too
demanding to allow them to make painstaking copies of this
kind. On the other hand, this was precisely the sort of exacting
training for the eye and hand that would have been assigned to a
junior apprentice. The trainee who produced these slick copies
must certainly have been a young artist of great promise.

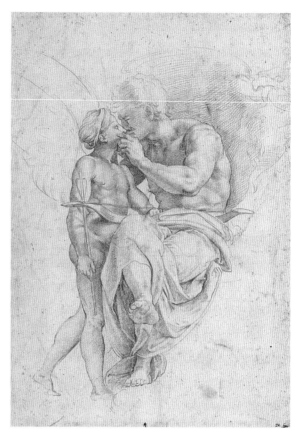

recto

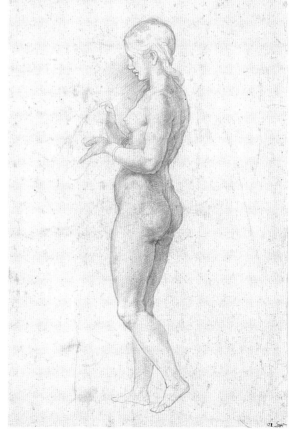

verso

ALBERTO ALBERTI 1526–1598

49 The Toilet of Psyche

Pen and brown ink over black chalk; losses to the edges of the sheet at top and
bottom; 29.3 × 41 cm.
INSCRIPTIONS: On the verso, in a 16th-century hand: *francesco Carissimo mio quanto
fratello salute questa sera per darte Aviso come io/ carissimo mio/ amatissimo mio.*
REFERENCES: Rome, 1983 (2), pp.176-79, no.108; Marek, 1983, p.210; New York,
1987, pp.136-38, no.35; Davidson, 1987, pp.510-11; Washington, 1990, p.30; Rome,
1992, p.233, no.94.

Rome, Istituto Nazionale per la Grafica (Inv. no. F.N. 2983)

Although of relatively little intrinsic aesthetic merit, this drawing
is of great interest for students of Raphael since it accurately
preserves the design of an unexecuted project by him for one of
the lunettes in the *Loggia di Psiche*. It was probably copied from a
now-lost modello, the sort of drawing likely to have been made by
a member of his studio rather than by Raphael himself, although
based on a sketch by him. Two detailed nude studies from a life
model, one by Raphael, the other a copy of a lost drawing by him,
correspond closely to two of the serving girls assisting Psyche at
her toilet in the copy (see the two previous entries). The scene
would have fitted well into the incomplete narrative sequence
actually painted in the Loggia, but a slight doubt remains about
the identification of the subject. According to Apuleius' account,
Cupid's assistants who helped Psyche to bathe were invisible, and
manifested themselves only as disembodied voices. The young
women in this scene, on the other hand, and especially in the life
studies, are palpably real, and Psyche interacts with them. This
inconsistency may have arisen because the imagery for the scene was
drawn from representations of the *Toilet of Venus*, where the same
problem did not occur (see also the following entry).

It has been suggested that an exploratory drawing attributed to
the young Giulio Romano (fig. 64) was preparatory for the seated
Psyche in this composition, which raises some interesting questions
about working procedures in Raphael's studio.[1] It is, however, an
open question whether this sketch is preparatory for or derived from
the figure in the Farnesina design. It has a related drawing on the
verso, apparently an alternative idea for the same figure, which tends
to undermine the connection, since it shows the bathing woman
standing and includes two winged putti or Cupids, indicating that
its subject may be Venus rather than Psyche.

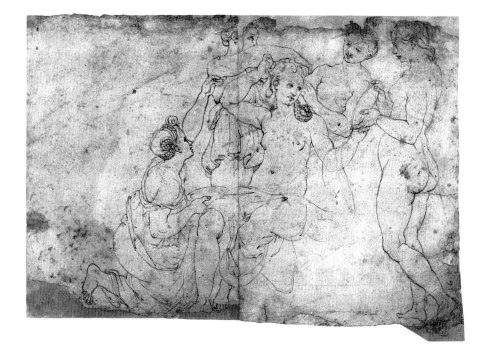

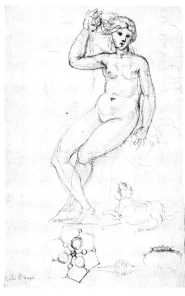

fig. 64 Attributed to Giulio Romano *A Woman at her
Toilet and other Sketches* (Toronto, Art Gallery of Ontario)

GIULIO BONASONE ACTIVE 1531–AFTER 1576

50 *The Toilet of Psyche*

Engraving, first state; 21.6 × 15.9 cm.
INSCRIPTIONS: At the lower right corner: I. BONASONO F.
PROVENANCE: Rev. C. M. Cracherode; his Bequest to the museum, 1799.
REFERENCES: Bartsch, 1803-21, XV, p.153, no.167; Shearman, 1964, pp.69-70; Rome,
1983 (1), I, p.54, no.44; Davidson, 1987, pp.510-513; Rome, 1992, p.232, no.93.

London, The Trustees of the British Museum
(Acc. no. H7 – 103)

This engraving by the Bolognese printmaker Bonasone was
probably made in the mid-1540s. It clearly reflects, in reverse and
in mutated form, Raphael's lost composition of the *Toilet of Psyche*
as recorded in the Alberti copy (see previous entry). It was on the
strength of this print that the Edinburgh *Kneeling Nude* (cat. no. 47)
and the Louvre *Young Woman with a Mirror* (cat. no. 48) were first
convincingly connected with the *Loggia di Psiche*. While that
unexecuted fresco was almost certainly intended to represent the
Toilet of Psyche, the traditional identification of the subject of the
engraving as *Venus Attended by the Graces* may nevertheless be correct,
for the number of maidens has been reduced from five to three.

Relatively little is known about Bonasone's movements, but
his figure style suggests that he knew the work of Giulio Romano
and his followers in Mantua. It is there that he may have gained
access to the design for the Farnesina on which this engraving is
based. Bonasone produced numerous other prints based on
designs by Raphael and his followers.

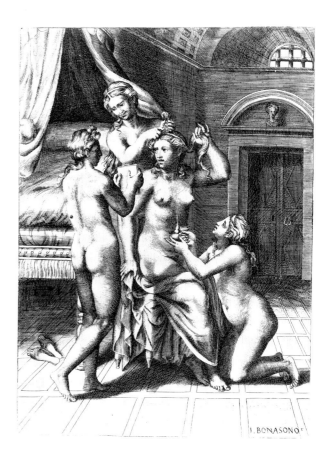

51 *Venus Asking the Advice of Juno and Ceres*

Pen and brown ink and wash over traces of black chalk, heightened with white, on faded blue-grey paper (much foxed); a ruled line in black chalk 8.5 cm from the bottom edge; 37.4 × 26 cm.

INSCRIPTIONS: In the lower left quarter, in pen and brown ink: *Julio Romana/ Jules Romain*. Numbered in pen and black ink: 75. Erased pen inscriptions in dark blue ink at both lower left and lower right. In an 18th or 19th century hand, on the back of the mount, in pen and black ink: *Original Drawing by/ Julio Romano/ Giulio Romano/ born at Rome 1492 died at Mantua 1546/ From the Collections of...*

PROVENANCE: Two unidentified collector's marks; W. F. Watson; his Bequest to the gallery, 1881.

REFERENCES: Andrews, 1968, I, p.103.

Edinburgh, National Gallery of Scotland (Acc. no. D3191)

This is an accurate and early copy, probably from the first half of the 16th century, after one of the pendentive frescoes in the *Loggia di Psiche*. The scene represents the episode from the fable in which the jealous and enraged Venus seeks the advice of the two other goddesses about how to capture and punish the beautiful upstart mortal Psyche. The attribution of the sheet to Giulio Romano inscribed twice on the drawing itself and again on the mount is, however, optimistic. The absence of any indication in the copy of the floral festoons which surround the scene in the Loggia might suggest that it was made from a preparatory modello rather than from the fresco itself, although so closely does it correspond in other respects, particularly in the rendering of light and shade, that this seems unlikely.

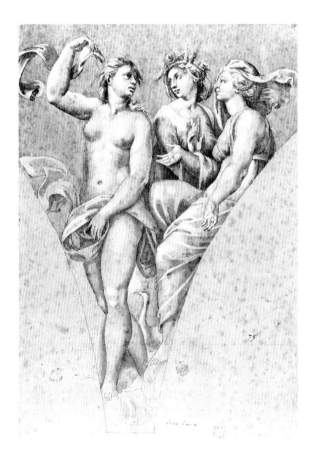

52 Mercury Bearing Psyche to Olympus

Oil on panel; 72 × 94 cm.
PROVENANCE: Listed in Rubens' posthumous inventory, item 76, *Un Psyché après Raphael d'Urbin*; Jeremias Wildens, Antwerp, 1653; Comte de Fraula; his Sale, Brussels, 10th July 1738; Mesdemoiselles Regaus; their Sale, Brussels, 18th July 1775 (lot 1); Jan Gildemeester Jansz;[1] his Sale, Amsterdam, May 11th-13th 1800, bought by Mr. Bryan for the Duke of Bridgewater; thence by inheritance.
REFERENCES: Jaffé, 1967, pp.105-07; Jaffé, 1977, pp.27-28.

Mertoun, St. Boswells, The Duke of Sutherland Collection

This composition by Rubens gathers together numerous disparate figure groups from Raphael's *Loggia di Psiche* and redeploys them within a single picture field. They are arranged in a great ellipse extending deep into space, and in such a way that although extracted from their original context, each group relates to the others in a convincing fashion. Pride of place in the foreground is given to Psyche being borne heavenwards by Mercury. To the left of them is Venus in her chariot drawn by doves, heading in the same direction, and to the right Cupid directing the attention of the Three Graces towards Psyche. Further back, pagan gods and goddesses, most of them identified by their attributes and adapted from the *Council of the Gods* on the vault of the Loggia, form a half-circle around Jupiter and Cupid, who are based on one of the pendentives (see cat. no. 48).

The picture represents Rubens' condensation of the fable as narrated, incompletely, by Raphael. He certainly grasped that in their executed form the frescoes only dealt with the celestial episodes, since he sets his scene firmly in the heavens, with an extensive landscape below. It is possible that Rubens, one of the most learned classical scholars of his period, intended in choosing to paint this picture, and in his selection and arrangement of its elements, some erudite gloss on the fable of Psyche which has not yet been deciphered. On the other hand, it may be that he was simply amused by the idea that the *Council of the Gods* should be assembled to witness the not altogether edifying spectacle of Jupiter kissing Cupid.

Rubens' great respect for the art of Raphael began, through the medium of reproductive prints, even before he left Antwerp for Italy in 1600.[2] One of his earliest paintings, an *Adam and Eve in the Garden of Eden* now in the Rubenshuis in Antwerp, is based on an engraving by Marcantonio Raimondi after a Raphael design. During his years in Italy, Rubens had two prolonged residences in Rome (1601-2 and 1605-8) and must have become very well acquainted with Raphael's mature works in the original. As a painter of great mythological and religious narratives himself, it was predictably to Raphael's grand manner and decorative cycles that Rubens was most attracted. Numerous copy drawings and

adaptations by him, after preparatory studies as well as the finished paintings, testify to his fascination. Together with reproductive engravings and his own recollections of the original works, this corpus of drawings was to serve as reference material and inspiration for many years after Rubens' return to Flanders. One portrait attributed to Raphael and several painted copies after works by him are also listed in Rubens' collection in his posthumous inventory.

The *Mercury Bearing Psyche to Olympus* probably dates from the mid-1620s. Drawn copies by Rubens, evidently made on the spot, after figure groups in the Farnesina survive,[3] but engravings were probably his point of departure for most of the figures in the present painting. Rubens has characteristically transformed these monochrome sources with his bright colours and lively brushwork. The Three Graces, in particular, have been thoroughly 'Rubenised', the marmoreal purity of Raphael's figures giving way here to more fleshy, sensual and vital forms, a process picturesquely, if disapprovingly, described by the 1st Earl of Ellesmere, once the owner of the painting, as *the profanation of expanding Raphael's classical contours into the tumefaction and flaccidity of Flemish female development*.[4]

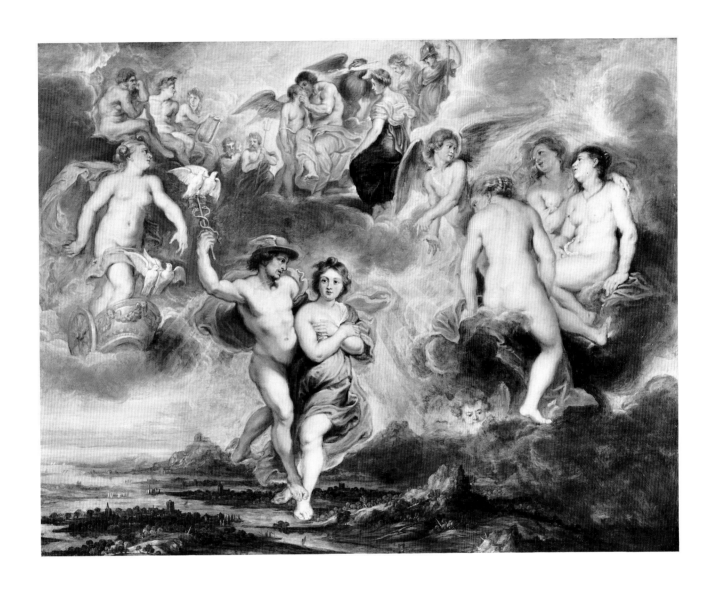

53 *St. John the Baptist in the Wilderness*

Pen and brown ink, heightened with white, over black chalk, on blue paper; a few retouched losses; 27.8 × 17.2 cm.
PROVENANCE: Sale, Christie's, London, 15th December 1992 (lot 52); Martin Moeller, Hamburg. Puchased 1993.

Edinburgh, National Gallery of Scotland (Acc. no. D5363)

This drawing is closely related to a famous composition by Raphael described by Vasari as having been painted in Rome for Cardinal Pompeo Colonna, and which since 1589 has hung in the prestigious Tribuna gallery of the Uffizi in Florence (fig. 65).[1] Raphael's authorship of that painting was uncontested until the mid-19th century, but since then it has widely been regarded as a studio work, with Giulio Romano considered the most likely executant. A recent restoration has brought with it a re-attribution of the picture to Raphael himself.[2] The subject shows St. John the Baptist isolated in a rugged landscape. He stares out at the viewer while pointing forcefully at a long cane cross tied to a branch (a detail cut off at the left edge of the drawing), and in his other hand holds a banderole. While certainly powerful and didactic in its presentation of the saint, it is difficult to escape the conclusion that the subject was here used as a pretext for the display of a handsome adolescent scantily draped in a leopard skin. When Vasari reports that its first owner felt *very great love for the beauty* of the painting, one suspects that he is referring more to its subject than to its skilful execution.[3]

The drawing is probably based on a now lost life-study for the painting by Raphael. Two other copies of the same drawing, both in red chalk (the likely medium of the original), are in Vienna[4] and in the Uffizi,[5] the latter, much damaged, considered by some to be the original. The main difference between the drawing and the Uffizi canvas is the introduction in the latter of the leopard skin (only 80 years later did Caravaggio risk a fully naked St. John the Baptist).

The attribution of the sheet to Penni is here qualified only because almost any statement concerning this elusive artist needs to be made with reservations.[6] He evidently joined the studio within a few years of Raphael's arrival in Rome, and became one of his most senior and prolific assistants. As his nickname il *Fattore* (meaning maker or executant) implies, he was more a sensitive and faithful interpreter of his master's designs than a strong and independent artistic personality like his fellow pupil Giulio Romano. Penni is often associated with the production in Raphael's workshop of elaborate preparatory modelli, and Vasari confirms that he specialised in highly finished drawings of this kind. This description obviously applies well to the present drawing, with its

firm contours, tightly controlled pen hatching and equally meticulous application of lead white with the tip of a brush. It shares these characteristics with a study of *Jonah* in the Royal Collection at Windsor Castle (fig. 66), which must be by the same hand.[7] The Windsor drawing, which in similar fashion probably elaborates a study by Raphael (in this case for a statue in the Chigi Chapel in Santa Maria del Popolo), has long been attributed to Penni.[8] The model used for the two drawings may well be the same and from the chest down, if we ignore the drapery in the *Jonah*, even the poses are remarkably similar. In each sheet there are traces of rather feeble but precise black chalk underdrawing left visible as pentimenti. Close parallels can also be found with several other studies attributed to Penni.[9]

Allowing for considerable license on the printmaker's part, the present drawing may have served as the basis for Ugo da Carpi's chiaroscuro woodcut of the composition.[10] Its three-tone technique would have served this purpose very well.

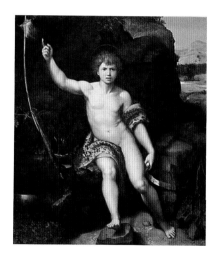

fig. 65
Raphael
St. John the Baptist
(Florence, Uffizi)

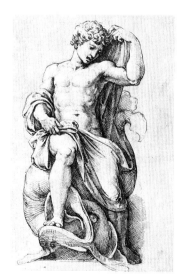

fig. 66
Giovanni Francesco Penni
Jonah (Windsor Castle, Royal Collection © 1994 Her Majesty The Queen)

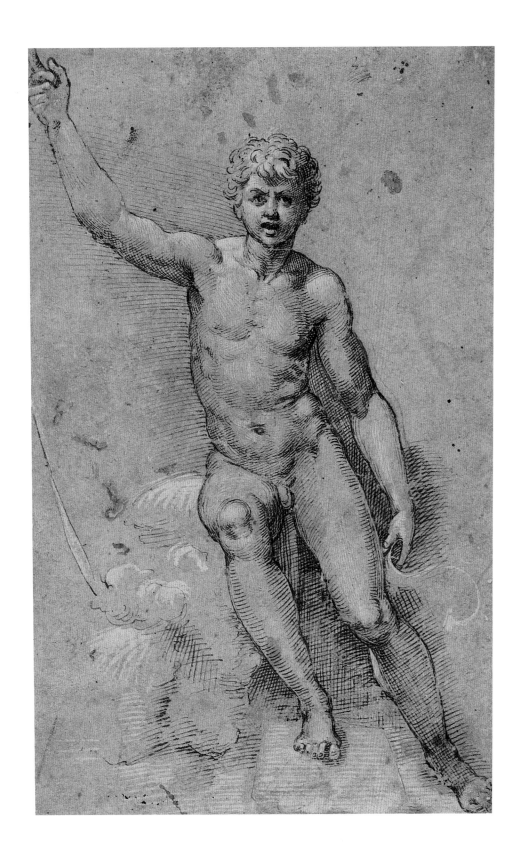

54 The Holy Family with the Infant St. John the Baptist (the 'Novar Madonna' or 'La Vierge à la légende')

Oil on panel; 82.5 × 63.5 cm.

PROVENANCE: Lord Gwydir, Grimsthorpe, by 1812; his Sale, Christie's, 8th May 1829 (lot 58), bought C.J. Nieuwenhuys; his Sale, Christie's, 10th May 1833 (lot 67); Hugh A.J. Munro of Novar; Sale, Christie's, 1st June 1878 (lot 152), bought Agnew's for Lord Dudley; Sale, Christie's, 25th June 1892 (lot 82), bought James Reid; thence by inheritance.; bought National Gallery of Scotand with the aid of the National Heritage Purchase Grant (Scotland), 1980.

REFERENCES: Passavant, 1860, II, pp.333-34; Crowe and Cavalcaselle, 1882-85, II, pp.478-79; Brigstocke, 1978, pp.665-66; Joannides, 1985, pp.31-32; Mantua, 1989, pp.35-37, 71-72, 211; Brigstocke, 1993, pp.69-71.

Edinburgh, National Gallery of Scotland (Acc. no. 2398).

Giulio Pippi, called Romano from his birthplace, was Raphael's most talented pupil and assistant, who, after his master's death, jointly took over responsibility for the studio with Gianfrancesco Penni, and in 1524 left Rome to become court painter, architect and designer to the Gonzaga family in Mantua. As an executant and collaborator of Raphael, he was capable of mimicking his master's style very convincingly, but even during Raphael's lifetime he produced independent works which display rather different tendencies. Some of his most fascinating early pictures are those, including the present panel, which rework in his own idiom compositions designed by Raphael himself (see below). As well as highlighting Giulio's own stylistic preferences, the contrast also tells us much about Raphael's 'originals' (the term is here used loosely, for Giulio was himself probably involved in the execution of some of the works in question). Giulio went on to develop a highly personal manner which was in some respects fundamentally opposed to the basic principles underlying Raphael's own art.

The main figure group in the Novar Madonna is derived from a Holy Family attributed to Raphael in the Prado (fig. 67), known misleadingly as the Virgin of the Rose (the flower is a later addition).[1] The status of that painting is difficult to assess, partly because it is one of the few paintings produced in Raphael's studio which is on canvas (others are the Sistine Madonna in Dresden, the St. John the Baptist in the Uffizi and three of the later portraits), and partly because the range of styles of which Raphael was capable in his last years is still not clearly defined. Its execution is certainly of a very high calibre, and the existence of this variant by Giulio itself argues that the basic design of the Prado canvas is by Raphael. Analogous pairings exist between Raphael's Madonna della Seggiola (Palazzo Pitti, Florence)[2] and Giulio's Wellington Virgin and Child (Apsley House, London);[3] the Holy Family known as La Perla (Madrid, Prado) and Giulio's Madonna del Gatto (Naples);[4] and La Fornarina (Galleria Nazionale, Rome) and a Portrait of a Naked Woman by Giulio in the Pushkin Museum in Moscow.[5]

In the Novar Madonna Giulio made several major changes to the composition of the Virgin of the Rose, plus a few minor adjustments. The setting is now out-of-doors, with a monumental architectural backdrop. Joseph, here accompanied by a donkey, has been relegated to the obscurity of the background archway, an arrangement much favoured by Giulio but which has its source in Raphael (see cat. no. 36). At the bottom of the compostion the Virgin's legs have been extended, only to be rather bizarrely and abruptly cut off at the ankles by the frame. The Baptist has been given a not very convincing right leg. The effect of these changes was to transform a relatively intimate, natural and harmonious design into a more spacious but more unstable one. The oddity of Giulio's scene is emphasised by the extraordinary use of colour, with its combination of acidic green and pink, pastel purple and brilliant turquoise. The fiery orange of the tassel on the cushion is echoed by the tiny flame of Joseph's lamp in the background. The blue is of an intensity found nowhere else in Giulio's work, the richness of the colour enhanced through contrast by painting the underlying layer in red (see John Dick's introductory essay). The harsh, metallic highlights and porcelain-like finish of the flesh areas are emphasised, in contrast to the Prado painting, by the panel support. The main figure group in the Novar Madonna is much more thickly painted than the background, with the draperies handled in an unusually loose, exploratory manner.

The architectural structure, an arched passage flanked by monumental rusticated half-columns with niches beyond, is probably intended to represent a classical triumphal arch. Giulio demonstrates his erudition by following closely the description of the Tuscan order given by the classical architectural writer Vitruvius, down to the unusual circular column bases.[6] The heavy rustication anticipates that used later in Giulio's most famous building, the Palazzo Te in Mantua.

The Novar Madonna probably dates from about 1520-1, shortly after Raphael's death.

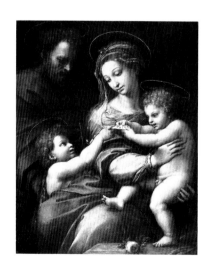

fig. 67
Raphael
The 'Virgin of the Rose'
(Madrid, Prado)

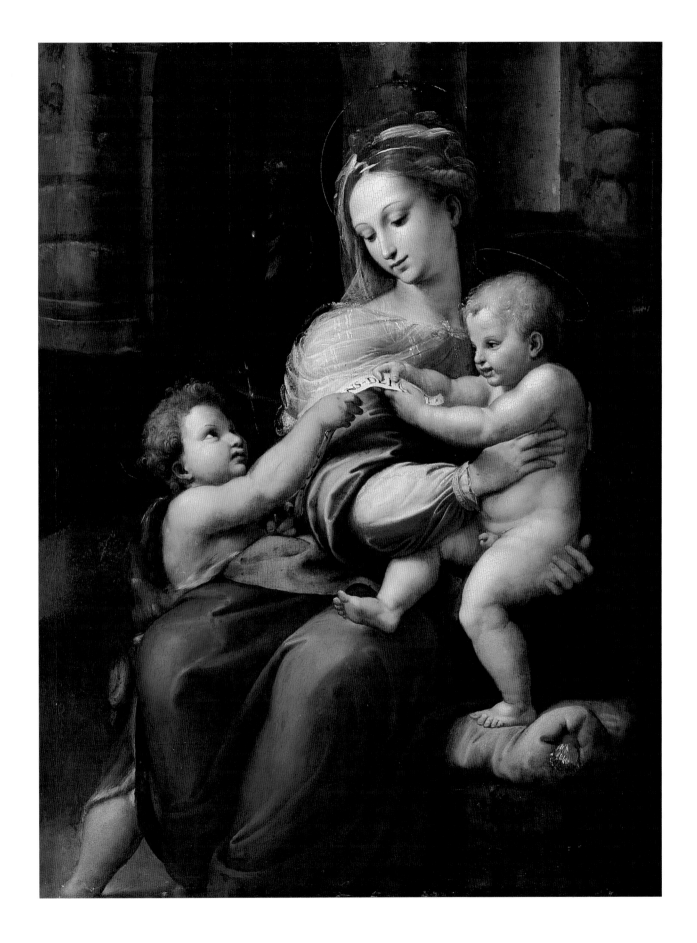

55 Two Heads from a Composition of the 'Massacre of the Innocents'

Tempera on paper (made up of two sheets joined together); parts of the surface creased and abraded, with some retouching; 52.3 × 36.1 cm.
PROVENANCE: Jonathan Richardson Senr.; his Sale, Cock's, London, 4th March 1747 (lot 52), bought Price; 5th Duke of Argyll; his Sale, Langford's, London, 1779 (day and month unknown), bought John Flaxman; given by him to John Saunders, Bath; Sir David Munro, Edinburgh; his Bequest to the Royal Scottish Academy, 1878–79; transferred, 1910.
REFERENCES: Passavant, 1860, II, p.219; Pouncey and Gere, 1962, pp.80–81; Vatican, 1984, pp.326–331; Brigstocke, 1993, pp.71–73.

Edinburgh, National Gallery of Scotland (Acc. no. 638)

This is a fragment of a cartoon for a tapestry of the *Massacre of the Innocents* (fig. 68), one of a series of twelve in the Vatican known as the *Scuola Nuova* tapestries, to distinguish them from the more famous *Scuola Vecchia* series representing the *Acts of the Apostles*, designed by Raphael himself for the walls of the Sistine Chapel.[1] The Edinburgh fragment corresponds, in reverse, to the two anguished mothers just above the centre of the composition. Six of the *Scuola Nuova* series deal with subjects from the infancy of Christ, with three separate panels devoted to the *Massacre of the Innocents* alone. The remaining subjects represent events after Christ's Passion, and in fact probably constituted a separate set of six, which could periodically replace the earlier scenes. That both groups are made up of tapestry panels of varying width and lighting suggests strongly that they were commissioned for a specific room, to cover wall areas of differing dimensions separated by windows and doorways. The room in question may have been the large papal audience chamber known as the Sala Regia, which adjoins the Sistine Chapel in the Vatican. Nothing is known about the origins of the commission, but the patron was likely to have been either Leo X (one early source states as much) or Clement VII. A final payment from the papal coffers was authorised in October 1524 to Pieter van Aelst in Brussels, in whose workshop the tapestries were woven (as the *Acts of the Apostles* series had been), although the finished tapestries did not arrive in Rome until 1531.

Vasari specifies that Gianfrancesco Penni was involved in the execution of the cartoons,[2] but this is improbable since these were apparently made in Brussels. Several modelli connected with the series can, however, be attributed to him, including three now in Haarlem corresponding to the *Massacre of the Innocents* panels. This does not necessarily mean that Penni was responsible for their designs, and most scholars in fact attribute the compositions to Giulio Romano. It is not known which member of the Giulio-Penni atelier was in Brussels to execute the cartoons themselves, including the Edinburgh fragment, but a plausible candidate is Tommaso Vincidor, who had performed a similar role a few years previously in connection with the *Giochi di putti* tapestry series (see cat. no. 57).

In contrast to cartoons for frescoes or panel paintings (see cat. no. 28), those for tapestries were usually coloured in tempera and they were used in rather a different way, with no direct, mechanical transfer process involved. They were cut into pieces, placed under the appropriate section of the warp, and the design and colours carefully copied in silk by the weavers. Since they worked from the back, the design was reversed in the process. The use of colour in the cartoons enabled the designer to retain control over this aspect of the tapestries, even if they were being manufactured abroad.

An annotation to a late 18th century edition of Vasari's *Lives* specifies that *early in the eighteenth century was imported from Holland a considerable portion ... of the Massacre of the Innocents ... not less than fifty pieces (of which), consisting chiefly of heads, hands, and feet ... fell into the possession of the elder Richardson.*[3] Among these was the present fragment, and other pieces from the same collection, relating to all three of the panels, are now in the Ashmolean Museum,[4] Christ Church, Oxford,[5] the British Museum[6] and the Foundling Hospital in London.[7] One additional fragment which is likely to have formed part of this group was formerly in the Clifford Collection.[8]

left fig. 68
Workshop of Pieter van Aelst
The Massacre of the Innocents tapestry
(Vatican, Musei Vaticani)

below fig. 69
Workshop of Martin Reynbouts
'*The Prisoner Chiefs*' tapestry
(Madrid, Patrimonio Nacional)

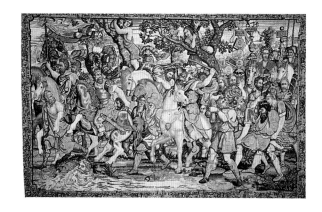

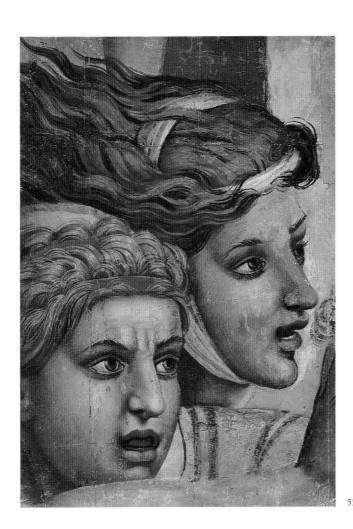

55

56

56 Head of a Bearded Man and a Right Forearm

Tempera on paper, much creased; 35 × 37.5 cm (maximum dimensions).

Private Collection, Scotland

This unpublished cartoon fragment relates to a tapestry of the *Prisoner Chiefs* (fig. 69) designed by Giulio Romano as part of a series of 22 scenes from the life of Scipio Africanus. The forearm and head in the fragment correspond respectively, in reverse, to the Roman cavalryman in the left foreground of the tapestry and the prisoner behind him. The set in fact consisted of two groups, a dozen panels representing Scipio's *Feats* (*Geste*) during the Punic Wars, and the remaining ten the Roman *Triumph of Scipio*.[1] It is to the latter series, which were inspired by Mantegna's famous *Triumphs of Caesar* then in Mantua, that the *Prisoner Chiefs* belongs. It shows Numidian and Carthaginian chiefs and generals captured during Scipio's campaigns being ignominiously paraded through the streets of Rome. The original set (*editio princeps*) of the tapestries began as a speculative venture on the part of a Brussels merchant, Marc Crétif, but the commission was taken over by Francis I, king of France, in 1532, and brought to completion by April 1535. Woven in Brussels, possibly in the Van der Moyen workshops, these extremely sumptuous tapestries of silk and gold were sadly destroyed during the French Revolution. Several replica sets were, however, produced during the 16th and 17th centuries, including the incomplete and partly mutilated series now in Madrid of which fig. 69 forms part.[2]

A *petit patron* (modello) by Giulio exists for all ten of the *Triumph of Scipio* suite, including one in the Louvre for the *Prisoner Chiefs*.[3] These modelli are in the same sense as the tapestries and therefore reversed in relation to the cartoons. The process of reversal and enlargement would no doubt have been delegated by Giulio to assistants, and there is evidence that the cartoons were actually executed in Brussels. It was much easier to carry a few small and highly finished drawings over the Alps than it was to transport bulky and fragile full-scale cartoons. Giulio's modelli for the *Triumph* were probably drawn in 1532. Those associated with the earlier part of the cycle dealing with Scipio's *Feats* are more problematic, since they appear to be by Gianfrancesco Penni. They probably date from 1528 when Penni was again collaborating with Giulio in Mantua.

Although much damaged, passages of considerable quality are evident in this cartoon fragment, notably in the depiction of the hair. The entire cartoons for two of the other scenes in this series survive.[4]

57 A Bacchanal of Putti [recto]
A Standing Female Figure, a Woman's Head in Profile and a Satyr [verso]

Pen and brown ink; 26.6 × 40.9 cm, the left edge irregular.
INSCRIPTIONS: On the recto of the mount, in ink: *box-3-1803/Raffaello*. On the verso, in ink: *chopt with m.r/* [two illegible words]; on the mount, top centre: *H.50./Y.51.2./ GG.41./*; lower left: *1803 WE P94. N40* [a second zero cancelled]/; lower centre: *Formerly in the coll.n of S. Peter Lely/Jon.n Raichardson Sen.r/John Barnard.*
PROVENANCE: Sir Peter Lely (L.2092); Jonathan Richardson Senr. (L.2184); John Barnard (L.1419); William Esdaile (L.2617), 1803; Sale, Sotheby's, London, 11th May 1960 (lot 6), bought H. M. Calmann. Purchased 1960.
REFERENCES: Andrews, 1968, I, pp.57-58.

Edinburgh, National Gallery of Scotland (Acc. no. D4827)

This amusing and very fluent drawing takes up a theme of disporting putti popular in Raphael's circle which probably had its origins in a classical literary source, the *Imagines* of Philostratus, and which derived inspiration from antique sarcophagus reliefs.[1] Shortly before his death, Raphael himself may have been involved with the design of a series of twenty tapestries with this theme of *Giochi di putti* commissioned by Pope Leo X. These were woven in Brussels in the workshop of Pieter van Aelst following cartoons completed there in July 1521 by Raphael's Bolognese pupil Tommaso Vincidor.[2] There is evidence to suggest that they were destined to hang, perhaps only periodically, in the Sala di Costantino, the last of the Vatican Stanze, which was frescoed by Raphael's assistants Giulio Romano and Gianfrancesco Penni after their master's death. A second series of fifteen *Giochi di putti* tapestries representing similar subjects – amorini dancing, playing, gathering fruit and flowers, etc. – was designed by Giulio himself for Duke Federico II Gonzaga in Mantua, a project which began in 1539 and was taken over after the Duke's death the following year by Cardinal Ercole Gonzaga.[3] These tapestries were woven by Nichola Karcher and his team in a workshop probably

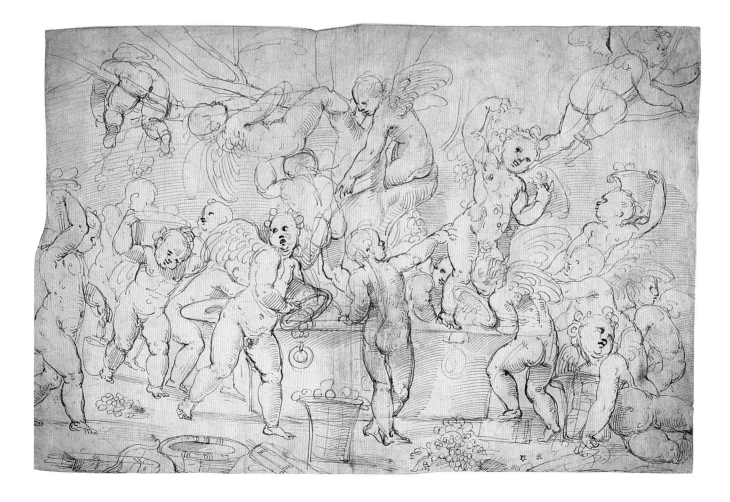

58 *A Battle Scene*

Pen and brown ink and wash, heightened with white (partially oxidised), over
black chalk; squared in black chalk; 26.6 × 33.9 cm.
INSCRIPTIONS: At the lower right, in ink: *Giulio Romano*, and numbered 4.
PROVENANCE: Charles Rogers (L.624); W. F. Watson; his Bequest to the gallery, 1881.
REFERENCES: Andrews, 1968, I, p.58.

Edinburgh, National Gallery of Scotland (Acc. no. D3083)

specifically set up for this purpose in Mantua itself.

Neither of these tapestry series, however, appear to have
included a subject corresponding exactly to the present drawing,
in which a crowd of amorini are busily gathering grapes and
making wine. One or two of them – the little fellow balancing on
the edge of the wine-vat and the putto falling over his basket in
the lower right corner – are already inebriated. The sheet has a
spontaneity about it which suggests it may have been drawn as an
end in itself. On stylistic grounds it can be dated around 1530. A
very similar putto appears in a drawing by Giulio of the *Neptune
Abducting Amymone* in the Louvre,[4] which is a study for a stucco
relief executed in 1527-8 in the Sala delle Aquile in the Palazzo Te
at Mantua.

None of the sketches on the verso has been connected with
any other surviving work by Giulio. The use of the pen for the
satyr is uncharacteristically weak and hesitant and this sketch may
therefore be by a different hand.

The conception of this battle scene has its roots, as do so many
later battle pictures, in the *Victory of Constantine over Maxentius at the
Milvian Bridge* in the Sala di Costantino in the Vatican, painted by
Raphael's assistants, Giulio himself most prominent among
them, in 1520 or shortly after. That fresco in turn incorporates
recollections of Leonardo's equally influential *Battle of Anghiari*
cartoon. This drawing, until recently catalogued as a copy after
Giulio, appears rather to be an elaborate modello by him dating
from the late 1520s.[1] The horsemen at the centre and to the right
of the sheet, but not the remaining figures, reappear in a fresco on
the vault of the Loggia della Grotta in the Palazzo Te in Mantua,[2]
executed by Giulio's assistants. A drawn copy of the fresco, or
more likely of a lost preparatory modello for it, is in the Uffizi, and
was published as an aquatint by Stefano Mulinari in 1774.[3]

Stylistically comparable modelli by Giulio, which feature
similarly elongated and contorted figures, include the *Caesar
Ordering the Burning of Pompey's Letters* and the *Soldiers with Women and
Children*, both in the Louvre, and the *Resurrection of Christ* in Berlin.[4]

57 verso

59 The Virgin and Child with the Infant St. John the Baptist and St. Elizabeth

Pen and brown ink and wash, heightened with white, over black chalk, on paper washed brown; 43.8 × 32.5 cm.

INSCRIPTIONS: On back of mount, in pen and brown ink: *Francesco Penni, Call'd Il Fattore/ born A:d: 1488. d: 1528.../ N: 41./ Bought at Hudson's Sale A:d: 1779*

PROVENANCE: Thomas Hudson (L.2432); his Sale, Langford's, London, 15th March 1779; David Laing; his Bequest to the Royal Scottish Academy, 1878.

Edinburgh, National Gallery of Scotland, on loan from the Royal Scottish Academy (Acc. no. RSA 876)

This unpublished drawing is a copy, possibly dating from as early as the 1520s, after the main figure group in the Holy Family known as *La Perla*, now in the Prado Museum in Madrid (fig. 70).[1] This was painted in Raphael's studio around 1518-20 for Ludovico Canossa, bishop of Bayeux. As with many of Raphael's late works, the respective contributions of Raphael himself and of his workshop (in this case probably Giulio Romano) in its execution has been much debated.[2] The evidence of preparatory studies for each of the infants on a double-sided sheet in Berlin,[3] and of recently revealed underdrawing,[4] argue in favour of extensive studio participation. The painting's nickname derives from the report, perhaps apocryphal, that it was described by King Philip IV of Spain as the 'pearl' of his collection.

The background aside, the present drawing differs in several respects from the painting, most notably in the pose of the Baptist and the absence of his animal skin. Comparison with infra-red photographs shows that the latter was also absent at the underdrawing stage. This drawing was therefore probably copied from a now lost drawn modello for the painting, rather than from the painting itself. The old attribution of the sheet to Penni, while not convincing, is interesting, since he is now often associated with the production in Raphael's studio of elaborate wash modelli of this kind. We know in the case of *La Perla* that no full-size cartoon was prepared, because the underdrawing includes a squared grid to facilitate the enlargement of the design from a smaller scale modello, which would have been similarly squared. The more upright posture of the young St. John was studied in one of the chalk drawings in Berlin mentioned above, which must have been made between the modello and underdrawing stages. This seems to have been a common procedure in Raphael's workshop (see cat. no. 46).

The present copy is therefore valuable as a record of a preparatory stage for the Madrid painting otherwise unknown to us. It is also a sheet of some beauty in its own right. The handling of the head and drapery of the Virgin, the best passage in the drawing as in the painting, suggests that it may be by one of the numerous Bolognese artists infatuated with Raphael's style at this time.

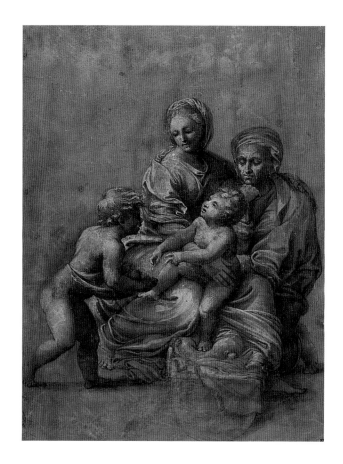

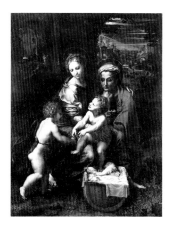

fig. 70 Raphael *'La Perla'* (Madrid, Prado)

ATTRIBUTED TO GIOVANNI DA UDINE (GIOVANNI NANNI OR DEI RICAMATORI) 1487–1561

60 *A Bacchanalian Figure Supported by Two Women*

Pen and brown ink over black chalk; the verso in black chalk only; 32.4 × 25.6 cm.
INSCRIPTIONS: At top centre, scarcely legible: *porta la (?) cesta...*; at the lower right, in
ink: *Bachio Bandinelli.*
PROVENANCE: David Laing; his Bequest to the Royal Scottish Academy, 1878;
transferred 1910.
REFERENCES: Andrews, 1968, I, p.57; Dacos, 1977, pp.257-58; Nesselrath, 1983,
p.364.

Edinburgh, National Gallery of Scotland (Acc. no. D644)

Previously catalogued as a copy, the suggestion that this might be
the original study for a figure group which formed part of the
decoration of one of the pilasters in the Vatican *Logge* is borne out
by the many discrepancies between the pen and ink contours and
the chalk underdrawing.[1] The stucco and grotesque decorations of
the *Logge*, inspired by antique examples, were executed by a team of
artists working under the direction of Giovanni da Udine, while
Giulio Romano and Gianfrancesco Penni were responsible for the
biblical scenes in the vaults. Giovanni was a specialist stuccoist and
decorative painter with a great talent for flora and fauna, and a
passion for the Antique which led him to rediscover the recipe for
white stucco used by the ancients.[2] He was trained originally in his
native province and under Giorgione in Venice, and appears to
have worked with Raphael in the capacity of independent collabo-
rator rather than assistant. He was responsible for the pergola and
the birds in Agostino Chigi's Psyche Loggia and at the Vatican he
also later decorated the loggie on the floors above and below
'Raphael's Logge'.

The original fresco to which this drawing relates is much
deteriorated, but it is known from 18th-century engravings.
Strategically placed festoons designed to cover the nakedness of
the female figures were added to the fresco by Giovanni later in his
career on the orders of Pope Pius IV. Although Giovanni da Udine
had overall responsibility for this part of the decoration, it is by no
means certain that he executed the present drawing or the
corresponding frescoed figures.[3] As a specialist in flowers and
animals, this indeed seems unlikely, although it would help to
explain the considerable weaknesses evident in the draughtsman-
ship and anatomy of the female figures in particular. No convinc-
ing stylistic parallels can be found among the identified drawings
by Giovanni da Udine, with the debatable exception of one sketch
at Windsor.[4] With the drawing styles of many of the artists
collaborating in the *Logge* as yet completely or largely undefined,
the question of the authorship of the present sheet must for the
time being remain open.

In common with the rest of the *Logge* decorations, the present
group is inspired by antique sources. A loose connection with the

Borghese *Dancing Maidens* in the Louvre has been noted,[5] and it is
difficult not to perceive in the arrangement of the figures a sort of
bacchanalian spoof on classical groups of the Three Graces.[6]

There is a slight black chalk sketch of a lower leg with a shin
guard on the verso.

61 *St. Christopher Carrying the Christ Child*

Pen and brown ink and wash over black chalk; 28.5 × 20.9 cm.
INSCRIPTIONS: At lower right, in ink: BALDASS: DI SIENA, partly covering an erased inscription beneath.
PROVENANCE: Sir Peter Lely (L.2092); David Laing; his Bequest to the Royal Scottish Academy, 1878; transferred 1910.
REFERENCES: Frommel, 1967, p.154, no.120; Andrews, 1968, I, p.91.

Edinburgh, National Gallery of Scotland (Acc. no. D1625)

Although never strictly speaking a pupil or assistant of Raphael, the Sienese Peruzzi was closely associated with him through their shared patronage by Agostino Chigi. Most important for his architectural work, Peruzzi produced the designs for Chigi's suburban villa, the Farnesina, around 1506, and building work was largely complete by 1510. Inside, he worked in fresco alongside Raphael in the *Loggia di Galatea*, where he painted zodiacal scenes on the ceiling representing Agostino Chigi's horoscope. He also decorated the Sala del Fregio and the influential Salone delle Prospettive, with its illusionistic vistas, in the same villa. The grisaille decorations on the vault of the Stanza d' Eliodoro in the Vatican, which predate Raphael's campaign there, have been attributed to Peruzzi, as has the execution of the principal scenes on the ceiling. Peruzzi succeeded Raphael as Architect to St. Peter's after the latter's death in 1520, and helped to decorate the loggia of Raphael's Villa Madama.

This *St. Christopher*, a characteristic drawing by Peruzzi, does not relate directly to any painted work by him. Indeed, replete with its landscape background it gives the impression of being an independent work in its own right, or possibly a design for a print. The *all' antica* style of the saint's costume is matched by Peruzzi's treatment of the drapery in long parallel folds with narrow ribs separating them, a recurrent idiosyncrasy of this artist which has its origins in classical sculpture. A sheet of pen and ink studies by Peruzzi in the École des Beaux-Arts in Paris includes two sketches of a *St. Christopher*, one of which directly anticipates the arrangement of the figures in this drawing.[1] A stylistically very similar pen and wash study by Peruzzi at Windsor represents a highly classical design for a statue of Jupiter.[2]

On stylistic grounds the *St. Christopher* can be dated late in Peruzzi's career, perhaps to the early 1530s. At this time he was engaged, among other projects, on supplying additions to the Villa of Belcaro, near Siena, which included the fresco decoration of the chapel there. St. Christopher, conceived in a manner very similar to the present drawing although in a different pose, features among the saints flanking the Virgin and Child in the apse fresco, probably executed largely by Peruzzi's pupils.[3]

62 *The Resurrected Christ with an Angel* [recto]
Two Sketches of a Horses' Heads and an Inscription [verso]

Red chalk (recto); pen and brown ink (verso); the paper discoloured and creased, with repaired tears at the edges; 40.7 × 26.5 cm.
INSCRIPTIONS: On the recto, at lower right: *Raffaello*, in black chalk or pencil; numbered *12.* in brown ink. On the verso: Signed at centre left *Hi.ro Ginga ur –* . The list of 'things to do' is illegible in places, but appears to read: *Ricordo andare a don Gironimo...nioner/ Ricordo andare A messer Gironimo.../ Ricordo andare A m.o Guido p. el Gruppo.../ pro antonio darlo portar...a casa di.../ In volti ne sciughatoio co la scuffia/ Ricordo far portar il materazzo al patrone/ Ricordo parlare a baldasare da Siena/ Rico* (cancelled).
PROVENANCE: David Laing; his Bequest to the Royal Scottish Academy, 1878; transferred 1910.
REFERENCES: Pouncey and Gere, 1962, p.159; Petrioli, 1964, pp.48-58.

Edinburgh, National Gallery of Scotland (Acc. no. D1595)

The study on the recto relates directly to the upper part of Genga's altarpiece of the *Resurrection* painted for the high altar of the Roman church of Santa Caterina di Siena in Strada Giulia (fig. 71). The painting was commissioned by Agostino Chigi (see p.94) on behalf of the recently founded congregation of the Sienese community in Rome. The project must have originated prior to Chigi's death in 1520, although it has been argued that since the plot on which the church was built may have been purchased only in 1526, the altarpiece is unlikely to have been painted before the late 1520s.[1]

Although Genga had some Sienese connections himself, his fellow Urbinate Raphael, Chigi's great friend, may have been instrumental in securing for his older compatriot the commission for the *Resurrection* altarpiece, in much the same way as the architect Bramante had fostered Raphael's own career in Rome. Their acquaintance may stem from the time when they were both associated with Perugino. The composition of the altarpiece has much in common with a *Resurrection* that Raphael had planned but never executed for another Chigi project, his chapel in Santa Maria della Pace. Furthermore, one of the fleeing soldiers in the lower register of Genga's painting (not visible in fig.71) is derived closely from a design by Raphael. Even the present drawing, according to the inscription, was once thought to be by him. It is one of very few sheets by Genga which can be related to a painting, and is the only identified red chalk drawing by him. Its precise and somewhat laboured execution, while reflecting the influence of studies being produced in Raphael's workshop at this date (see cat. nos. 45-8), suggests that this was a medium with which Genga was not particularly comfortable.

The sketches of horses' heads on the verso, inspired by the antique *Horse Tamers* on the Quirinal Hill, represent a more familiar aspect of Genga's work and find close counterparts in two drawings in the Louvre.[2] Genga's reminder to himself to have a chat with Baldassare Peruzzi ('baldasare da Siena') is tantalising in view of the fact that the latter was commissioned at the same time to design an elaborate funeral bier, of which there is now no trace, for the same church for which the *Resurrection* was destined.

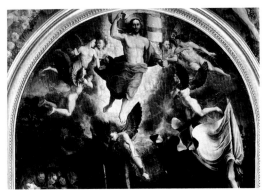

fig. 71 Girolamo Genga *The Resurrection* detail (Rome, Sta. Caterina da Siena in Via Giulia)

detail of verso

POLIDORO DA CARAVAGGIO
(POLIDORO CALDARA) c.1490/1500–c.1543

63 *An Angel Appearing to St. Roch*

Pen and brown ink and wash, heightened with white; 17.9 × 12.7 cm.
Inscription: On the recto, at lower right, in ink *Polidodro di Caravaggio* and numbered
183 on the mount; on the verso, in ink: *Polidoro di Carravagia / bought at the sale of Lord
Somers / at £1: 2: 0/ Fraim... / Glass....*
PROVENANCE: Sir Peter Lely (L.2092); N. F. Haym (L.1972); unidentified collector's
mark (L.2914a); Lord Somers; Jonathan Richardson (?); David Laing; his Bequest to
the Royal Scottish Academy; transferred 1910.
REFERENCES: Manchester, 1965, p.107, no.359; Andrews, 1968, I, p.97; Marabottini,
1969, p.349; Ravelli, 1978, pp.189–90, no.195.

Edinburgh, National Gallery of Scotland (Acc. no. D1799)

According to Vasari, Polidoro's earliest association with Raphael
and his circle was in the capacity of labourer, carrying bricks and
mortar to the workmen constructing the Vatican *Logge*. He
developed a passion there for art and improved so rapidly that he
was asked to assist in the *Logge* decorations.[1] After Raphael's death,
Polidoro began to specialise in the monochrome decoration of the
facades of Roman *palazzi*, an occupation which won him consider-
able fame. He spent much of his later career working in southern
Italy, mainly in Naples and Messina.

With St. Sebastian, Roch was the saint most frequently
invoked against the plague, a disease from which, according to his
legend, he had himself recovered. The angel which appears in this
drawing had watched over him while he lay stricken in the desert,
although Roch's usual companion, his faithful dog, does not
feature. The saint's right thigh is exposed to reveal the dark
blemish indicative of the plague. An especially virulent outbreak
of plague affected much of Italy in the later 1520s, the approxi-
mate date of the drawing, and it is quite possible that it was made
with some protective function in mind. A closely related and more
highly finished drawing in the Louvre repeats the pose of Roch in
this sheet but omits the angel.[2] The Louvre version includes a
frame drawn in such a way as to make it appear that the saint
projects physically in front of it, casting a shadow on the back-
drop. This is likely, however, to be an illusionistic experiment
rather than a design for a sculpture or other three-dimensional
object.

The fading of the washes makes this drawing much less
legible than it would once have been, but Polidoro's expressive
and idiosyncratic style and figure types are still easily recognis-
able. He much favoured wash drawings of this kind, with details
and contours picked out with very fine, wiry pen lines or strands
of white bodycolour.

PERINO DEL VAGA
(PIERO BUONACCORSI) 1501–1547

64 A Sheet of Anatomical Studies and a Sketch of Two Figures [recto]
Studies for Ceiling Compartments and Sketches of a Child's Legs [verso]

Pen and brown ink, with wash on the verso only; 25.3 × 17.2 cm.
INSCRIPTIONS: On the recto, in ink: upper left *1510*; lower left *rafael*; on the verso, in
ink: *par mo*
PROVENANCE: Chambers Hall (L.551); David Laing; his Bequest to the Royal
Scottish Academy, 1878; transferred 1910.
REFERENCES: Andrews, 1968, I, pp.124-25; Rome, 1981, II, pp.181-83, no.129.

Edinburgh, National Gallery of Scotland (Acc. no. D713)

Perino first came to Rome around 1518 and joined the group of
artists assisting Raphael in the execution of the frescoes,
grotesques and stuccoes in the Vatican *Logge*. It is debatable to
what extent Perino was strictly speaking a pupil of Raphael, since
he appears to have developed his own distinctive style before his
arrival in Rome, but he clearly learned a great deal from the study
of Raphael's Roman works. Like Raphael, Perino regarded his
drawings as having a primarily practical function, as tools for use
both by himself and by others. This sheet is a typical example of
the manner in which the artist committed his ideas to paper. The
swift and sparse medium of pen and ink quickly rendered the
organic essence of the figures and determined their poses. The
sketch of the torso on the left resembles, perhaps fortuitously, an
écorché ('flayed') study, undertaken to examine the blocks of muscle
and thus arrive at a better understanding of the anatomy of his
subject. The rather careless appearance of the sheet does not
indicate immaturity or inability, but the speed and energy which
typifies Perino's drawings.

A very similar leg appears on a sheet of studies in the Los
Angeles County Museum of Art,[1] and both studies have been
connected with a fresco of *Apollo and Marsyas* in the Sala di Apollo of
the Castel Sant'Angelo in Rome, completed by Domenico Zaga
after Perino's death in 1547.[2] Similar motifs can also be seen in a
drawing in the British Museum.[3]

The studies for ceiling compartments with carved surrounds
on the verso of the present drawing have not been connected with
any surviving work by Perino.
[S.D.]

verso

65 Jupiter and Alcmene

Pen and brown ink and wash and tempera, heightened with white, on brown
prepared paper; 38.7 × 89.5 cm. (drawn on two sheets of paper joined together; the
sheet subsequently cut into at least four pieces for use as a cartoon).
PROVENANCE: David Laing; his Bequest to the Royal Scottish Academy, 1878.
REFERENCES: Andrews, 1968, I, p.125; Rome, 1981, II, pp.188-95, no.141.

Edinburgh, National Gallery of Scotland, on loan from the
Royal Scottish Academy (Acc. no. RSA 169)

This curious drawing, certainly a fragment of a cartoon, has been
variously attributed in the past. The figure of Jupiter is highly
characteristic of Perino but certain gaucheries in execution and in
such details as the gesture of Alcmene suggest that the work is in
fact by a member of his studio. The juxtaposition of a narrative
scene in monochrome with the fully coloured figure of Cupid or a
putto, whose hand and wing are just visible at the right of the
drawing, indicates that this might be part of a cartoon for a
basamento (the narrow frieze-like field on the lower part of a wall)
or, more likely, for a decorative tapestry border. Such subsidiary
details, would often have been executed by the workshop rather
than by the master himself.

The loves and misdemeanours of Jupiter are subjects which
recur elsewhere in the work of Perino and his studio. For example,
two drawings by Perino himself, in the Courtauld Institute
Galleries in London, are preparatory for the *Furti di Giove* tapestries
designed in the early 1530s for Andrea Doria in Genoa.[1] Although
both the tapestries themselves and their cartoons are now lost, we
know their subjects and compositions from engravings, and close

parallels to the present drawing appear there. Such illustrations of
classical mythology were popular in Perino's studio and successful
devices may well have been carried over from one commission to
another.

An early and faithful copy of this cartoon fragment, possibly
executed in Perino's workshop, is also in the National Gallery of
Scotland.[2]

[S.D.]

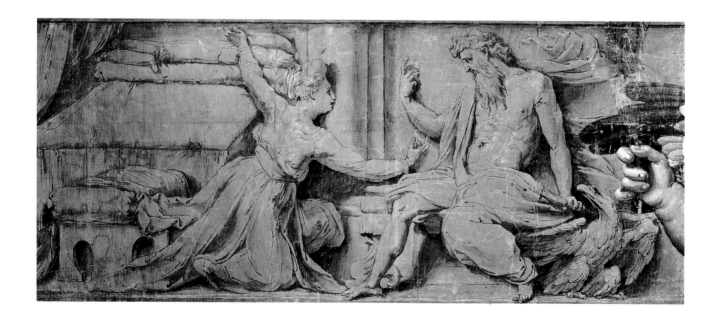

BIAGIO PUPINI ACTIVE 1511–AFTER 1551

66 The 'Canigiani Holy Family' (after Raphael)

Brush drawing in grey-brown ink, heightened with white, over black chalk, on bluish-grey paper; some contours stengthened in pen and ink; there is a framing line in black chalk about 1cm from the left edge; 27.5 × 25.3 cm.
PROVENANCE: Commendatore Genevosio (alias Gelozzi or Gelosi, L.545, see Appendix); Sir Thomas Lawrence; Samuel Woodburn.
REFERENCES: Passavant, 1860, II, p.54; Parker, 1956, II, p.248; Munich, 1983, pp.48-49, 62-63.

Oxford, Ashmolean Museum (P II 499)

In the early 19th century this drawing was considered to be a preparatory modello by Raphael himself for his *Holy Family with St. Elizabeth and the Infant St. John*, known as the *Canigiani Holy Family*, now in the Alte Pinakothek in Munich (fig. 72).[1] Like the *Madonna del Cardellino* (see cat. no. 4), the painting may have been painted to commemmorate a wedding, in this instance that between Domenico Canigiani and Lucrezia Frescobaldi, and it is usually dated to 1507-8. The *Canigiani Holy Family* is Raphael's only truly pyramidal (as opposed to triangular) composition, with Joseph's left heel supplying one point of its base and his head the apex. The putti visible at the top of the picture were mutilated in the early 19th century and subsequently painted out, and only recently have they been revealed and restored.

There are numerous minor differences between Pupini's drawing and the picture in Munich, among them its squarer format, the number and arrangement of the putti, the position of Joseph's hands in relation to his head and his pole in relation to the other figures, the direction of St. Elizabeth's gaze, the placement of the fingers of both Elizabeth and the Virgin, and the veil round Christ's torso. In view of these alterations it has been reasonably suggested that Pupini's drawing was copied not direct from Raphael's painting, but from an elaborate preparatory drawing or from the cartoon,[2] an idea further supported by the absence of any indication of a landscape background in the copy. The amendments noted above are not unlikely ones for Raphael himself to have made between an elaborate preparatory drawing and a finished picture. On the other hand Pupini, who made many copies after the Antique, often took liberties with his source material.

The attribution of the sheet to the Bolognese Pupini is stylistically convincing and receives support from the existence of numerous other copies and adaptations by him after works by Raphael.[3] It seems probable that Pupini gained access to this material when he was in Rome around 1520, perhaps through members of Raphael's studio. The mixed media technique of the drawing and the use of coloured paper is typical of Pupini, and he was influenced in these respects by artists from Raphael's circle

such as Polidoro da Caravaggio (see cat. no. 63). The strong vogue in Bologna for Raphaelesque styles was triggered by the arrival there in about 1515 of Raphael's *St. Cecilia* altarpiece, commissioned for the chuch of San Giovanni in Monte.[4]

A drawing in the Biblioteca Ambrosiana in Milan which is very closely related to the present sheet seems in fact to be copied from it, rather than from a common prototype.[5] It is probably also by a Bolognese draftsman.

Like the National Gallery of Scotland's study for the *Madonna of the Fish* (cat. no. 31), in the 18th century this sheet was in the collection of the Commendatore Genevosio in Turin, whose collector's mark appears in the lower right corner (see Appendix). When it was later in the collections of the portrait painter Thomas Lawrence and of the dealer Samuel Woodburn it was considered to be the work of Raphael himself, and this was no doubt the attribution it carried in when it was owned by Genevosio.

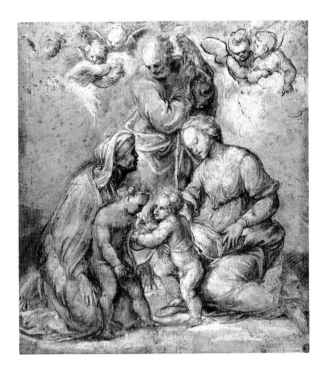

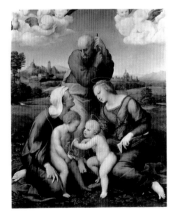

fig. 72
Raphael *Canigiani Holy Family*
(Munich, Alte Pinakothek)

67 The Entombment of Christ

Oil on canvas; 174 × 171.5 cm.
PROVENANCE: Robert Foulis, Glasgow, by 1756; bought by the 'friends of the college' in Glasgow from the exhibition which preceded the sale of paintings from the Foulis collection in London, 1776; bought from the friends by the University in 1779.
REFERENCES: Foulis, 1776, I, p.93; Murray, 1913, p.75; Miles, 1965, p.7, n.9; Irwin and Irwin, 1975, p.85.

Glasgow University, Hunterian Art Gallery (Inv. no. 78)

This is a full scale copy, dating from the 17th or early 18th century, of Raphael's painting in the Borghese Gallery in Rome.[1] Raphael's original, on panel, was commissioned by Atalanta Baglioni as the main part of an altarpiece for her family chapel in the church of San Francesco del Prato in Perugia, where Raphael's *Coronation of the Virgin* (1503, Vatican) was already installed in the Oddi chapel. The original ensemble included a predella below representing the three *Theological Virtues* separated by putti (now in the Vatican) and a lunette of *God the Father Blessing* above, executed by Domenico Alfani to Raphael's design, which is today in the Galleria Nazionale in Perugia. According to Vasari, the *Entombment* was ordered from Raphael when he was in Perugia in 1505 to execute the fresco of the *Trinity* in the Church of San Severo. He produced the cartoon for it in Florence, and then returned to Perugia to execute the painting, which is dated 1507.[2]

This was the first time that Raphael had tackled a dramatic biblical narrative on a large scale and the contrast with, for example, the docile and very Peruginesque *Marriage of the Virgin* (Milan, Brera) provides a striking illustration of what three years diligent study and self improvement could achieve. The care taken by Raphael to arrive at a satisfactory composition – involving in the process a transformation of the subject from a simple *Pieta* (or *Lamentation over the Body of Christ*) into a more active and challenging *Carrying of Christ's Body to the Tomb* – is documented in nearly twenty surviving preparatory drawings. Vasari was full of praise for the result: *The diligence, the love, the skill, and the grace of this work are truly marvellous, and everyone who sees it is stunned by the attitudes of the figures, the beauty of the draperies and, in brief, the perfection of all its parts.*[3] The theme of the male body in action had occupied Raphael around this time in a series of drawings of fighting men. But, while the *Entombment* is certainly charged with emotion, the artist was not entirely successful in combining in the bearers of Christ's body the portrayal of muscular tension and exertion with a sense of movement. Only in the Vatican Stanze was he to fully master the representation of the body in action.

The first notice of the copy appears in a letter of 1756 written by its owner, Robert Foulis, who commented that *the Carrying to the Tomb, an original by the same master [Raphael], is one of the noblest pieces of painting I ever saw.*[4] The terms 'original' and 'copy' were employed loosely and ambiguously by Foulis. The painting was then on display in the Foulis Academy in Glasgow and was subsequently one of only two picutres from the Foulis estate purchased (in 1779) by the Faculty of Glasgow University for their permanent collection.

The Foulis Academy, founded by Robert in 1754 (his brother Andrew became actively involved only in the later 1750s) and properly known as the Academy of the Fine Arts, was a private and remarkably enlightened initiative to provide some form of structured education for aspiring artists in Glasgow, free of charge and along the lines of foreign academies.[5] It pre-dated the foundation of the Royal Academy in London by fifteen years. A full range of subjects was taught. Life-drawing was advertised as one of the activities on offer, although it is not clear if this implied studies from the nude model. Particular emphasis seems to have been placed on the study and copying of the old masters, and at the core of the Academy's activities lay the impressive collections purchased abroad by Robert Foulis. Two consignments arrived from the Continent in 1753, one of them alone numbering no less than 350 oil paintings, and they included drawings, prints and engravers' plates. Additional paintings and sculpted busts, perhaps casts, were acquired in 1772. A total of over 550 paintings from the Foulis collection are listed in the sale catalogue compiled in 1776 after the Academy was disbanded. Some of these were original works, others claimed to be, but most were probably copies. As publishers and booksellers by trade, the Foulis' also encouraged printmaking, and some of their editions were illustrated with plates engraved by students of the Academy.

In common with academies everywhere, Raphael was held in very high esteem. The Foulis gallery included a copy of Raphael's *Transfiguration* believed to have come from the collection of the Cardinal Richelieu, a schematic rendering of which can just be made out in the sketch of the interior of the academy by David Allan (Hunterian Art Gallery).[6] It was presumably a student copy after this *Transfiguration*, itself a copy, that Robert Foulis considered presenting to George III in 1762. There was also a copy, attributed to Guido

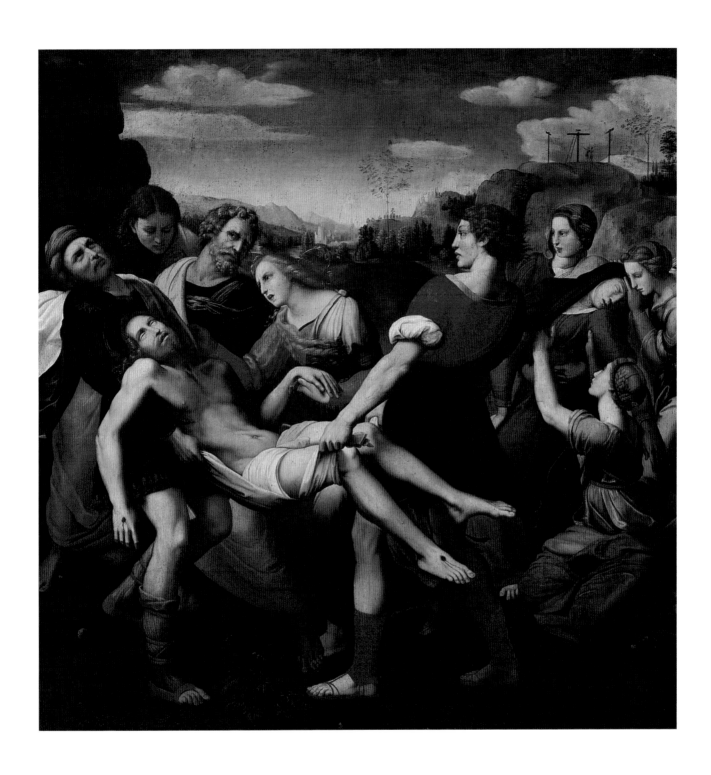

68 The 'Transfiguration' (after Raphael)

Oil on canvas; 414 × 285 cm.
PROVENANCE: Bought from the artist in Rome in 1827 by the Royal Institution,
Edinburgh, through the agency of David Wilkie and Andrew Wilson.
REFERENCES: Cunningham, 1843, III, pp.13, 24; Thompson, 1972, p.35.

Edinburgh, National Gallery of Scotland (Acc. no. 66)

Reni, of Raphael's *Galatea*, while a *St. Cecilia* was thought to be an original 'prior to' the famous painting in Bologna, although when sold at auction it raised only £25. The latter is discernible in the background of an engraved view of the Academy very similar to (and probably based on) the painting attributed to Allan just mentioned.[7] One student of the Academy headed for Rome after graduating to make a copy of the *School of Athens* in the Vatican. Much of the students' printmaking activity, although not very distinguished technically, also focussed on Raphael. The Foulis Press published a volume of engravings after the biblical scenes in the Vatican *Logge* in 1770, and a set entitled *The Seven Tapestry Cartoons of Raphael* three years later, which included at the end three bonus prints after the *Transfiguration*, the *School of Athens*, and the *Parnassus*. Most if not all of the Foulis engravings after Raphael seem to have been copied from earlier reproductive prints. Those after the *Tapestry Cartoons*, for example, were engraved by James Mitchell and William Buchanan after Nicolas Dorigny. A unique volume of miscellaneous engravings from the Foulis Academy preserved in the Mitchell Library in Glasgow includes two prints after preparatory drawings by Raphael for the *Entombment*, which were copied from Crozat's *Recueil d'Estampes* (see Bibliography). Other student copies after Raphael formed part of a consignment of paintings and prints from the defunct Academy sent by a Glasgow merchant to Montreal in Canada in 1782.[8]

The present copy of the *Entombment* was clearly, then, not an isolated or fortuitous representative of Raphael's work in the collection, but part of a much broader taste for his art within the Foulis Academy. It was presumably the immediate source for the *Magdalen*, a head out of Raphael's *Carrying to the Tomb* and the *Nicodemus*, a head from the same picture priced at a guinea each in the *Catalogue of Pictures, Drawings, Prints, Statues and Busts in Plaister of Paris, done at the Academy in the University of Glasgow*, published for the benefit of subscribers in 1758. Notwithstanding the enthusiastic reception of his work in Glasgow, the Raphael compositions available for study in the Foulis Academy, like the *Transfiguration* purchased half a century later for Edinburgh (see following entry), seem to have had little enduring impact on creative history painting in Scotland.

This is a full size copy painted in the mid-1820s of Raphael's celebrated *Transfiguration* then, as now, in the Pinacoteca Vaticana in Rome. The few facts that are known about the copyist, Urquhart, are as follows. He was born in Inverness, and is first recorded in 1817 advertising himself as a drawing and painting instructor in his home town.[1] The following year he apparently departed for Rome, where he was to remain for at least nine years, and where he painted the present copy, ostensibly in front of the original. Back in Britain, he spent some years in London before returning to Inverness, where he advertised as a portrait painter and restorer in 1844. He is last recorded in 1846. As a painter he seems to have been undistinguished, and the purchase of this copy by the Royal Institution, later to become the National Gallery of Scotland, must have been the high point of his professional career.

Urquhart's picture was bought by the Institution at the suggestion of the famous Scottish painter David Wilkie and the painter-dealer Andrew Wilson. Writing jointly from Rome on 28 April 1827, they recommended it in the following terms, which highlight both the qualities of the copy and the motives for its purchase:

Mr. Urquhart is a native of Inverness-shire and who came to Rome for the purpose of study has devoted himself for two years and a half in making this copy. It is the same size as the original (on canvas) painting by Raphael being on pannel; the characters of the heads and drawing of the figures are rendered with great care and the parts throughout detailed with much fidelity. Its colour is also given both with solidity and richness and is on the whole a performance calculated to give a complete idea of the impressive effect of the great original.

Connected as we have the honour to be with the Institution we further take the liberty to observe that such a copy of the Transfiguration, in directing the taste of the student and of the public to the high class of Art to which this master piece of Raphael belongs, would if consistent with the means of the Institution be in every respect an important acquisition.[2]

Art is apt enough of itself to decline, and requires to be excited by the highest examples, Wilkie added in letter written three months later to William Allan.[3] Urquhart's picture was duly bought for the sum

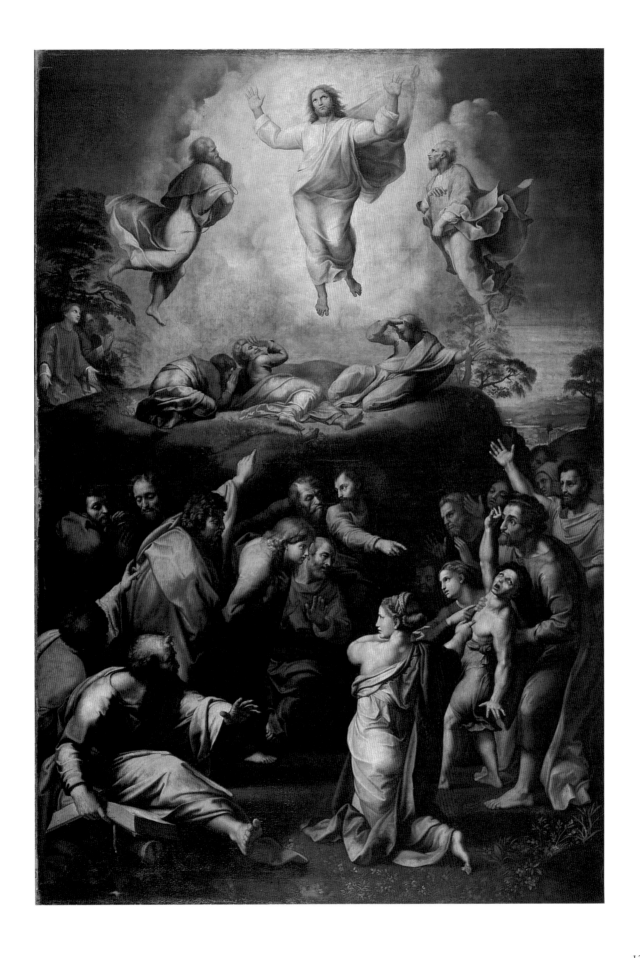

of £300. Following its safe arrival at Leith in January 1828, the painting was put on show in the Royal Institution from April to August of that year, during which period £167. 3/- was taken in entrance fees, over half of its cost price. The Directors of the Trustees Academy contributed a further £100 in recognition of the educational benefit the picture would bring to its students. Within two years Wilkie began to doubt that the picture was having the stimulating impact on Scottish painting he had envisaged: *The copy of the Transfiguration looks uncommonly well. It is on the staircase of the Institution. Nothing can look more like the picture. The purchasers look pleased with it, but I doubt if it is likely to lead to anything like imitation. I see none of the aspirants directing their attention that way. None of the painters have ever adverted it to me.*[4]

The colours in Urquhart's copy are muted in comparison with the Raphael, but this probably reflects the appearance of the original in the 1820s. The thick layers of deliberately tinted varnish which obscured its true colours were removed during the highly successful restoration of Raphael's *Transfiguration* undertaken in the early 1970s.[5]

Raphael's original, his largest, last and most sublime altarpiece, was commissioned by Cardinal Giulio de' Medici, cousin and favourite of Leo X, probably towards the end of 1516.[6] The intended destination was the Cathedral of Narbonne in France, of which the Cardinal was archbishop. A second altarpiece representing the *Raising of Lazarus* (now in the National Gallery in London) was shrewdly ordered for the same destination shortly afterwards from Sebastiano del Piombo, Michelangelo's Venetian protege. The intense competitiveness this generated between the two rival camps drew the best out of each artist. It may have been in response to the dramatic and expressive potential of the multi-figured subject commissioned from Sebastiano that Raphael decided to combine his representation of Christ's *Transfiguration* with a simultaneous scene from the Gospels in which the Apostles unsuccessfully attempt to exorcise a possessed boy. Sebastiano's picture was more or less complete by the summer of 1518, whereas Raphael had not yet started work on the *Transfiguration* at that date. It must, however, have been finished (or virtually so) at the time of

Raphael's death in April 1520, for it was displayed at the head of his body as it lay in state in his studio, before being moved to the Vatican palace a week later for direct confrontation with the *Raising of Lazarus*. That the *Transfiguration* won the contest can be deduced from the fact that Giulio de' Medici decided to keep it in Rome, commissioning a copy to join the Sebastiano in Narbonne. Soon after his accession to the papal throne as Clement VII in 1523, Giulio had the *Transfiguration* set up above the high altar of San Pietro in Montorio in Rome.

According to Vasari, the frescoes in Agostino Chigi's Loggia (see pp.94-5) had been heavily criticised for their lack of Raphael's characteristic grace and sweetness, and their faults were attributed to the excessive use of assistants in their execution. In response, Vasari asserts, Raphael resolved to paint the entire Transfiguration himself, and *by the ceaseless labours of his own hand brought it to a state of highest perfection.*[7] Although a few of the preparatory drawings have been attributed to pupils, technical examination of the altarpiece itself tends to confirm the truth of his statement.[8] The fabulous group of surviving drawings for the *Transfiguration*, notably a series of detailed studies for the Apostles' heads, are among Raphael's supreme achievements as a draughtsman. Vasari was surely not exaggerating when he wrote that it was *the shared judgement of artists that this work among all those that [Raphael] had painted was the most celebrated, the most beautiful and the most divine.*[9]

Appendix:
The Commendatore Genevosio as a Collector of Drawings

AIDAN WESTON-LEWIS

On the morning of 15th November 1778 a visitor to Turin, Angelo Maria Bandini, called on the *Sig.r Commendatore Genevos, called the Commendator Geloso*, for a cup of hot chocolate, and was shown part of his *most choice and superb museum*.[1] According to Bandini's diary, pride of place was taken by a large collection of antique gems and cameos, among them Egyptian and Etruscan examples, and some of the medals are also described as very rare. The Commendatore's copious collection of pictures by the best masters included *a Madonna by Andrea del Sarto, a St. Sebastian and a St. Jerome by Annibale Carracci, an Infant St. John the Baptist by Leonardo da Vinci and others by Carracci and by Tintoretto*. From what we know about the quality of the drawings owned by the Commendatore, these extravagant attributions for the paintings should not be dismissed out-of-hand. Bandini then goes on to mention that he was taken by surprise in the library by a *collection of original drawings by the most celebrated artists, that is by Michelangelo, the Carracci, Leonardo da Vinci and by other excellent masters* but then, frustratingly, singles out for special mention only *a print by Marc'Antonio, designed by Michelangelo, which represents the Rape of Ganymede*. A rare pamphlet by a fellow Torinese, François Gariel, published in Venice in 1783, describes the *Commandeur Genevosio* in a section on the most magnificent collections of Turin as *one of the greatest amateurs of the arts that one could meet*.[2] In addition to the superb paintings, drawings and engraved stones described by Bandini, he mentions a library full of precious books and a selection of natural history specimens (*tout ce que l'Histoire Naturelle peut fournir de plus rare*).

A Torinese collector described alternatively as the Conte or Commendatore Gelosi or Gelozzi has long been known to historians of Italian art, above all to drawings specialists, as the one-time owner of a very impressive group of mainly sixteenth- and seventeenth-century Italian drawings now dispersed in public and private collections throughout the world.[3] Two of these - Raphael's study for the *Madonna of the Fish* recently acquired by the National Gallery of Scotland, and Pupini's copy of the *Canigiani Holy Family* - are included in this exhibition (cat. nos. 31 and 66). Drawings from his collection can be identified on the basis of the Commendatore's distinctive collector's mark (fig. 73),

which consists of a capital C and G interlaced, surmounted by a coronet. It is given the number 545 in Frits Lugt's dictionary of collectors' marks,[4] although even that assiduous scholar was unable to discover anything concrete about the identity and biography of this elusive collector. Recent discoveries in the Turin archives have, however, at last supplied some facts about his life and about the dispersal of his drawings collection, although not, as yet, about its formation.

The Commendatore Vittorio Luigi Modesto Ignazio Bonaventura Genevosio was born in Turin in 1719, and died there on 14th April 1795. His surname is given variously as Geloso, Gelozzo, Gelozzi, Generoso or Genevos, but the correct form is Genevosio. His father Giuseppe Antonio was a wealthy banker, and the Commendatore himself was ennobled (without title) in December 1744. The title *Commendatore* derives from his prominent membership of a *commenda* (a military order) dedicated to Saints Maurice and Lazarus. In July 1781 Genevosio received from the King of Sardinia (a title held by the House of Savoy for most of the eighteenth century) a pension of 400 lire in exchange for a sizable gift of antique medals (*medaglie*). In his last will of 14th February 1795 he bequeathed all his goods to a charitable institution, the Ospedale della Carità in Turin, with instructions that the paintings and 'ancient stones' should be sold for the benefit of the poor. The cameos and engraved stones were listed in a printed catalogue while they were in the possession of the Ospedale, although their subsequent fate is not known.[5]

There is no mention of drawings in the will, and archival documents just unearthed in fact indicate that Genevosio had disposed of his drawings collection, together with a number of paintings, shortly before he died. On 28th March 1794 he agreed

NOTE: I am greatly indebted to Arabella Cifani and Franco Monetti of the Fondazione Pietro Accorsi in Turin for generously sharing with me their archival discoveries concerning Genevosio, and for their permission to summarise these here. They have already discussed some aspects of Genevosio as a collector in their recent book I Piaceri e le Grazie: Collezionismo, pittura di genere e di paesaggio fra Sei e Settecento in Piemonte, and intend in due course to publish more fully the inventory of Genevosio's drawings referred to in this note.

to sell to the Marchese Giovanni Antonio Turinetti di Priero seventeen paintings from his collection *representing fables, historical subjects and landscapes by the most famous painters of the past*, together with no less than 330 *figure drawings by the most celebrated authors from 1500 onwards*.[6] The price was fixed, after consultation with independent experts, at the enormous sum of 15,500 lire, although this was subsequently reduced to 11,500 lire in a mutual agreement of 7th August of the same year.[7] An inventory of all 330 drawings, stored in eight portfolios, was compiled when they were still in Turinetti's possession and is dated 2nd April 1801.[8] This lists the drawings individually, specifying the artist, whether the format is upright or horizontal and whether there was more than one drawing to a mount, but unfortunately no title or indication of subject is given.

We can be fairly sure that the collector's mark Lugt 545 is indeed that of Genevosio since it was identified as such as early as 1803.[9] Independent confirmation of this is supplied by a marginal note in Morel d'Arleux's manuscript inventory of the drawings in the Louvre, which includes a sketch of the mark with the accompanying identification *com. genevoso de turin*.[10] There are, in fact, two variants of this mark, one with five raised pearls on the coronet, the other with six (compare fig. 73 and cat. no. 31). At present we can only guess that this alteration was introduced to reflect some additional honour or title conferred on the Commendatore, after he was ennobled. This might conceivably have been connected with the pension he received from the king in 1781. In any event, the comparatively few drawings bearing the six-pearl variant of the mark are likely to have entered his collection later than those with five pearls.[11] There is as yet no evidence to confirm or deny Lugt's tentative association of a different collector's mark (Lugt 513) with the Commendatore.[12]

Examination of a considerable number of drawings from Genevosio's collection strongly suggests that he mounted his sheets in a distinctive although not rigorously consistent way, and that many of these mounts still survive. A typical example (see fig. 73) consists of a concentric series of ruled framing lines in pen and ink with one or more bands of wash, and a strip of gold, separated by fields of blank paper.[13] On almost all of the mounts examined the wash is pale green, although pink is used in at least one instance,[14] while another mount includes bands of both pink and green.[15] The smart and sympathetic way he mounted his drawings is not the only evidence we have of Genevosio's aesthetic sensitivity, and of his care and pride in his collection. Several sheets were extensively repaired prior to or during mounting, including two which had evidently been torn into half-a-dozen pieces and required patient and skilful salvaging.[16] He also displayed sensitivity in the placement of his collector's mark which, while not unusually large by eighteenth-century standards, is given prominence by its black field. His preferred position for it was evidently the lower right corner of the drawing, but he

sometimes moved it elsewhere on the sheet when placing it there would partly obscure or overly impose on that area of the design. In the case of one or two particularly densely worked drawings the mark was included on the mount rather than on the drawing itself.[17] A drawing by Polidoro da Caravaggio now in the British Museum appears to have been mounted by Genevosio to leave both sides of the sheet visible, and has his mark (and that of Richard Cosway, who owned it subsequently) on both recto and verso.[18] Additional evidence of Genevosio's passion for the arts is supplied by his involvement as an arbitrator in a dispute about the ownership of a group of paintings. For his services he stipulated the right to acquire two pictures by a mysterious Flemish painter called Soden Boden.[19]

The breakdown of Genevosio's drawings collection as it appears in Turinetti's inventory (which, for the sake of argument, is here taken to reflect Genevosio's own attributions) corresponds fairly well with what we can reconstruct from surviving sheets bearing Genevosio's mark. Sixteenth-century Italian artists, many of them associated with the Farnese circle in Rome (such as Perino del Vaga, Francesco Salviati, Giulio Clovio, Michelangelo), are particularly well represented, as are Bolognese, Genoese and Lombard draughtsmen of the seventeenth, with the Carracci, Guido Reni, Guercino, Carlo Cignani, Luca Cambiaso and the Procaccini foremost among them. Allowing for the eighteenth-century tendency to make somewhat generic attributions, a broader spectrum of artists was probably represented than the inventory implies. Sheets assigned to Raphael (eight in total, including one described as *dubioso*) and to Michelangelo (six, plus three ascribed to his school) are likely to have included copies and works by imitators, since only one sheet with a Genevosio provenance by each artist can now be identified.[20] Works by other draughtsmen were also probably hidden among the forty so-called Parmigianinos. Among these may have been some by Perino del Vaga, since twice as many sheets by him can now be identified as were listed in the inventory. On the other hand, drawings by a considerable number of the artists listed are so rare as to lend credence to their attributions. It is difficult to think of a reason for inventing an attribution to, for example, Scarsellino, Lorenzo Garbieri, Ercole Procaccini or Sisto Badalocchio.

The absence of titles in the Turinetti list makes it virtually impossible to correlate specific entries and surviving drawings with any degree of certainty, especially with regard to artists whose names appear repeatedly. In the case of a few of the draughtsmen who appear only once or twice it is nevertheless tempting to hazard a few guesses, and in this respect the indication of the vertical or horizontal format is useful. It is not unlikely, for example, that the one drawing attributed to Raffaellino da Reggio is identical with the sheet now in the Museo de las Bellas Artes in Oporto, which bears an old attribution to this artist inscribed on the mount (it matters little for present purposes that

this drawing was subsequently identified as an original Leonardo da Vinci).[21] The two vertical sheets by Bernardino Campi listed together in portfolio 5 might be the signed drawings now divided between the Lugt Collection at the Institut Néerlandais in Paris, and the Biblioteca Reale in Turin.[22] A compositional drawing by the Ferrarese Carlo Bonone in the Fitzwilliam Museum, Cambridge, may be identical with the one vertical-format drawing by him listed in the inventory.[23]

The Turinetti drawings comprised only a portion of those once owned by the Commendatore. In the case of three drawings now in the Louvre we can be certain that they had left Genevosio's collection by 1792 (and probably several years earlier), since they were seized for the French state the following year.[24] Among these is what was possibly the latest drawing in the Commendatore's collection, a lively pen and wash study by Ubaldo Gandolfi for an altarpiece painted in the early 1770s.[25] It is worth pointing out that the documents connected with the sale of the drawings to Turinetti specify that they were figure drawings (*disegni di figura*), while we know that Genevosio owned at least a few landscapes, animals and decorative designs. Furthermore, several surviving Genevosio drawings which one might reasonably expect to be able to identify in the inventory do not seem to feature there. Among these are the series of five allegorical triumphs by Michiel Coxcie (but once attributed to Carlo Cignani) now in Budapest,[26] a Leonardo da Vinci and a Leonardo copy now in the British Museum,[27] and a series of six episodes from the life of St. Catherine of Siena by Francesco Vanni in the Albertina.[28]

Only a closer study of the subsequent provenances of the drawings and further archival discoveries will clarify the issue of the dispersal of Genevosio's collection, and explain, perhaps, by what route Raphael's study for the *Madonna of the Fish* (cat. no. 31) passed from the hands of one discriminating collector of drawings in Turin into those of another, Sir Thomas Lawrence, in London.

fig. 73 Avanzino Nucci *The Presentation in the Temple* detail showing collector's mark and mount (Edinburgh, National Gallery of Scotland)

Bibliography

Works are listed alphabetically by author.
Exhibition catalogues are listed alphabetically by
venue.

ACHENBACH, 1946
Gertrude M. Achenbach, 'The Iconography of
Tobias and the Angel in Florentine Painting of the
Renaissance', in *Marsyas*, III, 1943-45 [published
1946], pp.71-86.

AMES-LEWIS, 1986
Francis Ames-Lewis, *The Draftsman Raphael*, 1986.

ANDREWS, 1968
Keith Andrews, *Catalogue of Italian Drawings in the
National Gallery of Scotland*, 2 vols., 1968.

ARETINO, ED. PERTILE AND CAMESASCA,
1957-60
Pietro Aretino, *Lettere sull'Arte*, edited by Fidenzio
Pertile and Ettore Camesasca, 3 vols., 1957-60.

ARQUIÉ-BRULEY, LABBÉ AND BICART-SÉE,
1987
Françoise Arquié-Bruley, Jacqueline Labbé and Lise
Bicart-Sée, *La collection Saint-Morys au Cabinet des Dessins
du Musée du Louvre*, 2 vols., 1987.

BAGNI, 1992
Prisco Bagni, *I Gandolfi: Affreschi, dipinti, bozzetti, disegni*,
1992.

BAMBACH CAPPEL, 1992
Carmen Bambach Cappel, 'A Substitute Cartoon for
Raphael's Disputà', in *Master Drawings*, XXX, 1992,
pp.9-30.

BARTSCH, 1803-21
Adam Bartsch, *Le Peintre Graveur*, 21 vols., 1803-21 (The
publication of the *Illustrated Bartsch* in many volumes
began in 1971 and is ongoing).

BEAN, 1960
Jacob Bean, *Les dessins italiens de la Collection Bonnat*
(Inventaire général des dessins des musées de
province, 4, Bayonne, Musée Bonnat), 1960.

BEAN, 1982
Jacob Bean, with the assistance of Lawrence Turcic,
*15th and 16th Century Italian Drawings in the Metropolitan
Museum of Art*, 1982.

BECCARIA, 1909
Augusto Beccaria, *Angelo Maria Bandini in Piemonte: dal
suo Diario di viaggio 9-23 novembre 1778*, 1909.

BELLORI, 1695
Giovanni Pietro Bellori, *Descrizione delle immagini
dipinte da Raffaelle d'Urbino nel Palazzo Vaticano, e nella
Farnesina della Lungara*, 1695.

BERGEON, 1983
Sérgolène Bergeon, 'La Grande Sainte Famille de
Raphaël du Louvre: La restauration, occasion de
recherche et contrubution technique à l'histoire de
l'art', in *The Princeton Raphael Symposium: Science in the
Service of Art History* (papers from a conference held in
October 1983), edited by John Shearman and Marcia
B. Hall, 1990, pp. 49-53.

BIRKE AND KERTÉSZ, 1992
Veronika Birke and Janine Kertész, *Die Italienischen
Zeichnungen der Albertina: Generalverzeichnis*, Band 1
(Inventar 1-1200), 1992.

BOBER AND RUBINSTEIN, 1986
Phyllis Pray Bober and Ruth Rubunstein, *Renaissance
Artists and Antique Sculpture: A Handbook of Sources*, 1986.

BOMFORD, 1980
David Bomford, 'Three Panels from Perugino's
Certosa di Pavia Altarpiece', in *National Gallery Technical
Bulletin*, vol.4, 1980.

BONNAFFÉ, 1884
E. Bonnaffé, *Dictionnaire des Amateurs francais au XVIIe
siècle*, 1884.

BORGO, 1968
Ludovico Borgo, *The Works of Mariotto Albertinelli*,
Doctoral Dissertation presented to the Department
of Fine Arts, Harvard University, 1968 [published by
Garland, 1976].

BRIGSTOCKE, 1978
Hugh Brigstocke, 'The Rediscovery of a Lost
Masterpiece by Giulio Romano', in *Burlington
Magazine*, CXX, October 1978, pp.665-66.

BRIGSTOCKE, 1993
Hugh Brigstocke, *Italian and Spanish Paintings in the
National Gallery of Scotland*, second revised edition,
1993 (first edition, 1978).

BRITTON, 1808
John Britton, *Catalogue Raisonné of the Pictures belonging
to the most honourable the Marquis of Stafford in the Gallery of
Cleveland House*, 1808.

BUCHANAN, 1824
William Buchanan, *Memoirs of Painting, with a
Chronological History of the Importation of Pictures into
England since the French Revolution*, 2 vols., 1824.

BYAM SHAW, 1976
James Byam Shaw, *Drawings by Old Masters at Christ
Church, Oxford*, 2 vols., 1976.

BYAM SHAW, 1983
James Byam Shaw, *The Italian Drawings of the Frits Lugt
Collection, Institut Néerlandais*, 3 vols., 1983.

CAMBRIDGE, 1985
Cambridge, Fitzwilliam Museum, *The Achievement of a
Connoisseur, Philip Pouncey: Italian Old Master Drawings*,
1985, exhibition catalogue by Julien Stock and David
Scrase.

CANDIDA GONZAGA, 1875
Conte Berardo Candida Gonzaga, *Memorie delle
famiglie nobili, delle provincie d'Italia*, Vol. I (Napoli),
1875.

CHANTILLY, 1979
Chantilly, Musée Condé, *La Madone de Lorette*, 1979-80,
exhibition catalogue edited by Sylvie Béguin.

CHIARINI, 1983
Marco Chiarini, 'Paintings by Raphael in the Palazzo
Pitti', Florence, in *The Princeton Raphael Symposium:
Science in the Service of Art History*, (papers from a
conference held in October 1983), edited by John
Shearman and Marcia B. Hall, 1990, pp.79-83.

CHIARINI, 1986
Marco Chiarini, 'La Madonna del Granduca:
deduzione techniche e stilistiche dopo le recenti
indagini scientifiche', in *Raffaello: Recenti indagini
scientifiche* (papers from a conference organised by the
International Council of Museums in June 1986 in
Milan), published 1992.

CHRISTENSEN, 1983
Carol Christensen, 'Examination and Treatment of
Paintings by Raphael at the National Gallery of Art',
in *Raphael Before Rome* (*Studies in the History of Art, Vol. 17*),
edited by James Beck, 1983, pp.47-54.

CIFANI AND MONETTI, 1993
Arabella Cifani and Franco Monetti, *I Piaceri e le Grazie:
Collezionismo, pittura di genere e di paesaggio fra Sei e
Settecento in Piemonte*, 2 vols., 1993.

CLARK, 1967
Kenneth Clark, *Leonardo da Vinci: An Account of his
Development as an Artist*, 3rd revised edition, 1967.

CLARK AND PEDRETTI, 1968
Kenneth Clark, *The Drawings of Leonardo da Vinci in the
Collection of her Majesty the Queen at Windsor Castle*, 2nd
ed., revised with the assistance of Carlo Pedretti, 3
vols., 1968.

CORDELLIER AND PY, 1992
Dominique Cordellier and Bernadette Py, *Raphael, son
atelier, ses copistes*, Musée du Louvre, Département des
Arts Graphiques, Inventaire général des dessins
italiens, V, 1992.

CROWE AND CAVALCASELLE, 1882-85
Joseph Archer Crowe and Giovanni Battista Cavalcaselle, *Raphael: His Life and Works, with particular reference to recently discovered Records, and an exhaustive study of extant Drawings and Pictures*, 1882-85, 2 vols.

CROZAT, 1729
J. A. Crozat, *Recueil d' Estampes d' après les plus beaux Tableaux et les plus beaux Dessins qui sont en France*, 2 vols., 1729.

CUNNINGHAM, 1843
Allan Cunningham, *The Life of Sir David Wilkie*, 3 vols., 1843.

DACOS, 1977
Nicole Dacos, *Le Logge di Raffaello: Maestro e bottega di fronte all'antico*, 1977.

DACOS AND FURLAN, 1987
Nicole Dacos and Caterina Furlan, *Giovanni da Udine: 1487-1561* (part of a three volume set produced in collaboration with Elio Bartolini and Liliana Cargnelutti), 1987.

DAVIDSON, 1987
Bernice Davidson, 'A Study for the Farnesina *Toilet of Psyche*', in *Burlington Magazine*, CXXIX, August 1987, pp.510-13.

DAVIDSON, 1988
Bernice Davidson, 'The *Furti di Giove* Tapestries Designed by Perino del Vaga for Andrea Doria', in *Art Bulletin*, LXX, no.3, 1988, pp.424-50.

DELLA PERGOLA, 1959
Paola della Pergola, *Cataloghi dei Musei e Gallerie d' Italia: La Galleria Borghese, I Dipinti*, II, 1959.

D'ENGENIO CARACCIOLO, 1623
Cesare D'Engenio Caracciolo, *Napoli Sacra*, 1623.

DETROIT, 1985
Detroit Institute of Arts and Fort Worth, Kimbell Art Museum, *Italian Renaissance Sculpture in the Time of Donatello*, 1985-86, exhibition catalogue.

DEVRIES, 1981
Anik Devries, 'Sébastien Errard, un amateur d'art du debut du XIXe siecle et ses conseillers', in *Gazette des Beaux-Arts*, XCVII, 1981, pp.78-86.

DI GIAMPAOLO, 1991
Mario Di Giampaolo, *Parmigianino: Catalogo completo dei dipinti*, 1991.

DOLCE, 1557
Lodovico Dolce, *Dialogo della pittura* 557.

D'ONOFRIO, 1964
Cesare D'Onofrio, 'Inventario dei Dipinti del Cardinal Pietro Aldobrandini compilato da G. B. Agucchi nel 1603', in *Palatino*, 1964, pp.15-20, 158-62, 202-11.

DORIVAL, 1976
Bernard Dorival, *Philippe de Champaigne 1602-1674: La vie, l'oeuvre et le catalogue raisonné de l'oeuvre*, 2 vols., 1976.

DREYER, 1971
Peter Dreyer, *Tizian und sein Kreis: 50 Venezianische Holzschnitte aus dem Berliner Kupferstichkabinett*, 1971.

DUNKERTON AND PENNY, 1993
Jill Dunkerton and Nicholas Penny, 'The Infra-red Examination of Raphael's *Garvagh Madonna*', in *National Gallery Technical Bulletin*, vol.14, 1993, pp.7-21.

DUSSLER, 1971
Luitpold Dussler, *Raphael: A Critical Catalogue of his Pictures, Wall-Paintings and Tapestries*, English ed., translated by S. Cruft, 1971 (first, German ed. 1966)

EASTLAKE, 1960
Sir Charles Eastlake, *Materials for a History of Oil Painting*, 2 vols., 1847 (reprinted as *Methods and Materials of the Great Schools and Masters*, 2 vols., 1960).

EDINBURGH, 1992
Edinburgh, National Gallery of Scotland, *Leonardo da Vinci: The Mystery of the Madonna of the Yarnwinder*, 1992, exhibition catalogue edited by Martin Kemp.

EKSERDJIAN, 1984
David Ekserdjian, Review of J. P. Cuzin, *Raphael, vie et oeuvre*, and K. Oberhuber, *Raffaello*, in *Burlington Magazine*, CXXVI, 1984, p.440.

FAHY, 1969
Everett Fahy, 'The Earliest Works of Fra Bartolommeo', in *Art Bulletin*, 1969, pp.142-54.

FÉLIBIEN, 1725
André Félibien, *Entretiens sur les Vies et sur les Ouvrages des plus excellens Peintres*, 1725.

FERINO PAGDEN, PROHASKA AND SCHUTZ, 1991
Sylvia Ferino Pagden, Wolfgang Prohaska and Karl Schutz, *Die Gemäldegalerie des Kunsthistorischen Museums in Wien: Verzeichnis der Gemälde*, 1991.

FISCHEL, I TO VIII (1913-41)
Oskar Fischel, *Raffaels Zeichnungen*, 8 vols., 1913-41.

FISCHEL, 1939
Oskar Fischel, 'Raphael's Pink Sketchbook', in *Burlington Magazine*, LXXIV, 1939, pp.181-87.

FISCHEL, 1948
Oskar Fischel, *Raphael*, translated by B. Rackham, 2 vols., 1948.

FLORENCE, 1983 (1)
Florence, Uffizi, Gabinetto disegni e stampe, *Disegni di Giovanni Lanfranco*, 1983, exhibition catalogue by Erich Schleier.

FLORENCE, 1983 (2)
Florence, Istituto Universitario Olandese di Storia dell'Arte and Rome, Istituto Nazionale per la Grafica, *Disegni italiani del Teylers Museum Haarlem provenienti dalle collezioni di Cristina di Svezia e dei principi Odescalchi*, 1983-84, exhibition catalogue edited by Bert W. Meijer and Carel van Tuyll.

FLORENCE, 1984 (1)
Florence, Palazzo Pitti, *Raffaello a Firenze*, 1984, exhibition catalogue.

FLORENCE, 1984 (2)
Florence, Casa Buonarroti, *Raffaello e Michelangelo*, 1984, exhibition catalogue edited by Anna Forlani Tempesti.

FLORENCE, 1986
Florence, Uffizi, Gabinetto disegni e stampe, *Disegni di Fra Bartolommeo*, 1986, exhibition catalogue by Chris Fischer.

FLORENCE, 1992
Florence, Palazzo Strozzi, *Maestri e Botteghe: Pittura a Firenze alla fine del Quattrocento*, 1992-93, exhibition catalogue edited by Mina Gregori, Antonio Paolucci and Cristina Acidini Luchinat.

FORLANI TEMPESTI, 1969
Anna Forlani Tempesti, 'The Drawings', in Mario Salmi (ed.), *The Complete Work of Raphael*, English edition, 1969 (Italian edition 1968)

FORTUNATI PIETRANTONIO, 1986
Vera Fortunati Pietrantonio (ed.), *Pittura Bolognese del '500*, 2 vols., 1986.

FOULIS, 1776
Robert Foulis, *A Catalogue of Pictures at present exhibited at the Great Auction Rooms*, 2 vols., 1776.

FREEDBERG, 1950
Sidney J. Freedberg, *Parmigianino: His Works in Painting*, 1950.

FREEDBERG, 1971
Sidney J. Freedberg, *Painting in Italy 1500-1600*, 1971.

FRIEDMANN, 1949
Herbert Friedmann, 'The Plant Symbolism of Raphael's Alba Madonna', in *Gazette des Beaux-Arts*, 36, 1949, pp.213-220.

FROMMEL, 1967
Christoph Luitpold Frommel, *Baldassare Peruzzi als Maler und Zeichner* (Beiheft zum Römischen Jahrbuch für Kunstgeschichte, XI), 1967-68.

GALERIE DU PALAIS ROYAL GRAVÉE, 1786
Galerie du Palais Royal gravée..., edited by J. Couché, with a description of each painting by the Abbé de Fontenai, 3 vols., 1786.

GAMBA, 1932
Carlo Gamba, *Raphael*, 1932.

GARAS, 1967
Klara Garas, 'The Ludovisi Collection of Pictures in 1633' (1), in *Burlington Magazine*, CIX, May 1967, pp.287-89.

GENEVA, 1984
Geneva, Cabinet des Estampes and Musée d'Art et d'Histoire, *Raphael et la seconde main*, 1984, exhibition catalogue.

GERSZI, 1971
Teréz Gerszi, *Netherlandish Drawings in the Budapest Museum: Sixteenth-Century Drawings*, 2 vols., 1971.

GIACOMOTTI, 1974
Jeanne Giacomotti, *Catalogue des majoliques des musées nationaux*, 1974.

GIUSTI AND LEONE DE CASTRIS, 1988
Paola Giusti and Pierluigi Leone de Castris, *Pittura del Cinquecento a Napoli, 1510-1540: forastieri e regnicoli*, 1988.

GOLZIO, 1971
Vincenzo Golzio, *Raffaello nei documenti, nelle testimonianze dei contemporanei e nella letteratura del suo secolo*, revised second edition, 1971 (first edition, 1936).

GOMBRICH, 1966
Ernst H. Gombrich, *The Story of Art*, 11th, revised ed., 1966.

GOMBRICH, 1972
Ernst H. Gombrich, 'Tobias and the Angel', in *Symbolic Images: Studies in the Art of the Renaissance* (II), 1972.

GOULD, 1975 (1)
Cecil Gould, *Leonardo: The Artist and the Non-Artist*, 1975.

GOULD, 1975 (2)
Cecil Gould, *National Gallery Catalogues: The Sixteenth Century Italian Schools*, 1975 (revised and combined edition of the two separate volumes published in 1959 and 1962).

GOULD, 1982
Cecil Gould, 'Raphael versus Giulio Romano: the swing back', in *Burlington Magazine*, CXXIV, August 1982, pp.479-87.

GRONAU, 1936
Georg Gronau, *Documenti artistici urbinati*, 1936.

GRUYER, 1869
François-Anatole Gruyer, *Les Vierges de Raphael et l' iconographie de la Vierge*, 3 vols., 1869.

HARPRATH, 1985
Richard Harprath, 'Raffaels Zeichnung *Merkur und Psyche*', in *Zeitschrift fur Kunstgeschichte*, Vol. 48, 1985, pp.407-33.

HARTT, 1958
Frederick Hartt, *Giulio Romano*, 2 vols., 1958.

HIBBARD, 1974
Howard Hibbard, *Poussin: The Holy Family on the Steps*, 1974.

HILL, 1930
George Francis Hill, *A Corpus of Italian Medals of the Renaissance before Cellini*, 2 vols., 1930.

IRWIN AND IRWIN, 1975
David and Francina Irwin, *Scottish Painters at Home and Abroad*, 1975.

JAFFÉ, 1967
Michael Jaffé, 'Rubens and Raphael', in *Studies in Renaissance and Baroque Art presented to Anthony Blunt on his 60th Birthday*, 1967, pp.98-107.

JAFFÉ, 1977
Michael Jaffé, *Rubens and Italy*, 1977.

JOANNIDES, 1982
Paul Joannides, 'Giulio Romano and Penni', in *Burlington Magazine*, CXXIV, 1982, p.634.

JOANNIDES, 1983
Paul Joannides, *The Drawings of Raphael, with a Complete Catalogue*, 1983.

JOANNIDES, 1985
Paul Joannides, 'The Early Easel Paintings of Giulio Romano', in *Paragone (Arte)*, no.425, July 1985.

JONES AND PENNY, 1983
Roger Jones and Nicholas Penny, *Raphael*, 1983.

JUNQUERA DE VEGA AND HERRERO CARRETERO, 1986
Paulina Junquera de Vega and Concha Herrero Carretero, *Catalogo de Tapices del Patrimonio Nacional, I, Siglo XVI*, 1986.

KAUFFMANN, 1982
C. M. Kauffmann, *Catalogue of Paintings in the Wellington Museum*, 1982.

KEMP, 1981
Martin Kemp, *Leonardo da Vinci: The Marvellous Works of Nature and Man*, 1981.

KLEIN AND BAUCH, 1983
Peter Klein and Josef Bauch, 'Analyses of Wood from Italian Paintings with Special Reference to Raphael', in *The Princeton Raphael Symposium: Science in the Service of Art History* (papers from a conference held in October 1983), edited by John Shearman and Marcia B. Hall, 1990, pp.85-91.

KNAB, MITSCH, OBERHUBER AND FERINO PAGDEN, 1983
Eckhart Knab, Erwin Mitsch, Konrad Oberhuber and Sylvia Ferino Pagden, *Raphael: Die Zeichnungen*, 1983.

KOSCHATZKY, OBERHUBER AND KNAB, 1972
Walter Koschatzky, Konrad Oberhuber and Eckard

Knab, *I grandi disegni italiani dell'Albertina di Vienna*, 1972.

LE BLANC, 1854-90
Charles Le Blanc, *Manuel de l'Amateur d'Estampes*, 4 vols., 1854-90 (1971 reprint, 2 vols.)

LIGHTBOWN, 1978
Ronald Lightbown, *Sandro Botticelli: Life and Work with a Complete Catalogue*, 2 vols., 1978.

LONDON, 1960
London, Royal Academy, *Italian Art and Britain*, 1960, exhibition catalogue.

LONDON, 1983
London, British Museum, *Drawings by Raphael from the Royal Library, the Ashmolean, the British Museum, Chatsworth and other English Collections*, 1983, exhibition catalogue by J. A. Gere and Nicholas Turner.

LONDON, 1987
London, British Museum, *Ceramic Art of the Italian Renaissance*, 1987, exhibition catalogue by Timothy Wilson.

LONDON, 1993
London, British Museum, *Old Master Drawings from Chatsworth*, 1993-94, exhibition catalogue by Michael Jaffé.

LONDON, 1994
London, British Museum, *The Study of Italian Drawings: the Contribution of Philip Pouncey*, 1994, exhibition catalogue by Nicholas Turner.

LUGT 1921
Frits Lugt, *Les Marques de Collections de Dessins et d'Estampes*, 1921, with a *Supplément*, 1956.

MADRID, 1985
Madrid, Museo del Prado, *Rafael en España*, 1985, exhibition catalogue edited by Manuela Mena Marqués.

MAHON, 1947
Denis Mahon, *Studies in Seicento Art and Theory*, 1947.

MALLETT, 1970
J. V. G. Mallett, 'Maiolica at Polesden Lacy (II): Istoriato Wares and figures of Birds', in *Apollo*, November 1970, pp.340-45.

MANCHESTER, 1965
Manchester, City Art Gallery, *Between Renaissance and Baroque: European Art 1520-1600*, 1965, exhibition catalogue by F. G. Grossman.

MANCINELLI, 1983
Fabrizio Mancinelli, 'La Trasfigurazione e la Pala di Monteluce: Considerazioni sulla loro tecnica esecutiva alla luce dei recenti restauri', in *The Princeton Raphael Symposium: Science in the Service of Art History* (papers from a conference held in October 1983), edited by John Shearman and Marcia B. Hall, 1990, pp.149-160.

MANTUA, 1989
Mantua, Palazzo Te and Palazzo Ducale, *Giulio Romano*, 1989, exhibition catalogue.

MANTUA, 1993
Mantua, Palazzo Te, *Giulio Romano pinxit et delineavit: opere grafiche autografe, di collaborazione e bottega*, 1993, exhibition catalogue by Stefania Massari.

MARABOTTINI, 1969
Alessandro Marabottini, *Polidoro da Caravaggio*, 2 vols., 1969.

MAREK, 1983
Michaela J. Marek, 'La Loggia di Psiche nella Farnesina: per la ricostrzione ed il significato', in *Raffaello a Roma: Il Convegno di 1983*, edited by

Christoph Luitpold Frommel and Matthias Winner, 1986, pp.209-16.

MARIETTE, 1857-58
Pierre-Jean Mariette, *Abecedario, et autres notes inédites de cet Amateur sur les Arts et les Artistes*, edited by P. de Chennevières and A. de Montaiglon, 6 vols., 1857-58.

MAROT, 1950
Pierre Marot, 'Recherches sur les origines de la trasportation de la peinture en France' in *Les Annales de l'est*, no. 4, 1950, pp.241-83.

MERRILL, 1983
Ross M. Merrill, 'Examination and Treatment of the *Small Cowper Madonna* by Raphael in the National Gallery of Art', in *Raphael before Rome* (*Studies in the History of Art, Vol.17*), edited by James Beck, 1983, pp.139-47.

MILES, 1965
Hamish Miles, 'A Parcel of Paintings sent from Glasgow to Montreal in 1782', in *National Gallery of Canada Bulletin*, 1965, III, no.2, pp.1-7.

MUNICH, 1983
Munich, Alte Pinakothek, *Raphael in der Alten Pinakothek*, 1983, exhibition catalogue by Hubertus von Sonnenburg.

MURRAY, 1913
David Murray, *Robert and Andrew Foulis and the Glasgow Press*, 1913.

NAGLER, 1835-52
G. K. Nagler, *Neues allgemeines Kunstler-Lexicon*, 25 vols., 1835-52.

NAGLER, 1919
G. K. Nagler, *Die Monogrammisten*, 5 vols., 1919 edition.

NESSELRATH, 1983
Arnold Nesselrath, 'Raphael's Archaeological Method', in *Raffaello a Roma: Il convegno di 1983*, edited by Christoph Luitpold Frommel and Matthias Winner, 1986, pp.357-71.

NEW YORK, 1979
New York, M. Knoedler and Co., Washington, National Gallery of Art, and Los Angeles, County Museum of Art, *The Legacy of Leonardo: Italian Renaissance Paintings from Leningrad*, 1979, exhibition catalogue by Everett Fahy.

NEW YORK, 1987
New York, Pierpont Morgan Library, *Drawings by Raphael and his Circle from British and North American Collections*, 1987, exhibition catalogue by John A. Gere.

NEW YORK, 1989
New York, Pierpont Morgan Library, and Chicago, Art Institute, *From Michelangelo to Rembrandt: Master Drawings from the Teyler Museum*, 1989, exhibition catalogue by Clifford S. Ackley, Michiel C. C. Kersten, William W. Robinson and Carel van Tuyll van Serooskerken.

NICOLSON, 1972
Benedict Nicolson, *The Treasures of the Foundling Hospital*, 1972.

OBERHUBER, 1982
Konrad Oberhuber, *Raffaello*, 1982.

OBERHUBER, 1983
Konrad Oberhuber, 'Raphael's Drawings for the Loggia of Psyche in the Farnesina', in *Raffaello a Roma:*

Il Convegno di 1983, edited by Christoph Luitpold Frommel and Matthias Winner, 1986, pp.189-207.

OBERHUBER-FISCHEL, 1972
Konrad Oberhuber, *Raphaels Zeichnungen: Entwürfe zu Werken Raphaels und seiner Schuler im Vatikan, 1511/12 bis 1520* (Vol. IX of Oskar Fischel's *Raphaels Zeichnungen*), 1972.

PARIS, 1975
Paris, Musée du Louvre, Cabinet de Dessins, *Dessins italiens de l'Albertina de Vienne*, 1975, exhibition catalogue.

PARIS, 1978
Paris, Grand Palais, *Jules Romain: L'Histoire de Scipion, tapisseries et dessins*, 1978, exhibition catalogue by Bertrand Jestaz and Roseline Bacou.

PARIS, 1983 (1)
Paris, Grand Palais, *Raphael dans les collections françaises*, 1983-84, exhibition catalogue.

PARIS, 1983 (2)
Paris, Musée du Louvre, Cabinet des Dessins, *Autour de Raphael: Dessins et peintures du Musée du Louvre*, 1983-84, exhibition catalogue.

PARIS, 1983 (3)
Paris, Grand Palais, *Raphael et l'art français*, 1983-84, exhibition catalogue.

PARIS, 1988
Paris, Musée Carnavalet, *Le Palais Royal*, 1988, exhibition catalogue.

PARKER, 1956
Karl T. Parker, *Catalogue of the Collection of Drawings in the Ashmolean Museum: Volume II, The Italian Schools*, 1956.

PASSAVANT, 1836
Johann David Passavant, *Tour of a German Artist in England*, 1836.

PASSAVANT, 1839
Johann David Passavant, *Rafael von Urbino und sein vater Giovanni Santi*, 1st ed., 2 vols.,1839.

PASSAVANT, 1860
Johann David Passavant, *Raphael d'Urbin et son père Giovanni Santi*, 2nd French ed., translated by Jules Lunteschutz , 1860, 2 vols.

PENANT, 1992
Jean Penant, 'Ferréol Bonnemaison (1766-1826): Un peintre et collectioneur toulousain méconnu', in *L'Olifant, Journal de l'Association des Amis du Musée Paul Dupuy*, no. 1, 1992.

PENNY, 1992
Nicholas Penny, 'Raphael's *Madonna dei garofani* Rediscovered', in *Burlington Magazine*, CXXXIV, February 1992, pp.67-81.

PETRIOLI, 1964
Annamaria Petrioli, 'La Resurrezione del Genga in Santa Caterina a Strada Giulia', in *Paragone (Arte)*, no. 177, 1964, pp.48-58.

PETRIOLI TOFANI, 1986
Annamaria Petrioli Tofani (ed.), *Inventario del Gabinetto disegni e stampe degli Uffizi: 1. Disegni esposti*, 1986.

PLESTERS, 1983
Joyce Plesters, 'Technical Aspects of Some Paintings by Raphael in the National Gallery, London', in *The Princeton Raphael Symposium: Science in the Service of Art History* (papers from a conference held in October 1983), edited by John Shearman and Marcia B. Hall, 1990, pp.15-37.

POLLEN, 1874
J. H. Pollen, *Ancient and Modern Furniture and Woodwork in the South Kensington Museum*, 1874.

POPE-HENNESSY, 1963
John Pope-Hennessy, *Italian High Renaissance and Baroque Sculpture*, 3 vols., 1963.

POPE-HENNESSY, 1970
John Pope-Hennessy, *Raphael: The Wrightsman Lectures*, 1970 (published 1974).

POPE-HENNESSY, 1980
John Pope-Hennessy, *Luca della Robbia*, 1980.

POPHAM, 1946
A. E. Popham, *The Drawings of Leonardo da Vinci*, 1946.

POPHAM AND POUNCEY, 1950
A. E. Popham and Philip Pouncey, *Italian Drawings in the Department of Prints and Drawings in the British Museum: The Fourteenth and Fifteenth Centuries*, 2 vols., 1950.

POPHAM AND WILDE, 1949
A. E. Popham and Johannes Wilde, *The Italian Drawings of the XV and XVI Centuries in the Collection of His Majesty the King at Windsor Castle*, 1949.

POUNCEY AND GERE, 1962
Philip Pouncey and J. A. Gere, *Italian Drawings in the Department of Prints and Drawings in the British Museum: Raphael and his Circle*, 2 vols., 1962.

PROHASKA, 1983
Wolfgang Prohaska, 'The Restoration and Scientific Examination of Raphael's *Madonna in the Meadow*', in *The Princeton Raphael Symposium: Science in the Service of Art History* (papers from a conference held in October 1983), edited by John Shearman and Marcia B. Hall, 1990, pp.56-64.

PUAUX, 1993
François Puaux, 'Un projet de façade de palais par Perino del Vaga (1501-1547) identifié au département des Arts graphiques du Louvre', in *Revue du Louvre*, 1993, no.2, pp.25-26.

RACKHAM, 1940
Bernard Rackham, *Catalogue of Italian Maiolica in the Victoria and Albert Museum*, 2 vols., 1940.

RAVELLI, 1978
Lanfranco Ravelli, *Polidoro Caldara da Caravaggio* (Monumenta Bergomensia XLVIII), 1978.

ROBERTSON, 1968
Giles Robertson, *Giovanni Bellini*, 1968.

ROME, 1981
Rome, Castel Sant'Angelo, *Gli Affreschi di Paolo III a Castel Sant'Angelo: Progetto ed esecuzione, 1543-48*, 1981-82, exhibition catalogue edited by Filippa M. Aliberti Gaudioso and Eraldo Gaudioso, 2 vols.

ROME, 1983 (1)
Rome, Istituto Nazionale per la Grafica, *Giulio Bonasone*, 1983, exhibition catalogue by Stefania Massari, 2 vols.

ROME 1983, (2)
Rome, Istituto Nazionale per la Grafica, *Disegni degli Alberti*, 1983-84, exhibition catalogue by Kristina Herrmann-Fiore.

ROME 1983 (3)
Rome (Farnesina, S. Eligio degli Orefici, S. Maria del Popolo, S. Maria della Pace, and S. Agostino), *I luoghi di Raffaello a Roma*, 1983-84, exhibition catalogue.

ROME, 1984
Rome, Galleria Borghese, *Raffaello nelle raccolte Borghese*, 1984, exhibition catalogue.

ROME, 1985
Rome, Istituto Nazionale per la Grafica, *Raphael Invenit: Stampe da Raffaello nelle Collezioni dell' Istituto Nazionale per la Grafica*, 1985, exhibition catalogue by Grazia Bernini Pezzini, Stefania Massari and Simonetta Prosperi Valenti Rodinò.

ROME, 1992
Rome, Villa Medici (Académie de France), *Raphael: Autour des dessins du Louvre*, 1992, exhibition catalogue by Dominique Cordellier and Bernadette Py, with an introduction by Konrad Oberhuber.

ROSSI MANARESI, 1983
Raffaella Rossi Manaresi, 'A Technical Examination of Raphael's *Santa Cecilia*, with Reference to the *Transfiguration* and the *Madonna di Foligno*', in *The Princeton Raphael Symposium: Science in the Service of Art History* (papers from the conference held in October 1983), edited by John Shearman and Marcia B. Hall, 1990, pp.125-34.

RULAND, 1876
Charles Ruland, *The Works of Raphael Santi da Urbino as represented in The Raphael Collection in the Royal Library at Windsor Castle, formed by H. R. H. the Prince Consort, 1853-61, and completed by Her Majesty the Queen Victoria*, 1876.

SANGIORGI, 1976
Fert Sangiorgi, *Documenti Urbinati: Inventari del Palazzo Ducale (1582-1631)*, Accademia Raffaello, Urbino, Collana di studi e testi 4, 1976.

SCHLEIER, 1993
Erich Schleier, 'Five Drawings by Carlo Bononi', in *Master Drawings*, 1993, XXXI, no.4, pp.409-14.

SÉROUX D'AGINCOURT, 1823
J. B. L. G. Séroux d'Agincourt, *Histoire de l'Art par les Monuments depuis sa décadence au IVe siècle jusqu'à son renouvellement au XVIe*, 6 vols., 1823.

SHEARMAN, 1961
John Shearman, 'The Chigi Chapel in S. Maria del Popolo', in *Journal of the Warburg and Courtauld Institutes*, XXVI, 1961, pp.129-60.

SHEARMAN, 1964
John Shearman, 'Die Loggia der Psyche in der Villa Farnesina und die Probleme der letzten Phase von Raffaels graphischem Stil', in *Jahrbuch der Kunsthistorischen Sammlungen in Wien*, XXIV, 1964, pp.59-100.

SHEARMAN, 1965
John Shearman, 'Raphael and his Circle' (review of Pouncey and Gere, 1962), in *Burlington Magazine*, CVII, 1965, pp.34-37.

SHEARMAN, 1967
John Shearman, 'Raphael...Fa il Bramante', in *Studies in Renaissance and Baroque Art Presented to Anthony Blunt on his 60th Birthday*, 1967, pp.12-17.

SHEARMAN, 1977
John Shearman, 'Raphael, Rome and the Codex Escurialensis', in *Master Drawings*, XV, no.2, 1977, pp.107-46.

SHEARMAN, 1983
John Shearman, 'The Organisation of Raphael's Workshop', in *Museum Studies*, X, 1983, pp.41-57.

SHEARMAN, 1984
John Shearman, 'Raphael Year: Exhibitions of
Paintings and Drawings', in *Burlington Magazine*,
CXXVI, 1984, pp.398-403.

STAMPFLE, 1991
Felice Stampfle, *Netherlandish Drawings of the 15th and
16th Centuries and Flemish Drawings of the 17th and 18th
Centuries in the Pierpont Morgan Library*, 1991.

STIX AND FRÖLICH-BUM, 1932
Alfred Stix and L. Frölich-Bum, *Die Zeichnungen der
Toskanischen, Umbrischen und Römischen Schulen*
(Beschreibender Katalog der Handzeichnungen in
der Graphischen Sammlung Albertina, Band III),
1932.

STOCKHOLM, 1992
Stockholm, Nationalmuseum, *Rafael Teckeningar*,
1992, exhibition catalogue.

SUTTON, 1973
Denys Sutton, 'The Great Duke and the Arts', in
Apollo, September 1973, pp.161-69.

TEMPESTINI, 1992
Anchise Tempestini, *Giovanni Bellini: Catalogo completo*,
1992.

THOMPSON, 1972
Colin Thompson, *Pictures for Scotland: The National
Gallery of Scotland and is collection: a study of the changing
attitude to painting since the 1820s*, with contributions by
Hugh Brigstocke and Duncan Thomson, 1972.

VAN ASPEREN DE BOER, 1983
J. R. J. van Asperen de Boer, 'Current Techniques in
the Scientific Examination of Paintings', in *The
Princeton Raphael Symposium: Science in the Service of Art
History* (papers from a conference held in October
1983), edited by John Shearman and Marcia B. Hall,
1990, pp.3-6.

VASARI, ED. MILANESI, 1878-85
Giorgio Vasari, *Vite de' piu ecelenti pittori, scultori ed
architettori...* , edited by Gaetano Milanesi, 9 vols.,
1878-85.

VASARI, ED. HINDS, 1963
Giorgio Vasari, *The Lives of the Painters, Sculptors and
Architects*, edited by A. B. Hinds, 1963.

VATICAN, 1984
Città del Vaticano, Braccio di Carlo Magno, *Raffaello
in Vaticano*, 1984-85, exhibition catalogue.

VATICAN, 1985-86
Città del Vaticano, Biblioteca Apostolica Vaticana,
Salone Sistino, *Raffaello e la Roma dei Papi*, 1985 and
1986, exhibition catalogue.

VENICE, 1976
Venice, Fondazione Giorgio Cini, *Tiziano e la silografia
veneziana del Cinquecento*, 1976, exhibition catalogue by
Michelangelo Muraro and David Rosand.

VIENNA, 1960
Vienna, Kunsthistorisches Museum, *Katalog der
Gemäldegalerie*, I, 1960.

VIENNA, 1983
Vienna, Graphische Sammlung Albertina, *Raphael in
der Albertina, aus Anlass des 500. Geburtsdages des Kunstlers*,
1983, exhibition catalogue by Erwin Mitsch.

VON SONNENBURG, 1983
Hubertus von Sonnenburg, 'The Examination of

Raphael's Paintings in Munich', in *The Princeton
Raphael Symposium: Science in the Service of Art History*
(papers from a conference held in October 1983),
edited by John Shearman and Marcia B. Hall, 1990,
pp.65-78.

WAAGEN, 1838
G. F. Waagen, *Works of Art and Artists in England*, 3 vols.,
1838.

WARD-JACKSON, 1979
Peter Ward-Jackson, *Italian Drawings in the Victoria and
Albert Museum: Volume I: 14th-16th Century*, 1979.

WASHINGTON, 1969
Washington, National Gallery of Art (and numerous
other venues), *Old Master Drawings from Chatsworth*,
1969-70, exhibition catalogue by James Byam Shaw.

WASHINGTON, 1983
Washington, National Gallery of Art, *Raphael and
America*, 1983, exhibition catalogue by David Alan
Brown.

WASHINGTON, 1990
Washington, National Gallery of Art, and Fort
Worth, Kimbell Art Museum, *Old Master Drawings from
the National Gallery of Scotland*, 1990-91, exhibition
catalogue by Hugh Macandrew.

ZUCKER, 1984
Mark J. Zucker, *Early Italian Masters: the Illustrated
Bartsch, Vol.25 (Commentary)*, 1984.

Notes and References

Raphael: The Pursuit of Perfection

TIMOTHY CLIFFORD

1 Vasari, ed. Hinds, 1963, II, p.247.

2 Vasari, ed. Hinds, 1963, II, p.247. Vasari also tells us that 'Raphael was very amorous, and fond of women, and ran always swift to serve them.' (Vasari, ed. Hinds, 1963, II, p.241).

3 Vasari, ed. Hinds, 1963, II, p.221.

4 Aretino, ed. Pertile and Camesasca, 1957-60.

5 Perhaps the most sweetly sentimental image of Raphael is the engraving by E. Eichens after Giovanni Santi (Pope-Hennessy, 1970, p.13, fig. 6) where the young master is shown, hands clasped in prayer, lightly cloaked, with his genitalia neatly covered by the leaves of a thornless rose bush, a sort of androgynous *Lolita* at first communion.

6 For the provenance, see Brigstocke, 1993, p.11.

7 Britton, 1808, p.vi.

8 Waagen, 1838, II, pp.41-42.

9 Christopher Simon Sykes, *Private Palaces: Life in the Great London Houses*, 1985, pp.286-90.

10 Vasari, ed. Hinds, 1963, IV p.123, where Vasari tells us Bramante was related to Raphael.

11 Vasari, ed. Hinds, 1963, II, p.222.

12 Golzio, 1971, p.10.

13 I had intended to publish this lecture independently, but now much of the material has been re-used in this show, rendering such a publication unnecessary.

14 Alberti, *De re aedificatoria*, x. Raphael himself reiterates this view in his letter to Leo X (see Golzio, 1971, pp.86-87).

15 Bober and Rubinstein, 1986, p.81, no. 41.

16 Nicole Dacos, Antonio Giuliano, Ulrich Pannuti, *Il Tesoro di Lorenzo il Magnifico, Le Gemme*, 1972, pp.41-42, cat. no. 5, fig. l.

17 Bober and Rubinstein, 1986, pp.77-78, no. 36.

18 Pope-Hennessy, 1970, pp.50-58.

19 Bober and Rubinstein, 1986, p.90, no. 52A.

20 Passavant, 1839, I, p.124.

21 Dussler, 1971, p.23.

22 Passavant, 1839, I, p.85.

23 Hill, 1930, I, pp.79-80, no. 320; II, pl. 50.

24 Gronau, 1936, pp.90-94.

25 Crowe and Cavalcaselle, 1882-85, I, pp.231-32.

26 Passavant, 1839, I, pp.497-98, reprinted *in extenso*.

27 Cordellier and Py, 1992, p.84.

28 Clark and Pedretti, 1968, I, pp.91-92, inv. nos. 12515-18.

29 Edinburgh, 1992, p.40, no. 1.

30 Florence, 1986, p.108, no. 58.

31 Vasari, ed. Hinds, 1963, II, p.235.

32 Inv. no. 54.1708.

33 Contrary to Sylvia Ferino Pagden (in Mantua, 1989, p.71).

The Cleaning of the Sutherland Raphaels

JOHN DICK

1 Van Asperen de Boer, 1983, pp.3-6.

2 Plesters, 1983, p.23

3 Merrill, 1983, pp.139-47

4 Klein and Bauch, 1983, p.85.

5 Marot, 1950, pp.250-51.

6 Buchanan, 1824, I, p.336.

7 Rossi Manaresi, 1983, p.125.

8 I am grateful to my colleague Nicola Christie for her interest in this project and for advice on the cross-sections in general and to Paul Wilthew of the National Museums of Scotland who kindly carried out the SEM based energy dispersive microanalysis.

9 Eastlake, 1960, p.152. Eastlake was one of the first to describe these techniques in handling from direct observation and without scientific aids.

10 Christensen, 1983, p.47.

11 Chiarini, 1983, p.79; Chiarini, 1986, pp.21-28.

12 The reflectogram was made by Rachel Billinge, Leverhulme Research Fellow at the National Gallery, London, to whom I am grateful for permission to reproduce it here.

13 Penny, 1992, pp.67-81; Dunkerton and Penny, 1993, pp.7-21.

14 Rossi Manaresi, 1983, p.130. This pigment combination is also noted by David Bomford (1980, pp.20)

15 Von Sonnenberg, 1983, p.68

16 Rossi Manaresi, 1983, p.125, pl.49

17 Bergeon, 1983, pp.51-55 pl.38

18 Bergeon, 1983 pl.140

Catalogue

AIDAN WESTON-LEWIS

1

1 Dussler, 1971, p.20; Prohaska, 1983, pp.56-64; Jones and Penny, 1983, pp.33-36.

2 Vasari, ed. Milanesi, 1878-85, IV, p.321.

3 For Taddei see Cecchi, in Florence, 1984, pp.40-41.

4 Dussler, 1971, p.22; Paris, 1983 (1), pp.81-84, no.6.

5 Jones and Penny, 1983, pp.33-36.

6 See Vienna, 1983, pp.22-26; Ames-Lewis, 1986, pp.60-63; Pope-Hennessy, 1970, pp.193-200. The latter, however, argues that the Vienna sheet is a *subsequent critique by Raphael of the scheme he had evolved.*

7 Dolce, 1557, p.27 (in Golzio, 1971, p.298); quoted by Petrioli Tofani in Florence, 1984, p.271.

2

1 Dussler, 1971, p.36.

2 Dussler, 1971, pp.22-23.

3

1 See New York, 1987, p.56.

2 Parker, 1956, p.266.

3 New York, 1987, pp.58-61, no.8.

4 Joannides, 1983, no.107.

4

1 Dussler, 1971, pp.20-21; Florence, 1984, pp.77-87, no.5.

2 Vasari, ed. Milanesi, 1878-85, IV, pp.321-22.

3 Florence, 1984, pp.39-41 and 77-87, no.5.

4 See Gregori, in Florence, 1984, p.23.

5 Drawings at Chatsworth (no. 722) and at the Ashmolean (Parker, 1956, II, no.634; Knab, Mitsch, Oberhuber and Ferino Pagden, 1983, no.151) are probably copies of lost preparatory studies by Raphael for the painting, and feature the Virgin and Child alone. In the former Christ holds a bird as he does in the painting.

6 Parker, 1956, II, no.516; London, 1983, p.74, no.56.

7 Pope-Hennessy, 1963, catalogue volume, pp.6-7.

8 Shearman, 1967, pp.12-13; and 1977, pp.134, 144 n.45.

5

1 Crowe and Cavalcaselle, 1882-85, I, p.286; Ekserdjian, 1984, p.440; Cordellier and Py, 1992, p.56.

2 The argument that the palm tree suggests an exotic, 'Egyptian' location is undermined by the fact that the species represented is the European fan palm (*Chamaerops humilis*), which is indigenous to Italy.

3 See the letter of recommendation from Giovanna Feltria della Rovere, Duchess of Sora and *Prefettessa* of Rome, to the *gonfaloniere* (chief magistrate) of Florence Piero Soderini (Golzio, 1971, pp.9-10).

4 Dussler, 1971, p.68.

5 Dussler, 1971, p.26.

6 Della Pergola, 1959, II, pp.16-17; Fahy, 1969, pp.143-45; Florence, 1992, p.79, no.2.11. Fra Bartolommeo may in turn have been influenced by Signorelli's extraordinary *Tondo di Parte Guelfa* now in the Uffizi.

7 Fahy, 1969, p.143.

8 Vasari, ed. Milanesi, 1878-85, IV, pp.326-27.

9 Vasari, ed. Milanesi, 1878-85, IV, p.184.

10 Rome, 1985, p.212, no. A XLIX; p.756, pl.1a.

11 Ruland, 1876, no. A XII.5.

12 Pope-Hennessy (1970, p.195) specifically made the connection with the *Entombment*.

13 Passavant, 1860, II, p.38; Gruyer, 1869, III, p.260; Vasari, ed. Milanesi, 1878-85, IV, p.321, n.2.

14 For Taddei, as indeed for all Raphael's Florentine patrons, see Cecchi in Florence, 1984 (1), pp.37-46.

15 First advanced by Crowe and Cavalcaselle (1882-85, I, p.287) and greatly elaborated recently by Clifford (see introductory essay).

16 The *Holy Family with the Infant Baptist* in Vienna from Raphael's studio (Vienna, 1960, p.98, no.630; Ferino Pagden, Prohaska and Schutz, 1991, p.98, pl.123) is known to have a Della Rovere provenance, and its prominent palm tree can therefore be more securely related to Francesco Maria's device.

17 See Viatte in Paris, 1983, p.216.

18 Sangiorgi, 1976, pp.95-97 n.2, 324 n.3. In summary, Sangiorgi's argument rests on the twin facts that no picture fitting this description appears in any other Della Rovere inventory of this period, and that the 1623 inventory is known only from an 18th-century copy. He surmises that a mistranscription must have occurred in the relevant entry, transforming a San Gio[vanni] into a San Gio[seffe]. He goes on to identify the inventory reference with the *Madonna della Seggiola* in the Palazzo Pitti. For an alternative suggestive, see Chiarini in Florence, 1984 (1), p.234.

19 Exceptions are the Botticelli workshop *Nativity* in Boston (Lightbown, 1978, II, pp.135-36, no.C37) and

Michelangelo's *Doni Tondo* in the Uffizi (Freedberg, 1971, pp.16-18).

20 Oberhuber (1982, p.49) suggested that it might signify Christ's acceptance of his earthly mission. He further stated that the palm is a 'symbol of the triumph of Christ over sin and death'.

21 The same motif appears in a strongly Raphaelesque painting by Bartolomeo Bagnacavallo in the Pinacoteca Nazionale, Bologna, and in the preparatory drawing for it in the Louvre. See Bernadini, in Fortunati Pietrantonio, 1986, I, pp.122-23 (ills. p.137).

22 Dussler, 1971, p.22.

23 Friedmann, 1949, pp.213-20; Munich, 1983, p.37.

24 This interpretation was given its fullest expression in the 12th-century writings of St. Bernard of Clairvaux; from the 16th century the *Song of Songs* was an important source for the iconography of the Immaculate Conception.

7

1 Dussler, 1971, pp.11-13, Madrid, 1985, pp.91-95, 137.

2 Both Fischel (1922, III, nos.137-38) and Viatte (in Paris, 1983, p.216) have argued for a more direct connection between the Vatican studies and the *Canigiani Holy Family*, and against any link with the *Holy Family with a Palm Tree*.

3 New York, 1987, no.5. Sale, Christie's, New York, 13th January 1993 (lot 6).

4 Vasari, ed. Milanesi, 1878-85, IV, p.320.

5 Vasari, ed. Milanesi, 1878-85, VII, p.160.

6 Forlani Tempesti, in Florence, 1984 (2), p.23. Ferino Pagden (in Vatican, 1984, p.20) proposed *c.*1507 for the Vatican sketches.

7 Raphael in any case frequently introduced modifications when copying from other works of art. See cat. no. 19 and Vatican, 1984, p.21.

8

1 Byam Shaw, 1983, I, pp.124-25, no.116. Byam Shaw suggested plausibly that a chalk sketch on the recto of this sheet (see Joannides, 1983, no.138) might be a schematic representation of a palm tree.

2 Pope-Hennessy, 1980, pp.66, 256; Detroit, 1985, pp.158-59, no.46.

3 Dussler, 1971, p.10.

4 Joannides, 1983, no.274.

5 See especially his study at Windsor Castle for the head of Judas in the *Last Supper* (Clark and Pedretti, 1968, I, p.101; Inv. no. 12547).

6 Joannides, 1983, commentary to no.155.

9

1 Bonnaffé, 1884, p.158; Paris, 1983 (3), pp.256-57, no.381.

11

1 For the history of the Palais Royal and its collections, see Paris, 1988, especially pp.95-115.

2 See Dorival, 1976, II, pp.33-34, no.52; 38-40, no.59.

14

1 Robertson, 1968, p.152; Tempestini, 1992, p.296, no.104.

2 Freedberg, 1950, pp.201-02; Di Giampaolo, 1991, p.52, no.13.

3 Detroit, 1985, no.42a.

15

1 Pope-Hennessy, 1963, catalogue volume, pp.9-11.

2 Pouncey and Gere, 1962, pp.12-13, no.14.

3 Shearman, 1965, p.35; Joannides, 1983, no.85 verso.

4 Compare Raphael's drawing at Windsor Castle after Leonardo's *Leda* (Joannides, 1983, no.98).

16

1 This entry is based largely on Nicholas Penny's 1992 article, to which I refer the reader for a more detailed discussion.

2 This feature was cited by Passavant (1860, ii, pp.62-63) as an argument against the attribution to Raphael himself.

3 Clark, 1967, pp.31-33; New York, 1979, pp.9-24; Kemp, 1981, pp.53-57.

4 I am indebted to Jane Bridgeman for her comments on the costume in the *Madonna of the Pinks*.

5 Cleveland Museum of Art, Acc. no. 78.37, purchase from the J. H. Wade Fund; Joannides, 1983, no.273.

6 Dussler, 1971, pp.11-13; Madrid, 1985, pp.91-95, 137.

7 Examples include the *Dream of Scipio* and the *Garvagh Madonna* (National Gallery, London), the *Three Graces* and the *Orléans Madonna* (Chantilly, Musée Condé), the *St. Michael* and the *St. George* (Paris, Louvre), the later *St. George* (Washington, National Gallery of Art) and the *Vision of Ezekiel* (Florence, Palazzo Pitti).

8 Golzio, 1971, pp.18-19.

9 Florence, 1984, pp.31-32; Paris, 1983 (1), pp.107-09, no.15.

17

1 Gould, 1975 (1), p.36.

2 A drawing by Raphael at Windsor Castle (Joannides, 1983, no.98), for example, is clearly a copy of a lost preparatory drawing by Leonardo for his *Leda* composition.

3 Popham, 1946, pp.28-29, pls.8-14.

4 Popham, 1946, p.22.

18

1 The existence of several apparently 16th century versions of the painting in French collections suggests an earlier French provenance for either the *Bridgewater Madonna* itself or an early copy of it. See Cordellier and Py, 1992, p.84.

2 Gombrich, 1966, p.230.

3 For example, his lost *Leda*, and his cartoon of the *Virgin and Child with St. Anne* in the National Gallery, London.

4 Chiarini, 1983, p.83; Chiarini, 1986, pp.21-28. The *Portrait of Maddalena Doni*, also in the Pitti, was initially planned as an interior with a window opening at the left (see Florence, 1984, p.255). In the later *Madonna di Loreto* at Chantilly a similar opening was replaced at an advanced stage with a bust length St. Joseph (see Chantilly, 1979, pp.55-59 and Paris, 1983 (1), pp.417-19).

5 The explanation offered by John Dick in his introductory essay (p.00) is, however, an attractive one.

6 Jones and Penny, 1983, p.36.

7 Crowe and Cavalcaselle, 1882-85, II, p.345; Freedberg, 1971, p.30; Oberhuber, 1982, p.48.

8 Passavant, 1860, I, p.152.

9 Pouncey and Gere, 1962, pp.19-20; Brigstocke, 1993, p.131; Clifford (see introduction).

10 The foreground Cupid in the *Galatea* fresco, for example, repeats the Christ Child's pose in reverse, while the Virgin's head reappears in a drawing in the Louvre of 1519-20 for the figure of *Charity* in the Sala di Costantino (Joannides, 1983, no. 454).

11 Uffizi Inv. no. 496E; Joannides, 1983, no.202.

12 Florence, 1986, p.108; Penny, 1992, p.68 and p.71, fig.9.

13 Dussler, 1971, pp.25-26.

19

1 For the tondo see Pope-Hennessy, 1963, catalogue volume, p.6.

2 For Taddei, see cat. no.1.

3 Joannides, 1983, no. 108 recto.

4 Joannides, 1983, no. 108 verso.

20

1 Popham, 1946, pp.28-29, pls.8-14.

2 Dussler, 1971, p.25.

3 Dussler, 1971, pp.31-32.

4 Dussler, 1971, pp.19-20.

5 Ames-Lewis, 1986, p.63.

6 Ames-Lewis, 1986, p.59.

21

1 Knab and Oberhuber (in Paris, 1975, no.28) reverse the chronology of the two drawings.

2 Penny, 1992, p.72.

3 Dussler, 1971, p.26.

22

1 Fischel, 1939, pp.181-87.

2 One copy of the painting, however, bears the date 1509 (see Dussler, 1971, p.27). The usual dating of the *Madonna di Loreto* to *c*.1512 is based on its early association with the *Portrait of Julius II* in the National Gallery, London, which can be dated to that time.

3 Inv. no. Pl. 437; Joannides, 1983, no. 274.

23

1 Paris, 1983 (1), p.278.

24

1 Sometimes incorrectly called Houlanger (see Passavant, 1860, II, p.119; Brigstocke, 1993, p.131, n.3).

2 Penny, 1992, p.78, fig.25.

3 Crozat, 1729, I, p.11.

4 Paris, 1983 (3), no.235; Cordellier and Py, 1992, p.84.

28

1 Gould, 1975 (2), pp.218-20.

2 Information kindly supplied by Nicholas Penny.

3 Golzio, 1971, pp.63, 74-77.

4 On substitute cartoons see Bambach Cappel, 1992, pp.9-30.

5 Pouncey and Gere, 1962, p.23.

6 Pope-Hennessy, 1980, no.40; Detroit, 1985, pp.197-98, nos.44 and 45.

7 See also Washington, 1983, p.128.

8 Joannides, 1983, p.60, no.160.

9 Dussler, 1971, p.26.

10 Joannides, 1983, nos.275 and 276.

11 Passavant (1860, II, p.121) was the first to make this connection.

12 Joannides, 1983, nos.211-13.

29

1 Buchanan, 1824, I, pp.336-40. I am grateful to my colleague Helen Smailes for her help in compiling this entry.

2 For Bonnemaison see Devries, 1981, pp.81-83; and especially Penant, 1992 (not paginated).

3 Passavant, 1836, I, p.173.

4 *Suite d'études calquées et dessinées d'après cinq tableaux de Raphaël accompagnées de gravures de ces tableaux et de notices....composées par M. J.-B. Eméric-David, ouvrage dedié à sa majesté Ferdinand VII roi d'Espagne, par le chevalier F. Bonnemaison, Paris, P. Didot, 1818, gr. in. fol.*

5 Candida Gonzaga, 1875, pp.208-210.

6 Golzio, 1971, p.151.

7 Bober and Rubinstein, 1986, pp.51-52, no.1; Shearman, 1977, pp.128-30. Raphael had used the same source for the unfinished *Madonna del Baldacchino* in the Palazzo Pitti (Dussler, 1971, p.26).

8 D'Engenio Caracciolo (1623, p.277) identifies him improbably as Pico della Mirandola, while St. Jerome was later believed to represent Cardinal Pietro Bembo.

9 Achenbach, 1946, pp.71-86; and especially Gombrich, 1972, pp.26-30.

10 Passavant (1860, II, pp.126-27) was unconvinced by this interpretation.

11 Cunningham, 1843, II, p.485.

12 Joannides, 1983, no.265 verso; Vienna, 1983, nos.31-32.

13 Knab, Mitsch, Oberhuber and Ferino Pagden, 1983, no.460. Albertinelli's authorship of the drawing was accepted by Borgo, 1968, p.324. A drawing by Raphael in Stockholm may, however, be related to the Accademia *Annunciation* commission (Joannides, 1983, no.317 verso).

14 Giusti and Leone de Castris, 1988, p.62. The influence is more pronounced in Sabatini's later Santa Maria di Constantinopoli altarpiece (Giusti and Leone de Castris, 1988, p.169).

30

1 Passavant, 1860, II, p.127. Fischel (1948, p.39) claimed that the figure representing St. Jerome at the right had been 'clumsily touched up' by a later hand.

2 On Raphael's use of *garzoni* see Ames-Lewis, 1986, pp.24-25.

3 See Christie's sale catalogue, London, 19th April 1988 (lot 27); the drawing was subsequently on loan from a private collection to the Fogg Art Museum, Harvard University.

4 Joannides, 1983, no.359.

31

1 Joannides, 1983, no.176.

2 Dussler, 1971, p.26.

3 Technical examination of the Prado painting was inconclusive on the issue of which method was used to transfer the design to the panel. See Madrid, 1985, pp.116-20.

4 Passavant, Dussler and Forlani Tempesti have rejected Raphael's authorship of the drawing; most other scholars accept it, while Joannides remains undecided.

5 Dussler, 1971, pp.31-32; 36-38.

6 Cunningham, 1843, III, p.286.

7 See Madrid, 1985, p.118, fig.54.

32

1 Vasari, ed. Milanesi, 1878-85, V, p.413.

2 Mariette, 1857-58, IV, p.281.

3 For his *Holy Family on the Steps* (versions in Philadelphia and Cleveland). See Hibbard, 1974.

4 Bartsch, 1803-21, XIV, p.63.

33

1 For Lucantonio see Zucker, 1984, pp.517-19.

2 Bartsch, 1803-21, VII, nos.108, 112 and 118.

34

1 On the *In Castel Durante* painter see Mallett, 1970, pp.340-42; London, 1987, p.51, no.65.

2 Giacomotti, 1974, p.253, no.828.

35

1 Gombrich, 1972, p.27.

36

1 Parker, 1956, II, pp.304-05, no.561.

2 Bartsch, 1803-21, XIV, p.54, no.48; and XV, p.20, no.11.

3 The hugging embrace in the Oxford drawing parallels that of Raphael's *Madonna della Tenda* in Munich (Dussler, 1971, p.39).

4 This idea was, however, resurrected in a later composition by Raphael, and was much favoured by his pupil Giuilio Romano (see cat. no. 54).

37

1 As John Dick first pointed out, the inventory number and attribution correspond to G. B. Agucchi's 1603 inventory of the Aldobrandini collection in Rome. See D'Onofrio, 1964, p.206; Brigstocke, 1993, p.134, n.3.

2 For Penni, see cat. no. 53.

3 Passavant, 1836, I, p.126; Crowe and Cavalcaselle, 1882-85, II, p.552; Pope-Hennessy, 1970, p.221; Dussler, 1971, pp.45-46. Oberhuber (1982, p.202) suggested Giulio Romano as the executant, and the names of Raffaellino del Colle (Gruyer, 1869, III, p.381) and Perino del Vaga (Gamba, 1932, p.114) have also been advanced. Following its recent cleaning Brigstocke has argued once again for the possibility of Raphael's authorship (1993, pp.133-34).

4 Vasari, ed. Milanesi, 1878-85, IV, p.646.

5 A similarly posed figure, seen from a different angle, appears in the fresco of *Joseph Recounting his Dreams to his Brothers* in the Vatican *Logge*. This scene, like most of the others, is generally thought to have been painted by Penni, who was also probably responsible for the preparatory modello (known now only through a copy). See Dacos, 1977, pp.178-79, pl.XXVIII.

6 Joannides, 1983, no.285; Oberhuber, 1983, p.203.

7 Knab, Mitsch, Oberhuber and Ferino Pagden, 1983, no.153; Rome, 1984, p.57; Joannides, 1985, pp.43-44, n.24.

8 Ferino Pagden, Prohaska and Schutz, 1991, pl.123, p.98.

9 I am grateful to Myril Pouncey, Julien Stock and Paul Joannides for sharing their views about this drawing and to Sotheby's for supplying a photograph of it.

10 Old, possibly 16th-century copies, all on panel, are in the Galleria Doria Pamphili, Rome, the Galleria Nazionale di Capodimonte in Naples, and Prado, Madrid.

40

1 Garas, 1967, p.289.

43

1 This entry relies heavily on information kindly furnished by Dr. Erich Schleier.

2 See Florence, 1983 (1), p.49, no.VIIIh. The connection was spotted by Carel van Tuyll. The drawing is in fact more closely related to the recently discovered second version of the painting, for which see n.5 below.

3 Bartsch, 1803-21, XVIII, pp.345-48, nos.1-28, pp.354-56, nos.1-23 (*Illustrated Bartsch*, vol.40, 1982, pp.304-32, 337-59).

4 On Agucchi see Mahon, 1947, pp.109-54.

5 42 × 31.5 cm. The St. Joseph in this version corresponds more closely in both pose and scale to the Uffizi drawing than does the equivalent figure in the exhibited painting. A third picture on canvas in the Musée d'art et d'histoire in Geneva is apparently a later copy, with variations, of one or other of the Lanfranco coppers (see Geneva, 1984, p.264, no.261).

44

1 A later state of Verdura's print is dated 1633. See Rome, 1985, pp.203-04, no.1.

2 Rome, 1985, p.204, no.2.

The Psyche Loggia

1 Shearman, 1964, pp.62-63, 71-75.

2 Marek, 1983, pp.213-16.

3 Vasari, ed. Milanesi, 1878-85, IV, pp.377-78; Golzio, 1971, p.227.

4 Harprath, 1985, pp.407-33.

5 Golzio, 1971, p.65.

45

1 Hartt, 1958, I, pp.32-33; p.288, no.23.

2 Vasari, ed. Milanesi, 1878-85, IV, pp.366-67.

3 Joannides, 1983, no.413; New York, 1987, pp.132-35, no.34.

46

1 Joannides, 1983, no.400; Byam Shaw, 1983, I, pp.125-27, no.117.

2 Bober and Rubinstein, 1986, p.127.

3 Joannides, 1983, no.408 and p.118.

4 Joannides, 1983, no.403.

5 Joannides, 1983, no.404; Rome, 1992, p.226.

47

1 Shearman, 1964, pp.69-70.

2 Shearman, 1964, pp.67-68, 88-89; Joannides, 1983, no.419.

3 Joannides, 1983, no.393. Although given there to Giulio Romano, Joannides now favours an attribution of both drawings to Raphael himself.

49

1 Davidson, 1987, pp.510-13.

52

1 The painting is visible in a view of Gildemeester's gallery of 1794-95 by A. de Lelie in the Rijksmuseum, Amsterdam. See Jaffé, 1967, p.105, n.77.

2 For a thorough discussion of Rubens' interest in Raphael see Jaffé, 1977, pp.22-29.

3 Stampfle, 1991, p.138, no.296.

4 Jaffé, 1967, p.105, n. 79.

53

1 Dussler, 1971, pp.48-49; Florence, 1983, pp.222-28, no.19.

2 Mantua, 1989, pp.266-67.

3 Vasari, ed. Milanesi, 1878-85, IV, p.371.

4 Inv. no. 254; Birke and Kertész, 1992, p.150.

5 Florence, 1984, pp.346-48, no.37.

6 On Penni see Vasari, ed. Milanesi, 1878-85, IV, pp.643-49; Pouncey and Gere, 1962, pp.50-52; Oberhuber-Fischel, 1972, IX, pp.38-50; Joannides, 1983, pp.28-31; New York, 1987, pp.9-20; and Oberhuber in Rome, 1992, pp.21-26.

7 Popham and Wilde, 1949, p.317, no.811; Shearman, 1961, p.131, n.12; New York, 1987, pp.185-88, no.51.

8 Oberhuber (1983, pp.201-02) has, however, proposed an attribution of the sheet to Raphael himself. One of the slight chalk sketches on the verso complicates matters, since it is connected with a painting attributed to Giulio. See Joannides, 1982, p.634.

9 For example, New York, 1987, nos.53 and 55.

10 Bartsch, 1803-21, XII, pp.73-74, no.18 (*Illustrated Bartsch*, vol.48, p.108).

54

1 Dussler, 1971, p.49; Madrid, 1985, pp.124-26, 140-41.

2 Dussler, 1971, p.36.

3 Joannides, 1985, pp.32-33, pl.24.

4 Gould, 1982, pp.480-83, figs.2-3.

5 Gould, 1982, pp.483-84, figs.8-9.

6 Mantua, 1989, p.211.

55

1 On the *Scuola Nuova* tapestries, see especially Hope in Vatican, 1984, pp.326-31.

2 Vasari, ed. Milanesi, 1878-85, IV, p.644.

3 Parker, 1956, II, p.326.

4 Parker, 1956, II, p.326.

5 Byam Shaw, 1976, I, pp.135-36, no.457.

6 Pouncey and Gere, 1962, pp.80-81, nos.137-38.

7 Nicolson, 1972, pp.76-77, no.69.

8 Sale, Sotheby's, London, 3rd July 1989 (Lot 9).

56

1 For the Scipio tapestry series see Paris, 1978 and Forti Grazzini in Vatican, 1984, pp.467-73.

2 They were woven in the Brussels workshop of Martin Reynbouts towards the end of the 16th century. See Junquera de Vega and Herrero Carretero, 1986, pp.185, 191.

3 Paris, 1978, pp.120-21.

4 Paris, 1978, pp.118-19, 124-25.

57

1 See especially the relief in the Campo Santo, Pisa (Bober and Rubinstein, 1986, p.91, no.53b).

2 Vatican, 1984, pp.357-58; Rome, 1992, pp.326-27.

3 Mantua, 1989, pp.474-77.

4 Hartt, 1958, I, p.297, no.162, II, fig.223; Paris, 1983 (2), pp.41-42, no.41.

58

1 The attribution to Giulio himself was proposed by Timothy Clifford.

2 Hartt, 1958, I, pp.143-45, II, fig.279.

3 Mantua, 1993, pp.317-18, no.314.

4 Mantua, 1989, pp.374-75, 432-33.

59

1 Dussler, 1971, p.51; Madrid, 1985, pp.99-104, 141.

2 Gould, 1982, pp.480-81.

3 Joannides, 1983, no.422.

4 Madrid, 1985, pp.99-104.

60

1 Nesselrath, 1983, p.364.

2 Dacos, 1977, p.44-45.

3 Dacos, 1977, p.258.

4 Dacos and Furlan, 1987, pp.256-57.

5 Dacos, 1977, p.257; Bober and Rubinstein, 1986, p.95, no.59A.

6 See Bober and Rubinstein, 1986, pp.96-97, no.60.

61

1 Frommel, 1967, p.154, no.119.

2 Popham and Wilde, 1949, p.294, no.685.

3 Frommel, 1967, pp.146-49, no.107C.

62

1 Petrioli, 1964, pp.52-53.

2 Paris, 1983 (2), pp.14-16, nos.6 and 8.

63

1 Vasari, ed. Milanesi, 1878-85, V, p.142.

2 Marabottini, 1969, p.350, no.211; Ravelli, 1978, p.190, no.196.

64

1 Acc. no. 53.20.1 verso. Rome, 1981, II, pp.181-83, no.128.

2 Rome, 1981, I, p.216, fig.175. Both the Edinburgh and Los Angeles sheets were assigned to Domenico Zaga himself in this exhibition.

3 Pouncey and Gere, 1962, pp.105-06, no.176.

65

1 Witt Collection, inv. nos. 4734 and 4735. See Davidson, 1988, pp.440-42.

2 On loan from the Royal Scottish Academy, 1966; Acc. no. RSA169A. Andrews, 1968, I, p.125.

66

1 Dussler, 1971, p.19; Munich, 1983, pp.12-89; Florence, 1984, p.43.

2 Parker, 1956, II, p.248.

3 There are numerous examples in the Louvre: see Cordellier and Py, 1992, references on p.679.

4 Dussler, 1971, pp.39-41.

5 Munich, 1983, pp.62-63, fig.56.

67

1 Dussler, 1971, pp.23-24; Rome, 1984, pp.39-49; Jones and Penny, 1983, pp.40-47.

2 Vasari, ed. Milanesi, 1878-85, IV, pp.325, 327.

3 Vasari, ed. Milanesi, 1878-85, IV, pp.327-28.

4 Murray, 1913, p.75.

5 For the Foulis Academy, see especially Murray, 1913, pp.57 ff.; Miles, 1965, pp.1-7; Irwin and Irwin, 1975, pp.85-90.

6 Miles, 1965, p.1.

7 See Murray, 1913, opposite p.68.

8 Miles, 1965, pp.1-7.

68

1 See the *Inverness Journal*, July 25th 1817. Information kindly supplied by the staff of the Inverness Reference Library.

2 Transcribed in the Board Minutes of the Royal Institution, 18th May 1827 (Scottish Record Office, NG1/1/35).

3 National Library of Scotland, MS 6294, f.70.

4 Cunningham, 1843, III, p.24.

5 Vatican, 1984, p.307.

6 For the original see Vasari, ed. Milanesi, 1878-85, IV, pp.371-72, 383; Dussler, 1971, pp.52-55; Jones and Penny, 1983, pp.235-39; Mancinelli, 1983, pp.149-53; Vatican, 1984, pp.307-09.

7 Vasari, ed. Milanesi, 1878-85, IV, pp.371, 378.

8 Vatican, 1984, p.309.

9 Vasari, ed. Milanesi, 1878-85, IV, p.372.

Appendix

AIDAN WESTON-LEWIS

1 Beccaria, 1909, p.18.

2 *Remerciement d'un bon piemontais a Monsieur *** par M. F.ois Gariel ... Venice, 1783* (copy in the Archivio Storico, Turin, Collezione Simeom, no. 5549).

3 The largest group, comprising sixty Italian drawings, is now in the Albertina in Vienna. I am grateful to Veronika Birke and Janine Kertész for supplying a computer print-out of these drawings.

4 Lugt, 1921, p.97 (*Supplément*, 1956, p.82).

5 Cifani and Monetti, 1993, I, pp.64-65, n.229.

6 Archivio di Stato di Torino, Sezioni Riunite, Insinuazione di Torino, 1794, libro 3, ff. 2596 r. and v. For the Turinetti family as collectors and patrons of the arts, see Cifani and Monetti, 1993, I, pp.32-33, 44.

7 Archivio di Stato di Torino, Sezioni Riunite, Insinuazione di Torino, 1794, libro 8, f. 937 v.

8 Archivio di Stato di Torino, Sezioni Riunite, Insinuazione di Torino, 1801, libro 9, vol. 8, ff. 3449 r.-3450 r.

9 Lugt, 1921, p.97.

10 I am most grateful to Catherine Goguel for this reference.

11 Other drawings with the six-pointed crown include the *Nude Woman seen from behind* attributed to Correggio in the British Museum (London, 1994, p.42, no.43), *Christ Carrying the Cross* by Andrea Solario in the Albertina (Koschatzky, Oberhuber and Knab, 1972, no.51), and the *Personification of Prudence* by Perino del Vaga in the Metropolitan Museum of Art, New York (Bean, 1982, p.174, no.168).

12 Lugt, 1921, I, p.93, no.513.

13 For reproductions of the whole mount, see Cambridge, 1985, no.28 (illustrated in colour at the beginning of the catalogue section) and Puaux, 1993, p.25.

14 Ward-Jackson, 1979, I, p.184, no.405.

15 Ward-Jackson, 1979, I, p.247, no.602.

16 The drawings in question are by Avanzino Nucci in the National Gallery of Scotland (Andrews, 1968, I, p.81) and Bernardino Campi in the Lugt Collection (Byam Shaw, 1983, p.451, no.396A)

17 For example, Ward-Jackson, 1979, I, p.247, no.602.

18 Pouncey and Gere, 1962, p.123, no.213.

19 Cifani and Monetti, 1993, I, p.45.

20 For the Raphael, see cat. no. 31. The Michelangelo is in the Musée Bonnat, Bayonne (Bean, 1960, no.66). An example of the sort of drawing that might easily have gone under Michelangelo's name in the inventory is the sketch in the Victoria and Albert Museum now attributed to Baccio Bandinelli after figures in the *Battle of Cascina* (Ward-Jackson, 1979, p.33, no.31).

21 Pouncey, 1978, p.405; Cambridge, 1985, no.28. Pouncey was of the opinion that the wayward misattribution to Raffaellino da Reggio was unlikely to have stemmed from the discriminating Commendatore.

22 Byam Shaw, 1983, I, p.451, no.396A and fig.117.

23 Schleier, 1993, pp.409-412, fig.3. I am grateful to David Scrase for bringing this drawing to my attention.

24 Arquié-Bruley, Labbé and Bicart-Sée, 1987, I, pp.17ff.

25 Bagni, 1992, p.155, no.142 and p.152, no.139.

26 Gerszi, 1971, I, pp.37-38, nos.56-60.

27 Popham and Pouncey, 1950, I, nos.98 and 119.

28 Stix and Frölich-Bum, 1932, pp.49-50, nos.418-23.